Getting Started with Camera Raw

How to make better pictures using Photoshop and Photoshop Elements

Ben Long

Peachpit Press

Getting Started with Camera Raw:
How to make better pictures using Photoshop and Photoshop Elements
Ben Long

Peachpit Press
1249 Eighth Street
Berkeley, CA 94710
510/524-2178
800/283-9444
510/524-2221 (fax)

Find us on the Web at www.peachpit.com
To report errors, please send a note to errata@peachpit.com
Peachpit Press is a division of Pearson Education
Copyright © 2006 by Ben Long

Project Editor: Alison Kelley
Production Editor: Hilal Sala
Copyeditor: Judy Ziajka
Tech Editor: Ross R. Allen, Ph.D.
Proofreader: Leona Benten
Compositor: Diana Van Winkle
Indexer: Valerie Perry
Cover design: Mimi Heft, Ellen Reilly
Interior design: Diana Van Winkle
Cover images: Ben Long; iStockphoto

ISBN 0-321-38400-8

9 8 7 6 5 4 3 2 1

Printed and bound in the United States of America

Acknowledgments

This book would not have been possible without the help of a lot of really talented people.

Dr. Ross Allen provided exceptional technical editing and, in the process, added and clarified a lot of very important information contained herein. I was also pleasantly surprised to find that Ross had many really good ideas for simply improving the writing of the book, and I think many sections are easier to understand because of his insight.

The Peachpit production team did an excellent job both editorially and with the design. Good editing is a thankless job because when it's done well, it's completely invisible. So you'll have to take my word for it that Judy Ziajka took a lot of clumsy words and made them more coordinated. My image for the book was of something that veered more toward "photography book" than "computer book," and Hilal Sala and Diana Van Winkle did an excellent job of working my text and pictures into Diana's design. Alison Kelley, meanwhile, kept the whole thing together and moving.

Finally, a big thanks to Pam Pfiffner for getting this book started in the first place and for bringing me onboard.

Contents

1

Getting Started

In April 1991, the Galileo space probe was picking its way through the main asteroid belt that lies between Mars and Jupiter, roughly 250 million miles from Earth. The 22-foot-long space probe had been sent to explore Jupiter and its complex system of moons and was packed with a number of high-tech instruments, including spectrometers, magnetometers, radiometers, a heavy ion counter, energy particle detectors, and a digital camera.

Unfortunately, Galileo (along with dozens of NASA engineers) was having a very bad day. Because of a mechanical failure, the ship's main antenna was stuck and unable to completely deploy. Though Galileo had a secondary antenna, it was capable of transmitting only a tiny fraction of the information that could be sent using the primary antenna. While the main antenna packed enough bandwidth to transmit one high-resolution image per minute, the secondary antenna would be able to manage only one high-res image *per month*. Without the main antenna, almost all of the data and pictures the probe would capture would simply have to be deleted—it would be lost forever because there was no way to send any of it home.

NASA never did recover the main antenna—it remained broken and useless for the remaining 12 years of the craft's mission, until it was finally destroyed along with the rest of ship when NASA controllers intentionally crashed the Galileo probe into Jupiter's atmosphere.

Building reflection, Talimm, Estonia, 2005. 1/200 s at 4/5.6. Canon EOS 20D with Canon 75-300mm EF lens.

Thanks to some clever software work, though, the mission was a raging success.

The problem was that the pictures the probe was trying to send were too big for the secondary antenna to deal with, given its limited bandwidth capability. Obviously, there was no way to replace the antenna from 250 million miles away. However, back on Earth, there had been some important technological advances since the ship's original computer design was frozen. In those intervening years, sophisticated image compression had been developed.

Technologies akin to JPEG—the technology used by your web browser or digital camera to compress digital images—could be employed to greatly reduce the size of Galileo's images, allowing them to fit through the secondary antenna's limited-bandwidth pipe.

Though Galileo's computer was equivalent to a 1970s-era Pong machine, NASA programmers managed to craft image compression software that would allow the computer to work more effectively with its less capable antenna. After several years of recoding, and with no second chance available (you can't reboot a space ship from a floppy if you screw up its computer), they uploaded the new, radically different software. To their tremendous joy, everything worked perfectly. Galileo was able to complete 75 percent of its planned mission and made many discoveries and tests that were *not* part of its original mission plan.

Digital cameras, whether on a space ship or in your camera bag, work by capturing some very fundamental grayscale data, which is then processed by the camera's on-board computer to produce a full-color image. The software inside the camera is used to determine everything from what color a pixel should be, to how much sharpening should be applied, to how the data should be compressed so that it can fit onto your storage card (or through a radio transmitter aimed at a far-away planet). Because this processing step is crucial to getting a finished image, the quality of your camera's processing software has a huge bearing on your final image.

In the case of Galileo, NASA was able to replace the probe's imaging software with something better. Similarly, NASA scientists often reprocess image data to create special "false-color images" that reveal types of information not normally visible in a true-color image.

The process of shooting raw with your digital camera works exactly the same way. When you shoot raw, your camera stores the very fundamental data that its image sensor collects, *without* doing any image processing at all. Later, you use special software on your desktop computer to process the raw image data—which appears pretty weird if you look at it directly—into a full-color, finished image.

Shooting raw has several advantages over shooting in TIFF or JPEG format:

✦ Raw gives you complete control of the image processing that is normally performed by your camera. Parameters such as white balance—which your camera's computer can often miscalculate— can be easily hand-tuned to yield better color.

✦ Most digital cameras capture 10 to 12 bits of data for each pixel in an image. However, when they write to JPEG or TIFF format, they discard a lot of that data to create an 8-bit file. With raw, you can create 16-bit files that allow for edits that are much more subtle and refined.

✦ If you use Adobe's Camera Raw, you can take advantage of its highlight-recovery capabilities to restore overexposed areas of your image—something that's impossible with JPEG or TIFF files.

The downside to raw is that it requires one or two extra steps that you don't have to worry about with JPEG. If you're shooting simple snapshots, then you'll have an easier time going from the camera to the web or print with JPEG files. But if you're planning on doing any editing of your images or are shooting in conditions that might confound your camera's automatic features, then raw is a much better way to work.

Who This Book Is For

If you have a camera that offers a raw mode and you've been wondering what it's for and how to use it, then this book is for you. Just a few years ago, raw mode was available only on expensive, high-end digital single-lens reflex (SLR) cameras. But as camera manufacturers have migrated their high-end chipsets to more affordable cameras, and as more people have seen the advantages of shooting raw, raw capability has begun to turn up in more cameras. Now even small point-and-shoot digital cameras often have raw capability.

You don't have to have any particular skill level to take advantage of raw. If you're new to digital photography and photo editing, this book will guide you through all of the basic theory and foundation skills that you need to take advantage of raw capabilities. If you're an experienced photographer—either digital or film—then this book will help you make the transition from shooting in JPEG or film formats.

If you shoot only in JPEG, then you may have already encountered the limitations of that format. Switching to raw may be the ideal solution for you if you've encountered any of these problems:

+ You can't get the color in your images quite right. If you find that you can't push and pull the colors in your images as far as you'd like, then shooting in raw may give you the additional editing latitude that you need.

+ You want more exposure control. Precise control of highlights and shadows is the goal of all photographers, and it's much easier to achieve when shooting in raw.

+ You frequently shoot in low light or in situations with lots of mixed lighting sources. The white balance controls offered by raw converters are ideal for getting accurate color from these difficult shooting situations.

+ You regularly crop and enlarge your images or print your images at very large sizes. You'll prefer raw over JPEG for its lack of compression artifacts.

If any or all of these benefits of raw sound appealing, then you'll want to know how to use raw, and this book will show you how.

What You'll Need

Obviously, the first thing you'll need if you want to shoot raw is a camera with raw capability. If you already have a camera, you can check its manual to find out if it provides raw shooting. On most cameras, you select raw mode from the same menu you use to select JPEG options (**Figure 1.1**).

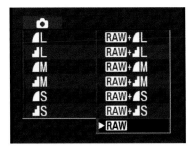

Figure 1.1 *On the Canon EOS-20D, you select raw mode from the same menu that you use to select JPEG quality. Note that this camera also provides modes that write a raw file and a JPEG file simultaneously.*

Choosing a camera is *way* beyond the scope of this book, but if you need some guidelines, check out my "How to Buy a Digital Camera" articles at www.completedigitalphotography.com.

Because raw images must be processed before they can be viewed and edited, you'll need some special raw processing software. Chapter 4 explores some of the options available to you and explains why I think Adobe's Camera Raw is the best choice.

Different raw conversion programs have different system requirements, but raw conversion is not a particularly taxing problem for today's computers. If your computer has at least the following specs, then you're ready to go.

Windows

+ Intel Pentium III or 4 (or compatible) processor running at 800 MHz or better
+ Windows XP Professional or Home Edition with Service Pack 1
+ 256 MB of RAM
+ 800 MB of available disk space
+ Color monitor with 16-bit color or greater video card
+ 1024 x 768 or greater monitor resolution
+ CD-ROM drive

Macintosh

+ G3, G4, or G5 processor
+ OS X version 10.2.8 or later
+ 256 MB of RAM
+ 200 MB of available disk space
+ CD-ROM drive

NOTE

This book makes no assumptions about whether you're using a Mac or a Windows-based computer. Except where otherwise noted, all examples and topics in this book apply to both platforms.

Where to Begin

No matter what your level of experience, if you've never worked with raw files before, you should read Chapter 2, "What Is Raw?" to get a better understanding of what a raw file is and how it differs from a regular JPEG file.

Whether you're shooting raw or JPEG, a lot of your image editing operations will be the same. If you aren't already familiar or comfortable with reading a histogram or using levels, then you should read Chapter 3, "Image Editing Basics." If you're a fairly experienced image editor, then you can probably skip this chapter.

With this editing foundation you're ready to start working on raw files. Chapter 4, "Getting Started with Camera Raw," starts with a quick run through some of the raw conversion programs that are available. My personal preference is Camera Raw, a plug-in for Adobe Photoshop Elements and Photoshop, and the rest of the book is built around Adobe's raw converter. If you have Photoshop Elements 3 or 4, Photoshop CS, or Photoshop CS2, then you already have Camera Raw. If you're using Photoshop 7, you'll need the Adobe Camera Raw plug-in. Adobe no longer sells the plug-in, but you may be able to find a used copy. Chapter 4 introduces you to the fundamentals of Camera Raw, provides an overview of the interface, and explains the basic steps you'll take for all of your raw processing.

Now you're ready to learn about streamlining your raw shooting workflow. Unlike JPEG files, you can't just copy raw files from your camera and start printing or uploading them, so developing a smooth workflow is essential to raw shooting. Chapter 5, "Workflow," walks you through the procedures you need to understand for streamlined raw processing. In addition to learning techniques for quickly reviewing and sorting your images, you'll see how to process entire batches of images and how to build automated processing mechanisms that perform a lot of routine functions for you.

In Chapter 6, "Advanced Editing in Camera Raw," you'll return to raw image editing and explore a few tools that weren't covered in Chapter 4. Then you'll look more deeply into how raw files differ from JPEG files, how your camera perceives light and dark, and how all of this affects your image editing practices. You'll learn about Camera Raw's Curves tool, which enables you to perform highly refined edits, along with Camera Raw's highlight-recovery features. You'll also explore Camera Raw's ability to create high-dynamic-range images, a feature that allows you to capture scenes with an extremely broad range of light and dark tones.

In the final chapter, Chapter 7, "Shooting Raw," you'll explore exposure and shooting concepts that will help you produce raw images that have more editing latitude. You may have heard the phrase "garbage in, garbage out," and while you probably haven't been shooting outright garbage, you'll find that making a few raw-oriented exposure choices when you're shooting will afford you more editing flexibility when you're back at your computer. Finally, you'll see how raw facilitates better low-light photography and how to shoot high-dynamic-range scenes.

There's Nothing to Fear but Bad Images

A lot of people still think of raw photography as the "advanced" or "professional" type of digital photography. Consequently, they're terrified of it, or think it's irrelevant to their needs and beyond their capabilities. For the most part, when you're shooting raw, you're not making any decisions that you don't have to make when you're shooting JPEG but when you're done shooting, you'll have an image file that's open to more sophisticated manipulation than a regular JPEG file. As for those more sophisticated manipulations, they're really not drastically different than the types of edits that you normally make with any modern image editing package.

Be aware that choosing to shoot raw is not some kind of major commitment. You can freely switch between raw and JPEG modes, and you will probably find yourself switching back and forth fairly regularly, depending on the nature of your shooting. If you're simply shooting snapshots that you want to quickly turn into prints, web-based images, or e-mail attachments, then JPEG is the way to go. Similarly, if you're shooting under conditions that you know your camera can handle well and you're not concerned about making major edits or enlargements, then shoot in JPEG mode for much easier workflow. Finally, raw files are *big*, so if storage is a concern, then you may have no choice but to shoot JPEG.

Whatever your shooting needs, an understanding of raw will add a valuable tool to your shooting arsenal. As for raw's being "difficult" or "advanced" or "professional," don't worry about any of that stuff. Raw's easy enough once you get a little background.

2
What Is Raw?

Before we proceed to revel in the extremely digital realm of raw photography, let's take a moment to consider one facet of that quaint nineteenth-century technology called film.

Arguing the merits of film versus digital is a little silly, as they both have strengths and weaknesses. Though I may sometimes sound like a digital chauvinist, there are times when I actually miss working with film (these times don't last very long and so are probably not apparent to an outside observer).

One of the most impressive things about film technology is that a piece of film—even one made 150 years ago—is both a recording mechanism *and* a storage technology. In fact, a frame of film is such a spectacularly self-contained imaging device that you don't even need to put it inside a camera to use it. Stick it in any old box with a pinhole in one side, and you can start creating photorealistic images. No matter what kind of film camera you have, you can drastically change its imaging characteristics and storage capacity simply by switching to a different type of film.

Digital imaging technology is not so remarkably self-contained. First, you need a digital image sensor, which is a special type of computer chip. Unlike film, the image sensor needs a power supply to be able to capture an image, and it needs a place to store the image data. These days, the storage mechanism is usually a flash memory card of some kind. A digital camera also needs lots of other components, from

Lighthouse, Warnemunde, Germany. 1/400 s at f/7.1. Canon EOS 20D with Canon 75-300mm EF lens.

memory buffers that facilitate fast shooting, to controller chips and special circuits for moving the image data between components, to an LCD and interface for configuring the camera's imaging parameters.

However, like film, a digital image sensor does not capture image data that can be immediately viewed as a picture. Just as film must be developed to render a visible image, digital image data must be processed by a computer to yield a final image. When you shoot in JPEG mode, your camera uses its built-in, on-board computer to perform this processing step. When you shoot raw, this processing is performed by your PC or Mac.

How a Digital Camera Sees

For the most part, your digital camera works just like any film camera dating back to the origins of photography: a lens focuses light through an aperture and a shutter onto a focal plane. The only thing that makes a camera a *digital* camera is that the focal plane holds a digital image sensor rather than a piece of film.

Many factors affect your final image, from the quality of your lens, to your (or your light meter's) decision as to which shutter speed and aperture size to use. One of the downsides to digital photography is that the actual imaging technology is a static, unchangeable part of your camera. You can't change the image sensor if you don't like the quality of its output.

Like a piece of film, an image sensor is light sensitive, be it a CCD (charge-coupled device) or CMOS (complementary metal oxide semiconductor) chip. The surface of the chip is divided into a grid of *photosites*, one for each pixel in the final image. Each photosite has a diode that is sensitive to light (a *photodiode*). The photodiode produces an electric charge proportional to the amount of light it receives during an exposure. To create an image, the voltage of each photosite is measured and converted to a digital value, thus producing a digital representation of the pattern of light falling on the sensor.

This process of *sampling,* or measuring the varying amounts of light that were focused onto the surface of the sensor, yields a big batch of numbers, which, in turn, can be processed into a final image.

As you may have already noted, knowing how *much* light there is in a particular photosite doesn't tell you anything about the color of the resulting pixel. Rather, all you have is a record of the varying brightness, or *luminance,*

values that have struck the image sensor. This is fine if you're interested in black-and-white photography. If you want to shoot full color, though, things get a little more complex.

Mixing a batch of color

You've probably had some experience with the process of mixing colors. Whether from getting paint mixed at the hardware store or learning about the color wheel in grade school, you probably already know that you can mix together a few primary colors of ink to create every other color. Light works the same way.

However, whereas the primary colors of ink are cyan, magenta, and yellow, the primary colors of light are red, green, and blue. What's more, ink pigments mix together in a subtractive process. As you mix more, your colors get darker until they turn black. Light mixes together in an additive process; as you mix more light, it gets brighter until it ultimately turns white.

In 1869, James Clerk Maxwell and Thomas Sutton performed an experiment to test a theory about a way of creating color photographs. They shot three black-and-white photographs of a tartan ribbon. For each photo, they fixed their camera with a separate colored filter: one red, one blue, and one green. Later, they projected the images using three separate projectors, each fitted with the appropriate red, green, or blue filter. When the projected images were superimposed over each other, they yielded a full-color picture.

Some high-end digital cameras use this same technique to create color images. Packing three separate image sensors, each fitted with a red, green, or blue filter, these cameras record three separate images and then combine them to create a full-color image. The problem with this multisensor approach is that image sensors are expensive and large, and by the time you add in the requisite storage and processing power, you have a huge camera that's prohibitively expensive. Some of these cameras are also very slow to create an image, making them impractical for shooting live subjects.

Most digital cameras use a single image sensor and get around the color problem by using a lot of math and some clever interpolation schemes to calculate the correct color of each pixel.

In these types of cameras, each photosite is covered with a colored filter—red, green, or blue. Red and green filters alternate in one row, and blue and green alternate in the following row (**Figure 2.1**). There are twice as many green photosites because your eye is much more sensitive to green than to any other color.

Figure 2.1 *In a typical digital camera, each pixel on the image sensor is covered with a colored filter: red, green, or blue. Though your camera doesn't capture full color for each pixel, it can interpolate the correct color of any pixel by analyzing the color of the surrounding pixels.*

This configuration of filters is called the *Bayer pattern* after Dr. Bryce Bayer, the Kodak scientist who thought it up in the early 1970s. Obviously, this scheme still doesn't achieve a color image. For that, the filtered pixel data must be run through an interpolation algorithm, which calculates the correct color for each pixel by analyzing the color of its filtered neighbors.

For example, let's say that you want to determine the color of a particular pixel that has a green filter and a value of 100%. If you look at the surrounding pixels, with their mix of red, blue, and green filters, and find that their values are all also 100%, then it's a pretty safe bet that the correct color of the pixel in question is white, since 100% of red, green, and blue yields white (**Figure 2.2**).

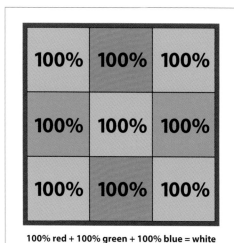

Figure 2.2 *To calculate the true color of the 100% green pixel in the middle of this grid, you examine the surrounding pixels. Because they're all 100%, it's a good chance that the target pixel is pure white, since 100% of red, green, and blue combines to make white.*

The pixel may be some other color—a single dot of color in a field of white. However, pixels are *extremely* tiny (in the case of a typical consumer digital camera, 26 million pixels could fit on a dime) so the odds are small that the pixel is a color other than white. Nevertheless, there can be sudden changes of color in an image—as is the case, for example, in an object with a sharply defined edge. To help average out the colors from pixel to pixel and therefore improve the chances of an accurate calculation, digital cameras contain a special filter that blurs the image slightly, thus slightly smearing the color. While blurring an image may seem antithetical to good photography, the amount of blur introduced is not so great that it can't be corrected for later in software.

Although calculating white is easy enough to understand, interpolating a subtle range of full color is plainly very complicated. This process of interpolation is called *demosaicing,* a cumbersome word derived from the idea of breaking down the chip's mosaic of RGB-filtered pixels into a full-color image. There are many different demosaicing algorithms. Because the camera's ability to accurately demosaic has a tremendous bearing on the overall color quality and accuracy of the camera's images, demosaicing algorithms are closely guarded trade secrets.

The Bayer pattern is an example of a *color filter array*, or CFA. Not all cameras use an array of red, green, and blue filters. For example, some cameras use cyan, yellow, green, and magenta arrays. In the end, a vendor's choice of CFA doesn't really matter as long as the camera yields color that you like.

No matter what type of color filter array the camera uses, a final image from a digital camera consists of three separate *color channels*, one each for red, green, and blue information. Just as in Maxwell and Sutton's experiment, when these three channels are combined, you get a full-color image (**Figure 2.3**).

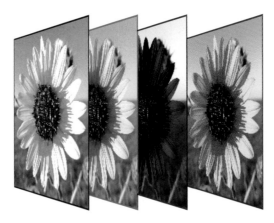

Figure 2.3 *Your camera creates a full-color image by combining three separate red, green, and blue channels. If you're confused by the fact that an individual channel appears in grayscale, remember that each channel contains only one color component—so the red channel contains just the red information for the image; brighter tones represent more red, darker tones, less.*

FOVEON X3: LOTS OF PIXELS, NO INTERPOLATION

You may have heard of a type of image sensor made by a company called Foveon. Foveon's sensors are unique in that they don't require any demosaicing. Rather than using an array of single photosites covered with filters, the Foveon sensor exploits the fact that silicon absorbs different wavelengths of light at different depths. Blue is absorbed near the surface, green farther down, and red even farther. The Foveon sensor can take readings at different depths, allowing it to measure all three color signals at the same location.

This lack of interpolation means that the Foveon sensor is not susceptible to interpolation errors or certain types of artifacts that can occur in a "normal" digital image sensor. On the downside, the three absorption layers have some overlap, which means that a photon with a color somewhere between green and red can be absorbed by either layer. Consequently, getting a clear measurement of the three separate RGB channels can be tricky.

While the Foveon chip can produce excellent images, Foveon-equipped cameras don't yet show a clear advantage over cameras equipped with the more prevalent CCD and CMOS sensors.

Anatomy of an Image

A digital image is, of course, composed of a grid of colored pixels. The color of an individual pixel in an image is usually specified using three numbers, one for the red information, one for the blue, and one for the green. If your final image is an *8-bit image,* then 8-bit numbers are used to represent the pixels in each channel. This means that any pixel in any individual channel can have a value between 0 and 255. When three 8-bit channels are combined, you have a composite 24-bit image that is capable of displaying any of approximately 16 million colors. While this is a far greater number of colors than the eye can perceive, bear in mind that a lot of these colors are essentially redundant. RGB values of 1,0,0 (1 red, 0 green, 0 blue) and 1,1,0 are not significantly different. Therefore, the number of *significant* colors in that 16 million-color assortment is actually much smaller.

If your image is a *16-bit image*, then 16-bit numbers are used for each channel, resulting in an image that can have roughly 35 trillion unique colors. Though the difference between 1,0,0 and 1,1,0, will be the same as in an 8-bit image, because each pixel of each channel can have a value between 0 and 32,768, 16-bit images have more significant colors—that is, more colors that your eye is capable of seeing.

It's important to understand channels because some edits and corrections can be achieved only by manipulating the individual color channels of an image. What's more, some problems are easier to identify and solve if you are in the habit of thinking in terms of individual channels. Finally, as you'll see later, an understanding of color channels makes it easier to make better use of your image editor's adjustment and correction tools.

How Your Camera Makes a JPEG Image

When you shoot with your camera in JPEG mode (or in TIFF mode, if the camera provides such a feature), a lot of things happen after the sensor makes its capture. First, the image data is amplified. The signals generated by your camera's image sensor are actually quite weak and need to be boosted to a level that's easier to work with. When you increase the ISO setting on your camera, you're doing nothing more than increasing the amount of amplification that is applied to the original data. Unfortunately, just as turning up the volume on your stereo produces more noise and hiss, turning up the amount of amplification in your camera increases the amount of noise in your image (**Figure 2.4**).

Figure 2.4 *As you increase the ISO setting of your camera (often done when shooting in low light), you increase the amount of noise in your image.*

Once the signal is amplified, the data is passed to your camera's on-board computer, where a number of important image processing steps occur.

Demosaicing

First, the raw image data is passed through the camera's demosaicing algorithms to determine the actual color of each pixel. Demosaicing is a very complex process, and while the computing power in your digital camera would make a desktop computer user of 15 years ago green with envy, camera manufacturers sometimes have to take shortcuts with their demosaicing algorithms to keep the camera's performance up.

Colorimetric interpretation

Though we noted that each photosite has a red, green, or blue filter over it, we never defined what "red," "green," and "blue" are. Your camera is pro-grammed with colorimetric information about the exact color of these filters and so can adjust the overall color information of the image to compensate for the fact that its red filters, for example, may actually have a bit of yellow in them.

Color space

After all this computation, your camera's computer will have a set of color values for each pixel in your image. For example, a particular pixel may have measured as 100% red, 0% green, and 0% blue, meaning it should be a bright red pixel. But what does 100% red mean—100% of what?

Your eye can see a tremendous range of colors, and your computer may be able to mathematically represent an even larger range of colors—so 100% red to your computer may be very different than 100% red to your eye. Similarly, your camera has a particular range, or *gamut*, of colors that it is capable of capturing and recording.

To ensure that different devices and programs understand what "100% red" means, your image is mapped to a *color space*. Color spaces are simply specifications that define exactly what color a particular color value—such as 100% red—corresponds to.

Most cameras provide a choice of a couple of color spaces, usually sRGB and Adobe RGB. Your choice of color space affects the appearance of your final image because the same color values map to different actual colors in different spaces. For example, 100% red in the Adobe RGB color space is defined as a much brighter color than 100% red in the sRGB space.

All of these color spaces are smaller than the full range of colors that your eye can see, and some of them may be smaller than the full range of colors that your camera can capture. If you tell your camera to use sRGB, but your camera is capable of capturing, say, brighter blues than provided for in the sRGB color space, then the blue tones in your image will be squeezed down to fit in the sRGB space. Your image may still look fine, but if you had shot in a larger color space, there's a chance that the image could have looked much better.

After demosaicing your image, the camera converts the resulting color values to the color space you've selected. (Most cameras default to sRGB.) Note that you can change this color space later using your image editor.

White balance

As technologically impressive as it may be, your digital camera still can't do one simple thing that your eye does without your even noticing. If you look at a colored object indoors, under artificial lighting, and then take the same object outdoors and look at it under sunlight, it will appear to be the same color in both places. Unfortunately, your digital camera can't manage such a feat so easily. (And before your film-using friends go all high-status on you, remember that film has the same trouble. You have to buy different types of film for indoor and for outdoor shooting.)

Different types of light shine at different intensities, measured as temperatures using the Kelvin (K) scale. To properly interpret the color in your image, your digital camera needs to know what type of light is illuminating your scene.

White balancing is the process of calibrating your camera to match the current lighting situation. Because white contains all colors, calibrating your camera to properly represent white automatically accurately calibrates your camera for any color in your scene.

Your camera will likely provide many different white balance settings, from an auto white balance mode that tries to guess the proper white balance, to preset modes that let you specify the type of light you're shooting in, to manual modes that let you create custom white balance settings. These settings don't have any impact on the way the camera shoots or captures data. Instead, they affect how the camera processes the data after it's been demosaiced and mapped to a color space (**Figure 2.5**).

Figure 2.5 *The same image shot with three different white balance settings: daylight, cloudy, and tungsten. As you can see, if you tell your camera that you're shooting under a different type of light, it interprets the colors it "sees" very differently.*

If you're shooting in auto white balance mode, the camera employs special algorithms for identifying what the correct white balance setting should be. Though most auto white balance mechanisms these days are very sophisticated, even the best ones can still be confused by mixed lighting situations—shooting in a tungsten-lit room with sunlight streaming through the windows, shooting into a building from outside, and so on. Fortunately, as you'll see, when shooting raw, these situations are no longer a concern, since raw processors allow you to adjust the white balance of an image after the fact.

If you're using a preset white balance or manual mode, the camera adjusts the color balance of the image according to those settings.

Gamma, contrast, and color adjustments

Say you expose a digital camera sensor to a light and it registers a brightness value of 50. If you expose the same camera to twice as much light, it will register a brightness value of 100. Although this makes perfect sense, it is, unfortunately, not the way your eye works. Doubling the amount of light that hits your eye does not result in a doubling of perceived brightness, because your eye does not have a linear response to light.

Our eyes are much more sensitive to changes in illumination at very low levels than they are to changes at higher levels. Because we need to be able to spot a wild animal creeping up on us in the dark—or find the light switch in a dark bathroom in the middle of the night—our eyes have evolved to be more sensitive to very subtle changes in low-light intensity. Because of this, we don't perceive changes in light in the same linear way that a digital camera does.

To compensate for this, a camera performs *gamma correction*, applying a mathematical curve to the image data to make its brightness levels match what the eye would see. Gamma correcting an image redistributes its tones so that there's more contrast at the extreme ends of the tonal spectrum. A gamma-corrected image has more subtle changes in its darkest and lightest tones than does an uncorrected, linear image (**Figure 2.6**). You'll learn more about gamma correction in Chapter 6.

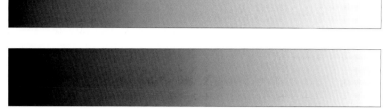

Figure 2.6 *The upper image shows what your camera sees when looking at a black-to-white gray ramp. Each value is precisely double the previous value. The lower image shows how your eye perceives the same ramp. Note that your eye registers many more fine gradations of dark and bright tones.*

Next, the camera adjusts the image's contrast and color. These alterations are usually fairly straightforward—an increase in contrast, perhaps a boost to the saturation of the image. Most cameras let you adjust these parameters using the built-in menu system, and most cameras provide some variation on the options shown in **Figure 2.7**.

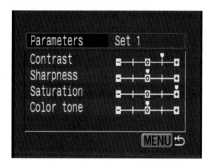

Figure 2.7 *On most cameras, the contrast, saturation, sharpening, and other in-camera image processing can be controlled through a simple menu.*

These options usually don't provide a fine degree of control, but they can improve the overall quality of an image if the camera's default settings are not to your taste.

Noise reduction and sharpening

Many cameras employ some form of noise reduction. In addition, some cameras automatically switch on an additional, more aggressive noise reduction process when you shoot using long exposure times.

All cameras also perform some sharpening of their images. How much varies from camera to camera, and the sharpening amount can usually be adjusted by the user. This sharpening is partly to compensate for the blurring that is applied to even out color variations during the demosaicing stage (**Figure 2.8**).

Figure 2.8 *This figure shows the same image sharpened two different ways. The image on the left has been reasonably sharpened, but the one on the right has been aggressively oversharpened, resulting in a picture with harsher contrast.*

8-bit conversion

Your camera's image sensor attempts to determine a numeric value that represents the amount of light that strikes a particular pixel. Most cameras capture 12 bits of data for each pixel on the sensor. In the binary counting scheme that all computers use, 12 bits allow you to count from 0 to 4,095, which means that you can represent 4,096 different shades between the darkest and lightest tones that the sensor can capture.

The JPEG format allows only 8-bit images. With 8 bits, you can count from 0 to 255. Obviously, converting to 8 bits from 12 means throwing out some data, which is manifest in your final image as a loss of fine color transitions and details. Though this loss may not be perceptible (particularly if you're outputting to a monitor or printer that's not good enough to display those extra colors anyway), it can have a big impact on how far you can push your color corrections and adjustments.

JPEG compression

With your image data interpreted, corrected, and converted to 8-bit, it's ready to be compressed for storage on your camera's media card. JPEG compression exploits the fact that your eye is more sensitive to changes in luminance than it is to changes in color.

Although your camera represents color as a combination of red, green, and blue values, there are many other *color models* that can be used. For example, color can also be represented as a combination of hue, lightness, and saturation values. To begin the process of JPEG compression, your camera converts your image to a color model wherein pixels are represented by separate luminance and color values. It then sets the luminance information aside and leaves it undisturbed.

The color information is divided into a grid of cells measuring 8 pixels by 8 pixels. Each 8 x 8 cell is then averaged to reduce it from a mosaic of slightly varied colors to a single square of more uniform color. Now that there is far less color variation, a simple lossless compression scheme—like the kind you might use when you zip or stuff a file before sending it via e-mail—can be applied to greatly reduce the size of the color information.

When the color and luminance information are recombined, your eye doesn't necessarily notice the loss of color, thanks to your eye's more prominent luminance sensitivity.

If you apply a lot of JPEG compression or recompress an image several times, you can actually see the grid pattern begin to emerge in your image (**Figure 2.9**).

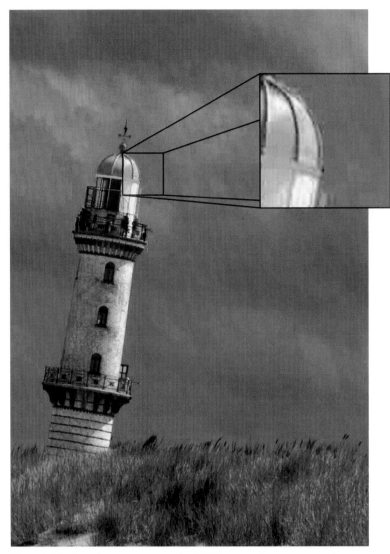

Figure 2.9 *In this rather extreme example of JPEG compression, you can see the posterization effects that can occur from aggressive compression (or repeated recompression) as well as the blocky artifacts that JPEG compression can produce.*

File storage

Finally, the image is written to your camera's memory card. These days, many cameras include sophisticated memory buffers that let them process images in an on-board RAM cache while simultaneously writing out other images to the storage card. Good buffer and writing performance is what allows some cameras to achieve high frame rates when shooting in burst mode.

Your camera also stores important *EXIF* (or exchangeable image file) information in the header of the JPEG file. The EXIF header contains, among other things, all of the relevant exposure information for your shot. Everything from camera make and model to shutter speed, aperture setting, ISO speed, white balance setting, exposure compensation setting, and much more is included in the file, and you can reference all of this information in almost any image editor (**Figure 2.10**).

▼ Photo EXIF	
Capture Date	7/4/05 1:55:45 AM
Aperture	f5.6
Shutter Speed	1/80 sec
Exposure Bias	+0.3
Exposure Prg.	Program
Focal Length	46.0 mm
Flash	OFF - Compulsory flash mode
Metering	Pattern
ISO Speed	400

Figure 2.10 *Most image editors let you read the EXIF information that your camera stores with each image.*

How Your Camera Makes a Raw Image

For your camera, making a raw file is substantially easier than making a JPEG file for the simple reason that, when shooting raw, your camera passes the hard work on to you. When shooting in raw mode, the camera does nothing more than collect the data from the image sensor, amplify it, and then write it to the storage card along with the usual EXIF information. It's your job to take that raw file and run it through some software to turn it into a usable image.

A raw converter is nothing more than a stand-alone variation of the same type of software that's built into your camera. With it, you move all of the computation that's normally done in your camera onto your desktop, where you have more control and a few more options.

Nevertheless, why do it yourself when you can get your camera to do it for you? Let's take a look at each image processing step to see why raw is a better way to go for many images.

Demosaicing

A raw file contains nothing more than the filtered grayscale information from your camera's sensor; it's up to your raw conversion application to apply demosaicing to create a full-color image.

As mentioned earlier, the quality of a demosaicing algorithm often has a lot to do with the final image quality that you get from your camera. Demosaicing is a complex process, and a poorly demosaiced image can yield artifacts such as magenta or green fringes along high-contrast edges, blue halos around specular highlights, poor edge detail, or weird Moiré patterns. Today, most cameras employ special circuits or digital signal processors designed specifically to handle the hundreds of calculations per pixel that are required to demosaic an image. However, though your camera may have a lot of processing power, it doesn't always have a lot of processing time. If you're shooting a burst of images at 5 frames per second, then the

camera can't devote much time to its image processing. Therefore, because time is often short and the custom chips used for demosaicing are often battery hogs, in-camera demosaicing algorithms often take some shortcuts for the sake of speed and battery power.

Your desktop computer can afford to take more time to crunch numbers. Consequently, most raw conversion applications use a more sophisticated demosaicing algorithm than what's in your camera. This often results in better color and quality than your camera can provide when shooting in JPEG mode.

For example, earlier we discussed the problem of correctly identifying a thinly colored edge among a larger field of color. A more sophisticated demosaicing algorithm such as what you might find in a raw conversion application will employ edge detection and pattern recognition routines to improve the accuracy of its color interpolation. A camera shooting in JPEG mode doesn't have the time to execute these kinds of routines.

Colorimetric interpretation

Just as your camera does when shooting in JPEG mode, stand-alone raw converters must adjust the image to compensate for the specific colors of the filters on your camera's image sensor. This colorimetric information is usually contained in special camera profiles that are included with the raw software. If your software doesn't provide a profile for your camera, then it can't process that camera's raw files. As you'll see, some raw converters allow you to tweak this colorimetric information to improve the quality of your raw conversions.

Color space

Just as your image data must be mapped to a color space when your camera shoots a JPEG file, your raw processor must map the colors in your image to a particular color space. Your raw converter lets you specify which color space you want to use. In addition to the sRGB and Adobe RGB color spaces that your camera probably offers, most raw converters provide choices such as ProPhoto RGB. You'll learn more about color space choice in Chapter 5.

White balance

Achieving good white balance is a tricky process, both objectively and sub-jectively. Objectively, calculating accurate white balance in a difficult lighting situation—say, sunlight streaming into a room lit with fluorescent light—can trip up even a good camera. Being able to adjust the white balance after the fact can often mean the difference between a usable and an unusable image (**Figure 2.11**).

Figure 2.11 *These images are from the same raw file. The only change that I made from one image to the next was an adjustment to the white balance setting in my raw conversion software.*

Subjectively, accurate white balance is not always the best white balance. Though you may have white balanced accurately and achieved extremely accurate color, an image that's a little warmer or cooler may actually be more pleasing. Altering the white balance of the image in your raw converter is often the best way to make such a change.

Though your camera doesn't perform any white balance adjustments when shooting in raw mode, it does still pay attention to the white balance setting you've chosen on your camera, storing it in the image's EXIF information. Your raw converter, in turn, reads this setting and uses it as the initial white balance adustment. You can start altering the white balance from there.

Gamma, contrast, and color adjustments

As discussed earlier, when shooting JPEG, your camera performs a gamma adjustment to convert the image so that the brightness values are closer to what our eye sees when we look at a scene. When shooting JPEG, you can't control the amount of gamma correction that your camera applies, but when processing a raw image, you can easily adjust and tweak the gamma correction to your heart's content.

Similarly, although your camera may provide contrast, saturation, and brightness controls for JPEG shooting, these controls probably offer only three to five different settings. Raw converters provide controls with tremendous range and far more settings.

These adjustments are not significantly different from some of the types of adjustments you can make in your image editing program. However, as you'll see in the next two chapters, there are tremendous advantages to performing these corrections in your raw converter, as opposed to in your image editor.

What's more, as you'll see later, raw converters such as Adobe's Camera Raw provide highlight-recovery tools that allow you to perform corrections that simply aren't possible using any other type of tool.

Noise reduction and sharpening

Just as your camera performs noise reduction and sharpening, your raw converter also includes these capabilities. However, like the gamma, contrast, and color adjustment controls, the noise reduction and sharpening controls of a raw converter provide much finer degrees of precision.

8-bit conversion

Although your camera must convert its 12-bit color data to 8 bits before storing it in JPEG format (since the JPEG format doesn't support higher bit depths), raw files aren't so limited. With your raw converter, you can choose to compress the image down to 8 bits or to write it as a 16-bit file. Although 16 bits provides more number space than you need for a 12-bit file, the extra space means that you don't have to toss out any of your color information. The ability to output 16-bit files is one of the main quality advantages of shooting in raw. You'll learn more about why in the next chapter.

File storage

When processing an image, your raw converter doesn't care what file format you ultimately will be using. It simply creates a big mess of colored pixels. How that image is saved is up to you. Obviously, you're free to save your image as an 8-bit JPEG file, just as if you had originally shot in JPEG mode, but you'll usually want to save in a noncompressed format to preserve as much image quality as possible. And if you've decided to work in 16-bit mode, you'll want to choose a format that can handle 16-bit images, such as Photoshop (.psd) or TIFF.

One of the great advantages of shooting in raw mode is that you can process your original image in many different ways and save it in many different formats. Just as you can choose to print a photographic negative using different exposures, chemistry, or printing processes, you can process a raw file using any number of settings, and each will create a separate file. Thus, there may be times when you *do* want to save your raw files in JPEG format—as part of a web production workflow, for instance. This doesn't mean that you've actually compromised any of your precious raw data, since you can always go back to your original raw file, process it again, and write it in a different format.

What's more, as raw conversion software improves, you can return to your original raw files and reprocess them and possibly get better results. Raw files truly represent the digital equivalent of a negative.

WHY NOT SHOOT IN TIFF MODE?

Before the development of raw, cameras got around the JPEG compression problem by offering an uncompressed TIFF mode. Many cameras still offer a TIFF option, but shooting in TIFF mode is a far cry from shooting in raw.

First of all, TIFF files don't offer the editing flexibility of raw files, and most cameras write 8-bit TIFF files, meaning that you don't get the high-bit advantage of raw. In addition, TIFF files are typically much larger than raw files. Whereas a raw file stores only one 12-bit number for each pixel, TIFF files are demosaiced into a three-channel color image, meaning that they have to store three 8-bit numbers per pixel.

Finally, the high-quality JPEG modes on most cameras are *very* good. In general, you probably won't be able to discern a difference between a well-compressed JPEG image and a TIFF image, so the storage space sacrifice will be of little value.

Raw Concerns

When compared side by side, it's easy to see that shooting raw offers a number of important advantages over shooting JPEG: editable white balance, 16-bit color support, no compression artifacts. But as you've probably already suspected, there is a price to pay for this additional power.

Storage

First, raw files are *big*. Whereas a fine-quality JPEG file from an 8-megapixel camera might weigh in at 3 MB, the same image shot in raw will devour 8 MB of storage space. Fortunately, this is not as grievous an issue as it used to be, thanks to falling memory prices. With gigabyte storage cards currently selling for under $100, you can amass a good amount of storage space for a very reasonable investment.

Workflow

One of the great advantages of digital photography is that it makes shooting lots of pictures very inexpensive. Thus, you can much more freely experiment, bracket your shots, and shoot photos of things that you normally might not want to risk a frame of film on. Consequently, it's very easy to quickly start drowning in images, all of which have unhelpful names like DSC78457.JPG.

Managing image glut is pretty easy with JPEG files. You can simply open the images and look at them, or you can drop them into a cataloging program to view thumbnails.

With raw files, things are a bit more complicated because a raw file doesn't contain any comprehensible image data until it has been processed—it's a little more difficult to quickly glance through a collection of raw images.

Fortunately, with raw gaining in popularity, a number of cataloging applications now allow you to view thumbnails of your raw files (**Figure 2.12**). Some raw converter applications also include this functionality. Creating the thumbnails can take a little while, so the workflow still isn't as speedy as with JPEGs, but the quality advantages are well worth this small inconvenience.

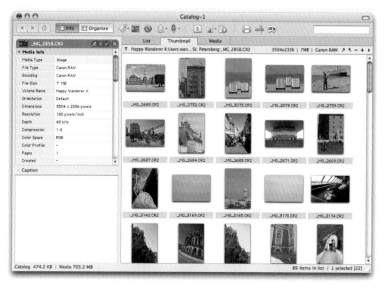

Figure 2.12 *Managing your raw files is much easier if you use an image cataloger that supports raw, such as iView MediaPro.*

Shooting performance

Because raw files are so big, the camera takes more time and memory to buffer and store them. Depending on the quality of your camera, choosing to shoot in raw mode may compromise your ability to shoot bursts of images at a fast frame rate. In addition, your camera may take longer to recover from a burst of shooting as its buffer will fill up quickly and take more time to flush.

If you want speedy burst shooting *and* the ability to shoot raw, then you may have to consider upgrading to a camera with better burst performance.

Choosing a Converter

As you've seen, shooting in raw doesn't do you any good if you don't have raw conversion software. There are a lot of good packages out there right now. Finding one that is right for you depends on your needs and experience. In Chapter 4, we'll take a quick look at the raw conversion options that are available.

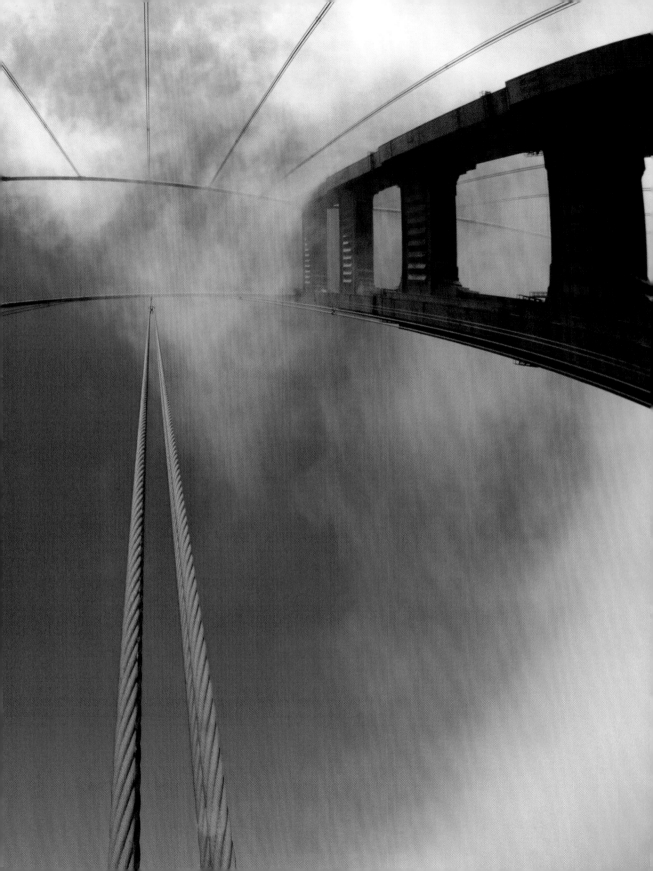

3

Image Editing Basics

Technically, all photography is "image editing." From the moment you compose a shot, you are editing—selecting a particular window onto your subject, manipulating the sense of depth in that window by choosing a focal length and camera position, emphasizing certain tones and colors through exposure. In other words: though photographs may appear realistic, they are a far cry from a truly accurate representation of reality, and represent one person's choice about what to capture and display.

Aside from these philosophical fine points, there are, of course, other, more direct edits and manipulations that the photographer can make. From choosing exposure, to shooting through filters, to dodging and burning, airbrushing, and compositing, photographers have long had the ability to manipulate images. Digital photographers have even more tools and options at their disposal, and unlike traditional darkroom techniques, digital tools don't require years of practice to master.

When you choose to shoot raw, you get one or two new editing and correction tools that aren't available in most image editing programs. For the most part, though, raw converter applications provide the same types of tools that you find in any image editor, but with one important difference: when you edit in a raw converter, you have much more image data to work with, which means that you can perform edits that are much more refined.

The Golden Gate Bridge as seen through a 10mm fisheye lens, August 2005. A fisheye lens yields an image with an extremely wide field of view and lots of spherical distortion.

Before we jump into the specifics of Adobe's Camera Raw converter in Chapter 4, we'll cover the image editing basics that you need to understand to use your raw converter and to get the most out of your digital camera and your image editor.

You're not going to learn how to perform wacky touch-ups in this chapter. We won't be covering compositing or cloning or airbrushing or any of those types of corrections. Instead, you'll learn about the fundamental tonal and color corrections that you'll apply to just about every image that you shoot.

Color Information Theory

If you take this book into a windowless closet right now and close the door, you'll have a very difficult time reading this text. In a darkened closet, your eyes can't gather enough light to render a legible image. Similarly, if you take a walk in the park at night, although you may be able to navigate and see things just fine, you probably won't experience a glorious display of color. Again, this is simply because your eyes are not able to gather enough light to render a color scene.

Your digital camera converts light into ones and zeros: data. Just as your eye needs a fair amount of light to be able to see an image, and even more light to be able to see a color image, the amount of data that you collect with your camera determines the quality and nature of the image that your camera will produce.

A sculptor needs a good-quality piece of stone to create a good work, and as a digital photographer, you need good data and as much of it as you can possibly lay your hands on. Therefore, your goal when shooting is to gather as much image data as you can. An image with lots of data will not only look better straight out of the camera, but it will afford you much more editing latitude. You'll be able to push and pull your colors further if your image is data-rich.

It's essential to remember that the level of detail in an image is directly related to the amount of color information that you have. For example, **Figure 3.1** shows an image that was overexposed; the brighter areas such as the chrome highlights around the headlight were "blown out" to complete white. Because they're a mostly uniform color, those areas show very little detail. Contrast and varying colors and tones are needed to render contour and detail in an image. If your image lacks data, it lacks the varying shadows and highlights that are needed to render fine detail.

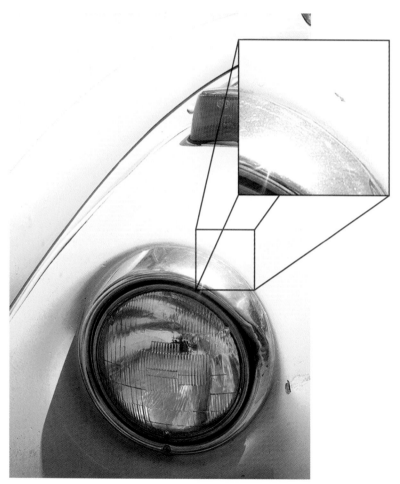

Figure 3.1 *Because this image is overexposed, many of the bright highlights and brighter areas of the image have "blown out" to white.*

Figure 3.2 shows the same image properly exposed. Now if you look at the chrome highlights, you should see a fine gradation composed of lots of subtly varying gray tones. Similarly, the yellow fender should have a little more contour and shape to it. The correlation is very simple: where there's data, there's image detail; where there's no data, there's no image detail. (Underexposing an image can lead to the same problem, but instead of producing fields of white pixels, an underexposed image will have shadow areas that are composed entirely of black pixels.)

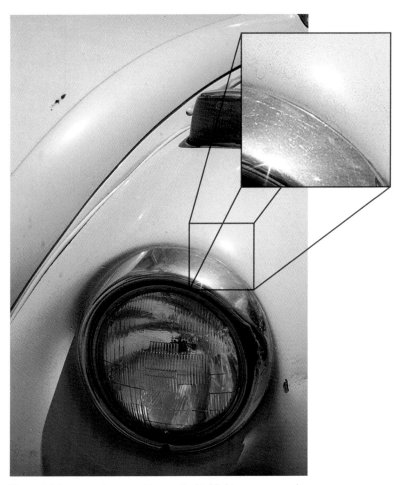

Figure 3.2 *In a properly exposed image, the highlights are composed of varying shades of light tones, rather than complete white.*

So how much is the right amount of color information? How do you keep track of it? How do you know if you've used it up? Fortunately, most image editors (and many cameras) provide a *histogram*, a simple tool that provides the answers to all of these questions. The histogram will quickly become your indispensable, irreplaceable, you-can-have-it-when-you-pry-it-from-my-cold-dead-fingers image editing tool.

Histogram 101

If you're not already familiar with an image editing histogram, then read this section very closely. Though it may seem to veer dangerously close to something mathlike, understanding a histogram is actually very simple.

Most image editors provide a histogram display of some kind. Photoshop and Photoshop Elements provide a Histogram palette, and some image editors employ a special Histogram dialog box. Still others display a histogram as part of their Levels control, a tool we'll explore in more detail later in this chapter.

A histogram is nothing more than a bar chart that graphs the distribution of tones in an image, with black at the left edge and white at the right and one vertical bar for every tone in between. In other words, for every gray value in the image, from 0 gray at the left to 255 gray at the right, the histogram shows a bar representing the number of pixels with that value. For a very simple image like the one in **Figure 3.3**, the histogram contains only four lines: one at the extreme left edge, representing the black swatch, two in the middle for the two gray swatches, and one at the extreme right edge for the white swatch.

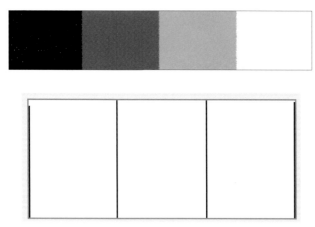

Figure 3.3 *This simple four-tone image (top) yields a histogram (bottom) with four bars: one for each tone.*

That's really all there is to a histogram. As an image becomes more complex, containing more tones, the histogram fills with more bars. **Figure 3.4** shows a simple grayscale ramp and its corresponding histogram.

 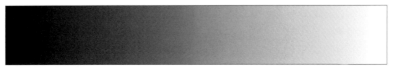

Figure 3.4 *A histogram is simply a graph of the distribution of tones in an image. The histogram for this gray ramp shows a smooth distribution from black on the left of the histogram to white on the right.*

Now consider some real-world examples. **Figure 3.5** shows a well-exposed image and its histogram. (The gray ramp beneath the histogram in Photoshop is provided to help you see that the histogram charts black to white.) The histogram shows that this image has a fairly complete range of tones from black to white. The shape of the histogram is irrelevant—there's no "correct" shape that we're trying to achieve. Every image has a differently shaped histogram because every image has different amounts of different colors. One thing we can learn from the histogram, though, is that this image has a good range of contrast from complete black to complete white.

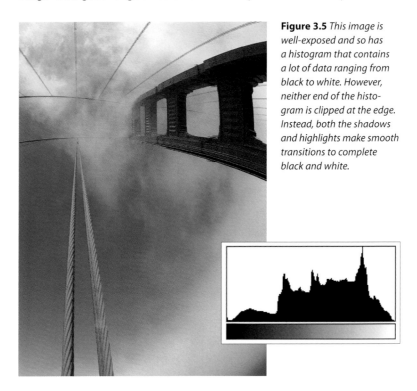

Figure 3.5 *This image is well-exposed and so has a histogram that contains a lot of data ranging from black to white. However, neither end of the histogram is clipped at the edge. Instead, both the shadows and highlights make smooth transitions to complete black and white.*

Figure 3.6 shows an overexposed image. On the left side of the histogram, the data tapers off, dwindling to nothing by the time we reach the histogram's middle. On the other side, though, the image data slams into the right edge of the histogram, indicating overexposure, a situation referred to as highlight *clipping*. Remember: Where there's pure white, there is no contrast and no information—no image data—and therefore no detail. Because the histogram shows a preponderance of pure white, it's safe to say that the image is overexposed and, therefore, has lost detail.

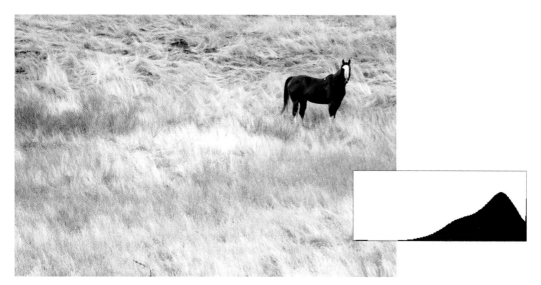

Figure 3.6 *This image is plainly overexposed. Its histogram lacks data in the shadows and midtones, and the highlights are heavily clipped.*

Figure 3.7 shows an underexposed image, and as you would expect, the results are pretty much the opposite of Figure 3.6. The histogram's data is clipped on the left side of the graph, indicating an undue number of pixels that have been reduced to featureless blobs of black. Although this image may not look so bad underexposed, there's no way to pull any detail back out of those solid-black shadow areas if you want to. Ideally, it's better to have a well-exposed image that you can darken later than to have a dark image (or an overly exposed bright image) with less editing flexibility.

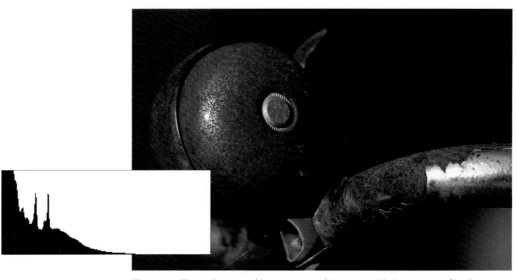

Figure 3.7 *This underexposed image sports a histogram with the majority of its data crammed against the left, black side. Because the blacks are clipped, the shadows in this image are solid black, making it impossible to pull out any usable detail.*

In addition to helping you spot over- and underexposure, your histogram can help you analyze other image troubles.

TIP

In Photoshop Elements 3 and Photoshop CS/CS2, you can display the Histogram palette by opening the Window menu and choosing Histogram.

Contrasty histograms

The human eye is much more sensitive to changes in luminance, or brightness, than it is to changes in color. Because of this, images that have more contrast are often more appealing (**Figure 3.8**).

Because an image with greater contrast usually has more tones and gradations, it delivers better detail and subtlety. I say "usually" because an image *can* have great contrast between its darkest and lightest tones without having a lot of other tones in between (consider a black-and-white checkerboard). The histogram makes it simple to determine how much contrast your image has and how much data there is between your lightest and darkest tones.

If we look at the histogram for the low-contrast image in Figure 3.8, we see that the image data neither extends all the way down to black nor all the way up to white—it's collected in the middle. In other words, there's not a lot of contrast between the darkest and lightest tones (**Figure 3.9**).

Figure 3.8 *In general, images with greater contrast, such as the right image here, are more pleasing to the eye.*

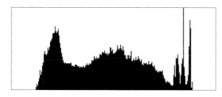

Figure 3.9 *Photoshop's histogram of the left image in Figure 3.8 shows that the image has no black or white tones. The distance from the darkest to the lightest tone is very short—showing low contrast.*

By contrast (sorry!), **Figure 3.10** shows a well-exposed image. Its histogram shows data that extends all the way to both ends, yielding an image with a good range of detail from black to white.

Figure 3.10 *This image was well exposed and has a good range of contrast. The histogram shows that the tonal range goes from black to white, without clipping on either end.*

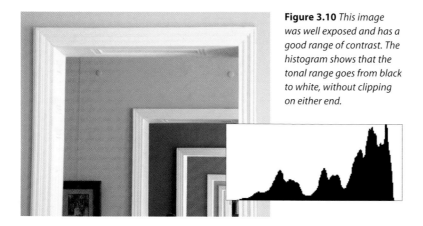

Another way of thinking about the histogram is to say that it shows how much information we've captured. The histogram in Figure 3.5 shows an image with a tremendous range of information (that is, gray levels), while the histogram in Figure 3.9 shows a much smaller quantity.

So tell me something I didn't know

So far you may be thinking, "What do I need a histogram for—I can see everything we're talking about just by looking at the image?"

While it may be obvious that an image is overexposed, the histogram gives you a little more information, which can be useful later in your raw conversion, as you'll see in the next chapter.

Also, most cameras these days let you view a histogram of any image that you've shot. As you'll see in Chapter 6, you can use your camera's histogram display to great advantage while shooting.

Perhaps the must useful application of the histogram, though, is in combination with other editing tools provided by your image editor, as you'll see in a moment.

Correcting Tone and Contrast with Levels

Once you've identified that an image has contrast or exposure troubles, you'll probably want to do something about it. Almost all image editing programs have a Levels feature, and most Levels interfaces follow the design of Adobe's original Levels control from Photoshop 1 (**Figure 3.11**).

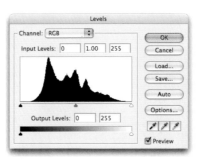

Figure 3.11 *Photoshop's Levels dialog box.*

In addition to a histogram display, Photoshop's Levels dialog box provides a pop-up Channel menu that lets you switch from adjusting the full-color image to adjusting individual color channels. Most important, though,

are the three sliders positioned below the histogram. At the far left is the black slider, which points to the leftmost edge of the histogram—the edge representing black. On the right is the white slider, and in the middle is the midpoint, or *gamma*, slider.

You can use the black and white sliders to redefine which tones in your image should be black, and which should be white. Photoshop will automatically stretch the tones in between, redistributing them accordingly.

For example, to correct the low-contrast image shown at the top in **Figure 3.12**, you can simply drag the leftmost slider so that it points to the darkest tone in the histogram and then drag the rightmost slider so that it points to the lightest tone in the histogram.

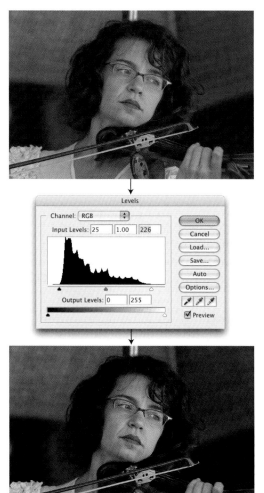

Figure 3.12 *By sliding the white and black points in the Levels dialog box, you can redefine which tones are black and which tones are white, resulting in improved contrast, as shown in the bottom image.*

TIP

In Photoshop Elements, you'll find the Levels control by choosing **Enhance > Adjust Lighting > Levels.**
In Photoshop CS and CS2, choose **Image > Adjustments > Levels.**

When you click OK, Photoshop will adjust the tones in your image so that the darkest tone is black and the lightest tone is white. The middle shades will be stretched across the intervening tonal range.

The Levels dialog box is a very interactive tool, and to really understand it you must get a feel for it. If you've never used the Levels tool before, open some of your own images and give it a try.

Losing data

Now the bad news: Just as there's no such thing as a free lunch, there's no such thing as a Levels adjustment that doesn't result in a little data loss.

Consider the histogram of the adjusted image at the bottom of Figure 3.12. The histogram now has a lot of gaps (**Figure 3.13**). When we moved the white point and black point in the Levels dialog box, we told Photoshop to expand the data between those two points to provide a full range of black to white. However, there wasn't enough data to fill a full range of black to white (if there was, our image wouldn't have been problematic in the first place), so Photoshop had to spread out the existing tones to cover the full range. In redistributing the tones, Photoshop had to leave some tonal values empty. These are the gaps that now exist in the histogram.

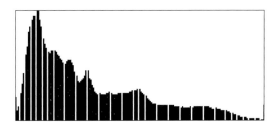

Figure 3.13 *The adjusted image in Figure 3.12 produces a histogram riddled with gaps because Photoshop has had to throw out data to make the adjustment.*

Is the elimination of tones a bad thing? It depends. As you saw in Figure 3.2, subtle gradients and details are composed of many different shades. If some of those shades are eliminated, those gradients and details will become a little rougher and more coarse. The good news is that you usually have to throw out a fair amount of data before you see a significant degradation in your image.

Avoiding data loss when editing is impossible, so don't feel like you have to try to make edits that preserve all of your data. However, it's important to keep an eye on this issue and to plan your edits accordingly. For example, trying to use a single Levels adjustment to improve contrast and saturation

in one fell swoop will often result in less data loss than using a Levels adjustment to improve contrast and then using another type of tool to adjust saturation.

The main downside to data loss is that it limits the amount of editing you can do. The histogram in Figure 3.13 shows an image that has already had a lot of its data used up just to get back to the level of contrast that should have been there in the first place. If you want to make additional edits—color corrections, for example—then you have a little less room to maneuver. Because you've already used up some data, further edits will more readily result in visible image degradation.

This is why proper exposure and good photography skills are so important. Though people often think "It doesn't matter how I shoot, because I can always fix it in Photoshop," the fact is, if you don't carefully calculate your exposure so as to capture the maximum amount of image data, you may not be able to "fix it in Photoshop" without severely degrading the image.

As you'll see in the next chapter, shooting raw not only yields more image data; it also provides you with additional tools that are less damaging to that data.

TIP

Too much data loss can leave very noticeable artifacts in your image. If you aren't already familiar with the term *posterization*, check out "What Missing Data Looks Like" later in this chapter.

Compression vs. clipping

Two things happen to your image data when you move a control point in the Levels dialog box. The data between the control points is either compressed or expanded, while the image data that falls outside the black and white control points gets clipped (**Figure 3.14**).

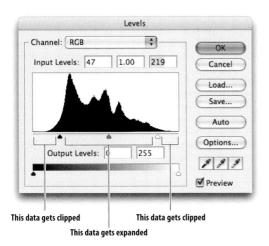

This data gets clipped This data gets clipped

This data gets expanded

Figure 3.14 *When you click OK after moving the black and white control points for an image, the image data outside those points will get clipped. The image data between the white and black points will get expanded to fill a full range from black to white.*

When data is expanded or compressed, it is redistributed to fit inside the new space. If you're trying to fit a lot of data into a smaller space, then your image editor will have to discard some tones. When pixels with different gray values are compressed into a single gray value, that value is shown on the histogram as a spike, to indicate that it is the product of multiple, combined tones. If you're expanding data to fit into a wider space, then the program will redistribute the tones, spreading them out to cover the new space. As seen earlier, where there's no data for a particular value, a gap will appear in the histogram.

In both cases, the software will try to preserve the distribution of tones, keeping the overall "shape" of the histogram. This ensures that the relative brightness between two areas remains the same.

When you clip part of the tonal range, everything outside of the clipping is simply eliminated. Because the data leading up to the white point is expanded, you end up with fewer tones being used to create the transition to white or black. Thus, clipping the highlights or shadows can result in a sudden transition to solid black or white tones. This can often look harsh and unrealistic. Clipping is more apparent in highlights than in shadows, because clipped shadows are often embedded in dark areas where the sudden change to black is not so apparent. Return to Figures 3.1 and 3.2 and take a look at the bright highlights on the top of the chrome headlight. In Figure 3.1, the highlights are clipped, resulting in a rather sudden transition from the chrome of the headlight to the bright white of the highlight. In Figure 3.2, this transition is much smoother, with far more intermediate tones.

When using the Levels dialog box, if you hold down the Alt (Windows) or Option (Mac) key while dragging the white or black point, Photoshop will highlight the clipped areas of your image with black or white (**Figure 3.15**).

Figure 3.15 *If you hold down the Alt or Option key while moving the black or white slider in Photoshop's Levels dialog box, you'll see exactly which areas of your image are getting clipped.*

Adjusting midtones

While the white and black points allow you to increase contrast as well as to brighten or darken an image overall, there will be times when you want to brighten or darken the image while leaving the blacks and whites untouched. For this, the Levels control provides the midpoint, or gamma, slider.

Perhaps the easiest way to understand the gamma slider is to look at its effect on some simple gradients.

In **Figure 3.16**, the gamma slider has been moved to the right, causing all of the tones between the midpoint and white to be compressed, while at the same time expanding all of the tones between the midpoint and black. Overall, the image is darker because the darker tones have been expanded into more of the image.

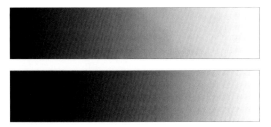 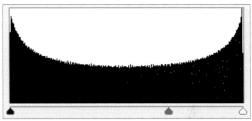

Figure 3.16 *A positive gamma adjustment shifts the midtones to the right, darkening the image.*

If the slider is moved the other way, as in **Figure 3.17**, the opposite happens, and the overall image is lighter.

 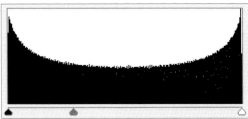

Figure 3.17 *A negative gamma adjustment lightens the middle tones of the image.*

What's important to notice is that the black and white points did not change at all. In other words, we were able to preserve the lightest and darkest tones in the image, while adjusting all of the tones in between.

For a less conceptual example, return to Figure 3.12. Though we were able to improve the contrast in this image by making white and black point adjustments, overall the image is still a little dark. A more aggressive white point adjustment would brighten the image further, but it would also blow out the highlight areas, resulting in a loss of detail and a generally uglier image (**Figure 3.18**).

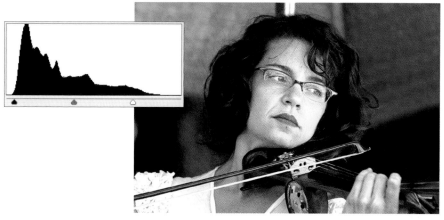

Figure 3.18 *You could brighten this image further with a more aggressive white point adjustment, but then the highlights would blow out.*

Instead, we want to brighten the image without brightening the white tones, since they're already as bright as they can go. As you've already seen, a gamma adjustment lets you brighten or darken middle tones without affecting the white and black tones. With a gamma adjustment, we can easily brighten the image without blowing it out (**Figure 3.19**).

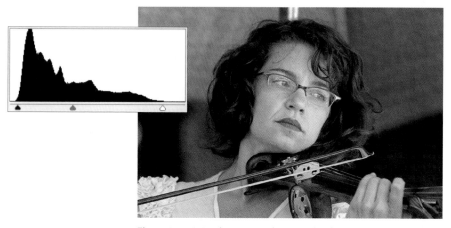

Figure 3.19 *A simple gamma adjustment brightens the image without blowing out the highlights.*

The Levels control is a very powerful editing tool, and one you'll probably use on almost every image you work with. As with most tools, the Levels control becomes much easier to use with practice. Once you start shooting raw, you may be a little less dependent on Levels, since you'll be able to control your white and black points and midpoint during your initial raw processing. You'll learn more about this in the next chapter.

Correcting Tone and Contrast with Curves

If you're using Photoshop 7, CS, or CS2, then you have access to Curves, another type of tone and contrast correction tool. Curves allows you to do the same thing as Levels—brighten and darken the pixel values of your image—but it uses a very different interface (**Figure 3.20**).

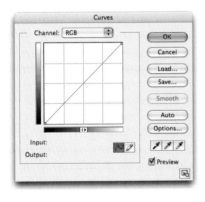

Figure 3.20 *The Curves dialog box shows an interactive graph with original tones represented by the horizontal grayscale ramp, and adjusted tones represented by the vertical grayscale ramp.*

First off, notice that unlike Levels, Curves does not provide you with a histogram display. If you're using Photoshop CS or CS2, then you can use the Histogram palette to watch your image's histogram while you edit.

Next, notice that there are two grayscale ramps: a horizontal one across the bottom, and a vertical one running up the side. The horizontal ramp is the input scale, and it represents the values in your image before the Curves adjustment. The vertical ramp is the output scale, and it represents the values that your image will have *after* the adjustment. The diagonal line through the center of the box shows the correspondence of the input scale to the output scale. This line is your curve, though when you first open the Curves dialog box, the curve is straight.

TIP

In Photoshop CS/CS2,
you access the Curves
dialog box by choosing
Image > Adjustments >
Curves or by pressing
Ctrl-M (Windows) or
Command-M (Mac).
Photoshop Elements
does not offer a Curves
control.

When you open Curves, if you trace a line from a gray tone on the input scale up to the curve, and from there directly across to the output scale, you'll see that the input tone corresponds to an identical output tone. In other words, the curve is not changing the value of the tone (**Figure 3.21**).

Figure 3.21 *Reading the Curves dialog box is very simple. For any particular original, or input tone, just trace a line up to the curve and over to the output graph to see what that tone will be after the Curves edit is applied.*

By reshaping the curve, you can remap the input tones to new output values. To change the shape of the curve, you simply click it and drag. This will add a new control point in addition to the two on the ends. The curve is redrawn to pass through this new point.

For example, if you click the middle of the curve and drag straight up, you will create a new control point and reshape the curve. Now go back to the input tone you looked at before and trace a line up to the curve and then over to the output scale, and you'll see that that tone is lighter (**Figure 3.22**). Most important, all of the surrounding tones have been adjusted to create a smooth transition.

Figure 3.22 *Dragging the curve upward causes the original tone to be remapped to a lighter value. All of the tones around that value are remapped to create a smooth transition.*

Curves actually does the same thing as Levels. The lower-left control point on the curve is the same thing as the black point in the Levels dialog box. Similarly, the upper-right point on the curve is equivalent to the Levels white point. When you add a point to the middle of the curve, you get a gamma control.

So to use Curves to perform the same correction that you saw in Figure 3.12, you would define a curve that looks like **Figure 3.23**.

The main advantage of Curves over Levels is that whereas Levels lets you adjust only 3 points, Curves lets you add up to 14 control points. By adding more points, you can brighten or darken selected portions of your image.

Although the gamma adjustment in Levels offers a great way to change the midtones of an image without affecting the white and black points, there are times when you won't want to adjust all of the midtones equally.

For example, **Figure 3.24** shows another image that could use more contrast. Although we could increase the contrast by moving the white and black points inward, we would clip both the highlights and the shadows. With Curves, we can leave the white and black points where they are and apply separate adjustments to the middle of the curve.

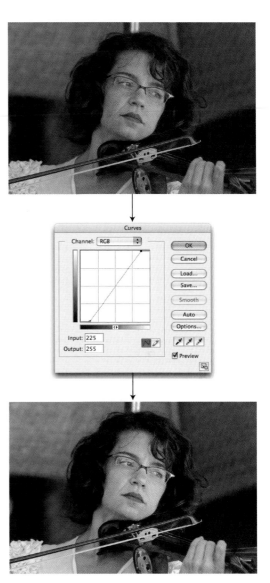

Figure 3.23 *The end points of the curve allow you to change the black and white points of the image, just as the black and white control points in the Levels dialog box do.*

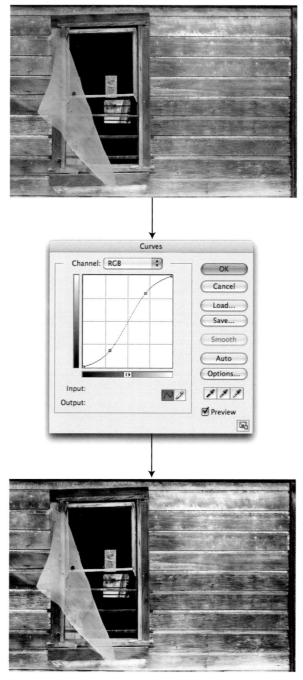

Figure 3.24 *Applying an S-curve to this image improves the contrast of the image by darkening some of the shadows while brightening the highlights. Notice that the black and white points are left untouched, so you don't have to worry about clipping.*

The lower point on our curve darkens the shadows, while the upper point brightens the highlights. The overall effect is to give a big contrast boost to the image, without hurting the shadows and highlights. In most cases, adding a slight S-curve edit like this to an image will improve its contrast.

Making selective corrections

The ability to add multiple control points means that you can target Curves to adjust very specific parts of your image. For example, overall **Figure 3.25** is well exposed. However, when this image is printed on glossy paper, the already dark house becomes much darker.

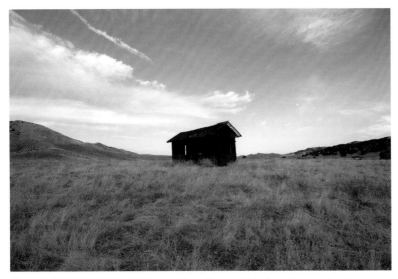

Figure 3.25 *Though this image is generally well exposed, the barn becomes too dark when the image is printed. With a Curves adjustment, it's possible to lighten the barn while leaving the rest of the image untouched.*

Ideally, you want to lighten the house without adjusting any other parts of the image. There are many ways to achieve this type of edit in Photoshop. You could select the house using the Pen or Lasso tool and apply an adjustment to only that selected part of the image, or you could use an adjustment layer with a layer mask—the list goes on and on.

With Curves, though, you can constrain the adjustment to only the house by editing only the part of the curve that contains the tonal values that make up the house.

With the Curves dialog box open, you can click anywhere in your image, and a small circle will appear over the curve to indicate the tonal value of the pixel you clicked. So if you click the barn, you see that its tones live in a very particular part of the lower-left end of the curve (**Figure 3.26**).

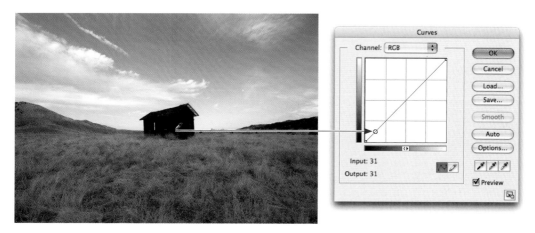

Figure 3.26 *With the Curves dialog box open, you can click within your image to see where particular tones lie on the curve.*

To adjust only that part of the curve, you first "lock down" the rest of the curve by adding control points. These will serve as anchors to prevent other areas of the curve from being affected by your edit (**Figure 3.27**).

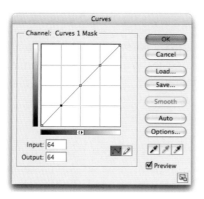

Figure 3.27 *To edit just one part of the curve, you first anchor the curve by placing a few control points.*

Now you can simply drag the barn part of the curve up to create your edit (**Figure 3.28**).

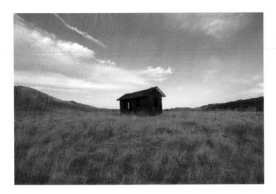

Figure 3.28 *With the curve anchored, it's possible to edit just the area that contains the tonal values of the barn. With this edit, the barn brightens while the rest of the image remains the same.*

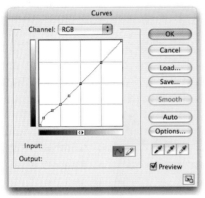

Like Levels, Curves becomes much easier to use with practice. With just a little experimentation, you'll get a better feel for how to drag and shape the curve. Be careful, though—even a slight reshaping of the curve can create a big adjustment to your image. Keep your eyes peeled for posterization (the reduction of tones that can turn some transition areas into splotchy masses of solid color), especially if you're targeting a specific area where there aren't a lot of tones, such as deep shadows or highlights. A sudden or steep change in the curve will almost always yield posterizing. Try to keep the bends in your curve gentle.

PHOTOSHOP ADJUSTMENT LAYERS AND NONDESTRUCTIVE EDITING

When you apply a Levels or Curves correction, Photoshop adjusts your image data accordingly and then hands you back control of your computer. These types of operations are known as *destructive edits* because they directly manipulate your original image data, making it difficult or impossible to later change or remove the effects of the adjustment.

Photoshop and Photoshop Elements provide an excellent mechanism for *nondestructive editing* in the form of adjustment layers. From the pop-up menu on the Layers palette (**Figure 3.29**), you can easily create Levels adjustment layers (and Curves adjustment layers, if you're using Photoshop 7, CS, or CS2). After you define the Levels adjustment that you want, a new adjustment layer will appear in the Layers palette. The adjustment associated with this layer is applied to the underlying layers on the fly as your image is displayed, printed, or output. Because your original image data is untouched, you can change the settings of your adjustment layer (by double-clicking it) or delete it entirely (by dragging it to the trash can at the bottom of the Layers palette) without destroying or altering any of your original pixels.

Figure 3.29 *In Photoshop and Photoshop Elements, you can add adjustment layers, which allow you to apply Levels adjustments nondestructively.*

Adjustment layers also provide a built-in layer mask feature that makes it simple to confine your adjustments to one part of your image. Consult Photoshop's Help file for more information.

Too Much of a Good Thing: Recognizing Overcorrection

Levels (along with several other tools that you'll see later) allows you to make dramatic changes to your images. As you work with these tools more, you'll probably be surprised by how much detail you can pull out of what may appear to be a useless image. However, it *is* possible to go too far in your edits. As you've already seen, you can drag those sliders a long way and change your image a *lot*. So how do you know how much is too much?

Obviously, any type of correction is a subjective exercise. What looks great to you may look lousy to someone else. There are, however, some objective guidelines that you can observe while editing that will help you maintain a certain level of technical quality.

What missing data looks like

As you've seen, when you use editing tools such as Levels, you compress and expand the tonal information in your image, and this invariably results in some data loss. A well-exposed image will provide enough latitude for a good amount of editing, but it is possible to push edits to the point where you visibly degrade your image. This degradation is a good, nonsubjective benchmark for determining when you've performed too much adjustment

In Figure 3.1, you saw how an overexposed image lacks the detail that is necessary to produce smooth-looking highlights. When you throw out too much data in the course of an edit, you end up with a situation that's similar to the problem you face with over- or underexposure. Let's look a little more closely at what happens to your image when you throw out data.

Consider **Figure 3.30**, which shows two black-to-white gradients. Below the smooth gradient on top is a black-to-white gradient that has been edited so that it has only 16 shades of gray.

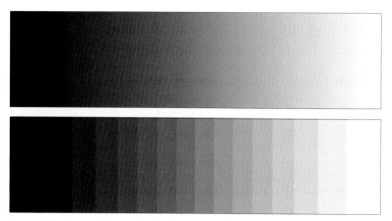

Figure 3.30 *A grayscale ramp (top) and a posterized grayscale ramp (bottom).*

With only 16 shades to work with, it is impossible to create a smooth transition from black to white. The overall tonal range is the same—the image still goes from black to white—but now the smooth gradient has turned into stark bands of gray. By reducing the number of colors that represent the gradient, we have thrown out a substantial amount of data, making it impossible to create a smooth transition from one tone to the next. The process of reducing the number of tones in an image is called *posterization*.

Too much data loss yields posterization, and posterization appears in your images as banding or breaks in what should be a smooth transition of tones. Tone breaks will rarely be as obvious as shown here. In fact, this type of artifact will often be concealed by other image details in your picture. However, even a little bit of tone break can be annoying and distracting, depending on where it appears in your image.

Clouds and skies are often subject to bad banding, as are highlights and bright gradients. Similarly, shadow tones can often suffer from bad data loss–related banding. When pushing your Levels sliders around, keep your eye peeled for banding artifacts like those described here. In particular, pay close attention to those areas of your image, such as clouds or subtle highlights, that are already composed of only a few tones. With little room to spare for data loss, these are the areas that will suffer the most once you start throwing out image data.

Out-of-gamut color

All color devices—including your eyes—have a particular gamut, or range, of colors that they are capable of displaying or capturing. Unfortunately, your monitor, eyes, camera, and printer all have very different gamuts, and a color that's within the range of one device may not be in the range of another. This problem is particularly troublesome when you're preparing images for print.

When you edit an image, it's actually possible to push the color in your image beyond the gamut of your printer. This can result in annoying arti-facts in your final print, because your printer will try to bring the out-of-gamut colors back to something that it knows how to print. Rather than letting your printer make these kinds of decisions for you, it's better to try to stay within the printer's gamut while working in Photoshop. This will allow *you* to stay in control of what colors should look like. Similarly, when you edit photos destined for video or a particular web-based color space, you'll want to ensure that you don't push your colors too far.

Photoshop's color management tools provide gamut warning features that make it easier to stay within a particular printer gamut. However, color management is a complex, sometimes bewildering subject that is way beyond the scope of this book. Nevertheless, it's worth at least reading the color management sections in Photoshop's help files to get an idea of how to use Photoshop's color management workflow to ensure that you don't edit your colors into colors that aren't legal for your target device.

Ready to Raw and Roll

Color and tone correction and adjustment are huge subjects worthy of thousands of pages and years of study. Obviously, this chapter doesn't cover all of the details and fine points of good color correction. However, these pointers should help you deal with the day-to-day, basic corrections that you will perform on most of your images. In addition, the concepts introduced here are essential for understanding the raw discussion in the next chapter.

4

Getting Started with Camera Raw

We all know the arguments for digital over film: instant feedback, smaller cameras, no film or processing costs, none of the hassle of carrying and changing rolls of film. But nowadays it's hard for the digital photographer or 35mm film photographer to remember that mass-produced roll film was actually a similar convenience when compared to the tools and techniques required in the early days of photography.

Early masters of photography such as Ansel Adams not only had tremendous command of exposure and composition, but they also were experts in film chemistry. They spent countless hours making their own photographic paper and preparing custom emulsions for their film plates. They experimented at length with everything from the mixture of their chemicals, to the timing of development, to the amount of agitation used while processing their film.

Because they had such a precise understanding of the chemical response of the film and paper that they had created, when shooting they frequently made exposure decisions based upon how they expected to process the film when they got back to the lab. While looking through the camera, they never lost sight of what they would need to do in the darkroom to achieve the image they were visualizing.

Though these photographers were frequently referred to as "expert craftsmen" or "master artisans," if they were alive today we would use another word to describe them: geeks. These people were the

Milton Cardona with his Eya Arania Ensemble, performing at a wedding in upstate New York. Canon EOS 20D, 1/30s at f/4 with a Canon 10-22mm EF-S lens.

original photography gearheads and nerds. Granted, they also had an incredible level of innate talent and artistry, but this talent was useful only thanks to their fundamental understanding of the basic imaging characteristics of their technology.

Shooting raw requires a similar combination of technical understanding and visual artistry. When you shoot raw, you're capturing fundamental image data, just like the fundamental data captured by a piece of film. It's only after that data is processed through raw conversion software that a usable image appears. Because raw conversion is not an objective, quantifiable process, the quality and appearance of the image produced from a raw file may vary from one raw conversion program to another. However, in the future, as raw converters improve in quality, you will be able to go back to your original raw files, reprocess them, and possibly get better results.

In this chapter, you're going to learn the basics of Adobe's Camera Raw converter. You'll learn how to open and process images and how to use the seemingly simple controls provided in Camera Raw. Understanding what each slider and control does is essential to processing your images and getting good results, but it's important to learn more than just the theory behind the tool.

The camera is only one part of the photographic process. Since the inception of photography, good photos have depended as much (and sometimes more) on good darkroom work as on good shooting skills. Digital photography is no different. And just as geeky master photographers of old made shooting decisions based on their understanding of what they could achieve in their darkrooms with their chosen chemicals and films, you need to develop a similar understanding of your raw converter and editing software.

The image in Figure 4.1 is very flat and not particularly dramatic. When I shot it, though, I knew that I would have enough latitude in my image to brighten up the doorway and wall to create a very different picture.

The image in Figure 4.2 was initially nothing more than a composition exercise. As I shot, though, I realized that I would be able to pull a lot more contrast out of the sky and deepen the texture and saturation of the lighthouse to make a more compelling picture.

Figure 4.1 *Because I had a good idea of how much I could push and pull the tones and colors in my image, I was able to visualize a more dramatic image when I saw this scene.*

Figure 4.2 *Paying attention to the potential contrast and color in a scene is essential to visualizing a good photo when you're in the field. But the only way to recognize those potentials is to become familiar with the capabilities of your editing software.*

So while working through these explorations of Camera Raw, don't just try to memorize what each control does. Play with the controls and experiment with images from your particular camera, and pay attention to how much you can brighten or darken an image before it turns noisy or blows out. Note how far you can expand the contrast of an image before you start to see posterization artifacts. Different cameras yield different amounts of data, so try to get a feel for how much latitude the images from your camera have. This understanding will help you identify potential pictures when you're out shooting. We'll discuss this topic more in Chapter 6.

The Raw Format

One of the most troublesome issues about "raw format" is that there is no such thing. While "JPEG format" refers to a particular, published file specification, there is no widely accepted standard for the formatting of raw camera data. Instead, each camera manufacturer creates its own raw file format. So when you shoot raw with a Canon camera, you get .CRW or .CR2 files. When you shoot raw with a Nikon camera, you get .NEF files, Olympus cameras produce .ORF files, and so on (**Figure 4.3**).

Figure 4.3 *Because every camera maker insists on creating its own type of custom raw file, there is no single raw format or specification as there is for JPEG, TIFF or Photoshop files.*

Because there's no single accepted, standardized format, and because manufacturers don't always publish the details of their specific formats, application developers have to do a lot of work to figure out how to support raw files from a particular camera. In addition, in some cases a maker's raw format can change from camera to camera. Most raw software developers are diligent about releasing upgrades that support new cameras, but these upgrades can take time to come to market.

A lot of people are concerned about this "corporate ownership" of the various raw formats. They worry that, years from now, if any of these companies go out of business, the details of their raw files could disappear, leaving us all with gobs of raw images and no specifications for how to read them.

Adobe Digital Negative Specification

To address the lack of an open raw standard, Adobe has created the *Digital Negative Specification*, sometimes referred to—mysteriously—as *DNG*. The Digital Negative Specification is a completely open format—Adobe has published all of the details of the spec—so even if Adobe one day goes out of business, the standard can continue to be supported and developed.

In addition to providing a single open standard for formatting raw camera data, the DNG spec includes the ability to store special "private" data that only the camera manufacturer knows how to access. In this way, camera makers can continue to include raw features that can be accessed only by their own special software, allowing them to differentiate themselves from other makers (ideally, though, they'll stick to the open part of the DNG format). In theory, everyone wins with DNG. Camera makers get a robust spec that addresses all of their concerns, and end users get an open standard, which ensures that they'll always have access to their images.

At the time of this writing, no manufacturers have built DNG support into their cameras. However, Adobe provides a free DNG Converter application that you can download from www.adobe.com/products/dng. This application can read any of the raw formats currently supported by the Camera Raw software. With it, you can convert your current proprietary raw files to Adobe's open DNG files, ensuring that your raw data will exist in a form that will most likely always be readable (**Figure 4.4**).

Figure 4.4 *Adobe's DNG converter allows you to convert the proprietary raw images from your camera into Adobe's DNG format, an open format that anyone can use.*

In Chapter 5, we'll discuss how to work DNG support into your raw workflow.

Why you should use Camera Raw

Despite the myriad high-quality camera raw conversion apps available, you will probably find that Camera Raw is your best option in terms of quality, price, workflow, and feature set. Camera Raw was originally released as a plug-in for Photoshop 7. Adobe no longer sells a stand-alone version of Camera Raw—Adobe wants you to upgrade your copy of Photoshop—but Camera Raw is built in to Photoshop Elements 3 and 4 and Photoshop CS and CS2.

Camera Raw sports a clean, extremely functional interface that's easy for novice users to negotiate, but also offers all of the controls that power users expect. In addition to its full support of all of the basic raw processing features that you need for day-to-day work, Camera Raw includes important extra features, such as controls for eliminating vignetting and chromatic aberration. One of Camera Raw's most impressive extras is its highlight recovery capability, which you'll learn more about in Chapter 6.

In addition to its features and quality, Camera Raw scores over its competition simply because it's integrated into Photoshop. If you're going to be using Photoshop for your image editing anyway, why hassle with the expense and workflow complication of an external raw converter? With Photoshop/Camera Raw, you get a raw converter plus all of the other retouching tools that you're already used to in one package. Finally, Adobe has done an excellent job of building a smooth workflow around Camera Raw, making it simple to process individual images or huge batches.

Camera Raw compatibility

To find out if the latest Camera Raw is compatible with your camera, take a look at www.adobe.com/products/photoshop/cameraraw.html. There, you will find a list of currently supported cameras. Elements and Photoshop CS2 present slightly different versions of the Camera Raw dialog box, simply because Elements 3 doesn't support all of the features that CS2 does. We'll go over these differences later in this chapter. Some of the differences are higher-end features that we won't be covering in this book.

If you're using Photoshop 7 or CS, then you can't run the latest version of Camera Raw. However, previous versions use an interface that is almost identical to version 3.1's. What's more, the underlying concepts and workflow, as well as Camera Raw's fundamental image processing tools, are the same in the earlier versions, so you should be fine with this book. If you find yourself confused by any of the interface differences shown here, you should be able to clear things up with a quick look at Photoshop's built-in Help facility.

If you've chosen a different raw converter, you'll probably find that almost all of the concepts in this book still apply, except for the features that are specific to Camera Raw. Obviously, your program's interface will vary.

Getting Started

Raw workflow begins with the transfer of files from your camera to your computer. This is really no different than when you work with JPEG files, and just as with JPEG files, you can use your camera's USB cable to move images directly out of your camera, or you can use a media card reader to transfer the contents of your camera's storage card to your computer.

As you probably already know from shooting JPEG, your camera labels images with sequential numbers. Raw files follow this same scheme, but instead of a JPEG extension, they have some kind of raw format extension (.CRW or .CR2 for Canon, .NEF for Nikon, .ORF for Olympus, .RAF for Fuji, .SRF for Sony, .MRW for Minolta, .PEF for Pentax, and so on). Some cameras provide an option for simultaneously shooting raw and JPEG files. In this case, you'll find two files with the same file name but with different extensions.

With JPEG files, you may be used to seeing image previews in various places throughout your system—thumbnail icons on files, previews in Open dialog boxes, and so forth. Unfortunately, with raw files, you're not going to see as many of those (or any, depending on your operating system). When your camera shoots raw, it generates a small preview thumbnail and embeds that in the file. This thumbnail is what you see when you look at the image on your camera's LCD monitor. Unfortunately, because there's no raw format standard, extracting those thumbnails can be complicated, so you probably won't see a lot of raw image previews throughout your system.

Opening a raw file

Opening a JPEG file is pretty simple. Double-click the file, and your computer will open it using a JPEG-compatible application. Opening a raw file can be a bit more complicated.

First, if you're looking at a directory full of raw files with camera-generated names and no thumbnails or previews, how do you know which file to open? If your camera can shoot raw and JPEG files simultaneously, then you can simply browse through the JPEG files to find the image you want and then open the corresponding raw file. The downside to this is that shooting two copies of every image will take up much more space on your camera's storage card and possibly slow down your camera's ability to shoot bursts of images. Fortunately, if you're using Photoshop Elements 3 or 4 or Photoshop 7, CS, or CS2, Adobe has provided a better solution.

Using the File Browser and Bridge

In Photoshop 7, Adobe introduced the File Browser to provide an easier way to find and open images. The File Browser is almost like a separate application that lives inside Photoshop. In Elements 3, you access the File Browser by choosing File > Browse Folders. In Photoshop 7 and CS, you choose File > Browse.

In Photoshop CS2, Adobe replaced the File Browser with a separate application called Adobe Bridge. Bridge provides all of the same functionality as the CS File Browser, but offers additional features to facilitate batch processing, working with stock photo agencies, and moving photos between Photoshop and other Adobe applications such as Illustrator and InDesign. You access Bridge from within Photoshop CS2 by choosing File > Browse, or because it's a stand-alone application, you can simply launch Bridge like you would any other program.

For the basic browsing, sorting, viewing, and opening of files, Bridge and the File Browser are almost identical, and for the tasks you'll be performing in this book, either will work fine. We'll be using Adobe Bridge for our screenshots and examples. If you're using the Elements 3 or CS File Browser, you'll see some slight interface variations, but these shouldn't affect your ability to follow along.

Bridge and the File Browser both display a single window divided into several panes (**Figure 4.5**). In the upper-left corner, you'll find the Folders pane, which provides a directory browser that lets you select the folder you want to view. The large pane to the right displays thumbnails of all of the images

in the selected folder. Click an image, and you'll see a larger preview in the Preview pane. Finally, all of the image *metadata* is displayed directly below the Preview pane. Metadata is simply the additional information that's stored with each image. From the date and time the image was shot, to the exposure settings and white balance information, the Metadata pane shows just about everything you'd ever want to know about your image.

You can resize the panes by dragging their borders, so you can choose to view more thumbnails, see a bigger preview, or view a longer list of metadata. As you'll see in the next chapter, you can also edit the metadata of an image, allowing you to protect your images with copyright notices and add keywords and descriptions to facilitate searches.

NOTE

The Elements and Photoshop CS File Browser has its own separate menu bar that's contained within the File Browser menu. In the rest of this book, when we refer to selecting something from, for example, the View menu in the File Browser, this means the View menu located on the File Browser menu bar, not the View menu in Photoshop.

Figure 4.5 *Adobe Bridge, which is bundled with Photoshop CS2, serves as a file browser as well as a host application for Camera Raw. The File Browser included in Elements 3 or Photoshop CS provides nearly identical functionality.*

Working with Adobe Photoshop Elements 4 and Organizer

For Photoshop Elements 4, Adobe created a new application called Organizer (**Figure 4.6**). Organizer can automatically find all of the images on your computer, and it provides you with several ways to search and sort them. Organizer offers almost all of the same functionality as Bridge and the File Browser but packs a different interface.

Figure 4.6 *The Adobe Photoshop Elements 4 Organizer provides most of the same functionality as the Elements 3 Browser and Adobe Bridge.*

Organizer keeps your images in an internal catalog that you can browse in the main preview window. You can add new images by selecting from the File > Get Photos menu. From there, you can choose to import from your camera or card reader, or from a scanner or mobile phone, or from a directory of images that are already on your computer.

You can control the size of the thumbnails in the thumbnail view by using the small slider at the bottom of the Thumbnails pane. You can also view images by date, by simply clicking the Date View icon on the Organizer toolbar.

As with Bridge and the File Browser, you can edit the metadata of an image using Organizer. Simply right-click an image thumbnail and select Show Properties. This will bring up the Properties pane, which provides access to a number of metadata tags. We'll explore metadata in more detail later.

Browsing for files

Using the Folders pane at the upper left of the Bridge/File Browser window, you can easily navigate your entire system to find the folder that contains the raw files that you're looking for.

The Folders pane provides you with a hierarchical view of all of the volumes and directories on your computer. If you single-click a folder, its contents will be displayed in the Thumbnails pane, as well as in list view in the Folders pane. To dig deeper into your directory structure, you can click subfolders in either the thumbnails view or the Folders pane. Finally, clicking an image will display a larger preview image in the Preview pane, as well as all of the image's metadata in the Metadata pane. To navigate back up your directory structure, you can either click directories in the directory tree in the Folders pane or use the pop-up menu above the Thumbnails pane (**Figure 4.7**).

Figure 4.7 *In Bridge, you can navigate up from the current directory by using the pop-up menu and Go Up button located above the Thumbnails pane.*

If you're using Bridge, then you'll also have access to the Favorites pane, which sits right next to the Folders pane. From the Favorites pane, you can view the Bridge Center, a sort of centralized command post that lets you quickly navigate through recent folders and documents, as well as to RSS newsfeeds on the web (**Figure 4.8**).

Figure 4.8 *In addition to the Folders pane, Bridge provides a Favorites pane that gives you a place to store folders that you visit regularly. It also provides access to the Bridge Center, a one-stop repository of all of your recently opened documents, with a built-in RSS reader to keep track of your favorite photography sites.*

The Favorites pane also provides access to Adobe's stock photo service and to Version Cue, a tool for collaborative project management that we won't be covering in this book.

One of the handiest features of the Favorites pane is the ability to drag a folder from the Thumbnails pane into the Favorites pane to create a short-cut. This allows you to quickly create single-click access to any number of folders on your system.

Finally, the Favorites pane also provides access to any collections you have stored, something we'll talk about more in the next chapter.

If you're using Organizer, then you don't have to concern yourself with directories, as Organizer simply displays a directory of all of the images that you've ever handed to it.

Viewing raw thumbnails

The Adobe browsers can read all of the same file formats that Photoshop can read. So in addition to Photoshop format documents, they can also show you thumbnails of TIFF files, PICT and BMP files, JPEG and GIF files, and files in many other formats. Most important for this discussion, though, is the fact that the browsers can display thumbnails of your raw images, making it simple to find the file you want to open.

When you first view a folder full of images in the browsers, you'll see the camera-generated thumbnails that are embedded in each file. As soon as the browers display these, though, they will begin to generate new thumb-nails. Camera-generated thumbnails are intended to be quick references that look good on your camera's LCD screen. Camera Raw slowly replaces those thumbnails with new thumbnails that it generates from the raw image data in the file.

There's no single, "correct" interpretation of a raw file, and the thumbnails generated by the Adobe browsers are not meant to create great-looking images. Instead, Camera Raw simply applies some default parameters to the raw data to come up with a conversion that displays as much of the cap-tured image as possible. Therefore, Camera Raw's thumbnails may not actu-ally look that great. Don't panic if your raw files look lousy in the browser! As you'll soon see, they can be quickly and easily processed into something that looks much better (**Figure 4.9**).

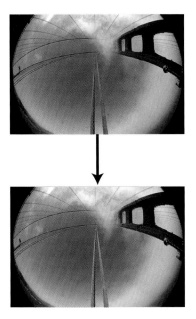

Figure 4.9 *Adobe's browsers initially display the thumbnail that's embedded in your raw file. After these are displayed, the browsers build new thumbnails that present a more accurate view of the extent of the data contained in your file.*

If you're looking at a folder that contains a lot of images, it may take a while for the browser to build all of its thumbnails (performance will vary depending on your computer's speed, of course). The Adobe browsers provide a status display at the bottom of the window that keeps you updated as to which image it's currently processing (**Figure 4.10**). If you click an image to view a preview, then the browser will immediately process an update preview for that image, if one isn't available.

Figure 4.10 *Both Bridge and the Elements 3/Photoshop CS File Browser provide a status display that indicates which thumbnails are being constructed.*

Opening an image

When you've found the image that you want to process, double-click it. If it's a "regular" file such as a Photoshop, TIFF, or JPEG file, it will open in Photoshop. If it's a raw file, though, it will open in Camera Raw. Now your serious work begins.

If you're using Organizer, select the raw file you want to open and then choose Edit > Go to Standard Edit, or press Ctrl-I.

TIP

If you already know which image you want to open, you can skip the whole browser step and simply choose File > Open in Photoshop. This opens the image in Camera Raw just as if you'd selected the file from the browser.

The Camera Raw Interface

Technically, Camera Raw is a plug-in, just like a special effects plug-in that you might install. Camera Raw's interface changes slightly depending on whether you're running it in Elements or CS2, but the underlying image processing code is the same. Some of the features that aren't there when running Camera Raw in Elements are high-end features that you probably won't miss, and that we won't be covering in this book anyway.

Camera Raw in Photoshop CS2

Camera Raw presents the dialog box shown in **Figure 4.11** when you open it from Photoshop CS2 or Bridge.

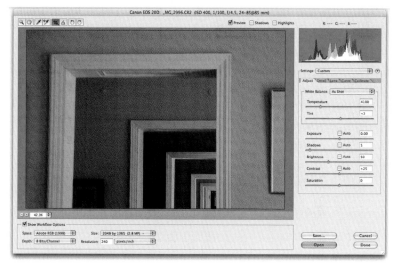

Figure 4.11 *When running Camera Raw 3.1 under Photoshop CS2, you see the following interface. Previous versions differ only slightly.*

The Camera Raw interface is divided into five major areas. The large preview lets you zoom and pan across your image. The upper-right corner houses a histogram, and directly below are the program's main controls, which you use to configure Camera Raw to process your image. Below the preview window are some simple pop-up menus for defining the size that you want your final, processed image to be. Across the top of the window is a simple tool palette for zooming and panning, sampling colors, cropping and straightening, and rotating your image.

Camera Raw in Photoshop Elements 3 and 4

The Camera Raw interface presented by Elements 3 and 4 (**Figure 4.12**) is very similar to the one presented by Photoshop CS2. The main differences are the simplified tool palette, which lacks Crop and Straighten tools, and the simplified raw parameters, which omit the Lens, Curve, and Calibrate controls. Camera Raw in Elements also lacks the ability to specify a size for the final image, as well as options for different color spaces and bit depths. These deficiencies may not matter to you, depending on the nature of your work. You'll learn more about what's missing as you read the rest of this book.

Figure 4.12 *Photoshop Elements 3 presents a Camera Raw interface that's almost identical to the CS2 version.*

From this point forward, the screenshots are from the CS2 version of Camera Raw. In most cases, the controls that you'll see explained will be exactly the same in Elements.

Camera Raw in Photoshop CS

Photoshop CS runs a slightly older version of Camera Raw than does Elements 3 or Photoshop CS2. While the CS version is very similar to the CS2 version, it lacks a few features. First, it doesn't have any auto buttons

for the Exposure, Shadows, Brightness, and Contrast sliders. It also lacks the Crop and Straighten tools of the CS2 version, and it doesn't include the ability to save directly to a file. Finally, by default, it shows only two parameter panes: Adjust and Details; you need to click the Advanced button (**Figure 4.13**) to reveal the Lens and Calibrate panes. The CS version lacks CS2's Curves tab, which you'll learn more about in Chapter 6.

Figure 4.13 *When running Camera Raw in Photoshop CS, you must click the Advanced button to reveal the Lens and Calibrate panes.*

The Camera Raw histogram

This histogram presented by Camera Raw looks a little different from the histograms displayed by Photoshop (and probably different from the histogram displayed on your camera). You've already learned that images on your computer are composed of separate color channels, usually red, green, and blue. The histograms we've looked at so far in this book have been graphs of a composite of all three color channels. The Camera Raw histogram superimposes three separate graphs: one each for the red, green, and blue channels (**Figure 4.14**).

Figure 4.14 *Camera Raw's histogram overlaps separate graphs for each color channel to give you a more refined analysis of your image.*

While a composite histogram is fine for determining whether you've over- or underexposed an image to the point of clipping the highlights or shadows, Camera Raw's histogram lets you see whether you've clipped *individual color channels*. As you'll see, this feature comes in handy when you start using the Exposure control.

The histogram in Camera Raw represents the image as it looks with the current Camera Raw settings applied to it. This is true even when you first open the raw file in Camera Raw.

Aside from its three-color display, the Camera Raw histogram works exactly like the histograms you've already learned about; it's simply a graph of the distribution of tones in your image, from darkest on the left to lightest on the right.

Camera Raw settings

Directly beneath the histogram, you'll find Camera Raw's main Settings pane. This is the heart of Camera Raw, and these are the controls that you'll use to specify exactly how you want your image processed. Many of these controls are similar to the Levels control that you've already learned about. We'll be exploring these controls in detail.

When running under CS2, the Settings pane is divided into five tabs (**Figure 4.15**):

◆ The Adjust tab provides the basic exposure processing controls that you'll use on all of your raw images.

◆ The Detail tab houses Camera Raw's sharpening and noise reduction tools.

◆ The Lens tab contains controls for correcting chromatic aberrations (strange color fringes that can occur due to inferior lens optics or lens-sensor misalignment) as well as for fixing vignetting (the corner darkening that can occur when you use a wide-angle lens).

◆ The Curve tab provides an interface for making localized contrast changes to the image. If you've ever worked with the Curves control in Photoshop, then you'll be familiar with this tool.

◆ The Calibrate tab provides a mechanism for tweaking Camera Raw's colorimetric information to better match your specific camera.

Pressing the Alt (Windows) or Option (Mac) key turns the Cancel button into a Reset button, allowing you to return to default values if you've made too many changes and the result isn't what you want.

We'll be looking at the details of all of these controls throughout the rest of this book.

NOTE

If you're using Photoshop Elements, then you won't see tabs in the Settings area. The single group of sliders provided in Elements contains the same controls as the Adjust and Details tabs in CS2.

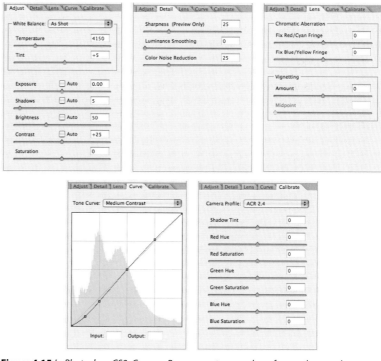

Figure 4.15 *In Photoshop CS2, Camera Raw presents a number of controls spread among five tabs.*

Workflow options

Beneath the Preview pane are a collection of simple Workflow Options pop-up menus that let you specify the size and color parameters for your final image (**Figure 4.16**).

Figure 4.16 *Camera Raw's Workflow Options controls let you set the size, bit depth, resolution, and color space as part of your raw processing.*

Raw files are created using the full pixel dimensions provided by your camera. However, if you shoot with an 8-megapixel camera but are preparing images for a web site, you probably don't want the full 3504 x 2336 collection of pixels that your camera captured. By changing the selection in the Size pop-up menu, you can tell Camera Raw to automatically downsample

your image to create a smaller file. Resizing in Camera Raw (either up or down) has no advantage over resizing in Photoshop, except that it can save you some time if you're batch processing images (you'll learn more about batch processing in Chapter 5).

Similarly, just as you can set pixel dimensions, you can set the resolution that you want your target image to have. Like the Size pop-up menu, the Resolution pop-up menu simply provides a shortcut for setting resolution while converting your image, rather than having to set it later using Photoshop's Image Size dialog box.

HOW MANY DOTS?
HOW CLOSE TOGETHER?
UNDERSTANDING RESOLUTION

Many people are confused by the relationship between pixel dimensions and resolution. All images have fixed pixel dimensions—these are simply the width and height of the image as measured in pixels. Resolution is the measure of how many of those pixels fit into a particular space. Resolution is usually measured in pixels per inch. So if you have an image that's 3072 x 2048 pixels (typical of what you get from a 6-megapixel camera) and you've set the resolution to 300 pixels per inch, then those pixels will be squeezed together to yield a final image size of 10.24 x 6.8 inches. If you take that same 3072 x 2048 image and specify a resolution of 100 pixels per inch, then the pixels won't be crammed together quite so closely, and your final image will measure 30.7 x 20.4 inches.

For viewing images on a computer, resolution is irrelevant, because the computer can resize the display of the image on the fly to fit it into different-size windows. When printing, however, resolution makes a big difference. If your resolution is too low, then you'll see blocky pixels and poor detail. For typical printing tasks, most inkjet printers work best with an image resized to your desired printing dimensions and with a resolution setting of 240 to 300 pixels per inch.

The Space pop-up menu lets you select the color space that you want your image mapped to. As explained in Chapter 3, your choice of color space defines what the colors recorded in your image correspond to in the real world. Most cameras allow a choice of sRGB or Adobe RGB color space, and the Camera Raw Color Space pop-up menu defaults to the color space that was assigned by your camera. If you're using Photoshop CS2, you'll be able to choose from some additional color spaces, which we'll discuss later in this chapter.

The Depth menu lets you specify whether your final image should use 8 bits per pixel or 16 bits per pixel for specifying color. As discussed in Chapter 3, a 16-bit image is capable of displaying more colors and gives you more latitude when editing. You can do a lot more to a 16-bit image before you begin to see posterization and other signs of image-data loss.

Processing an Image Using Camera Raw

Although Camera Raw's controls may initially be intimidating, processing an image is actually very simple. To get the most out of this section, open a raw image of your own and follow along with the descriptions of each control. Getting a feel for the controls is an important part of learning which parameters are good for which types of adjustment.

Before getting to work adjusting the color and contrast of your image, though, it's good to make any necessary geometric adjustments to it.

Rotating

These days, many cameras can automatically detect whether an image was shot in portrait or landscape mode (vertically or horizontally). Cameras with such a mechanism will automatically tag your image as either portrait or landscape, storing this information in the image metadata. Adobe Camera Raw can read this tag and automatically rotate your image accordingly. If your camera doesn't detect rotation, or if it has detected it incorrectly, then you may need to rotate your picture manually. Simply click the Rotate buttons—located above the Preview pane when running in CS2, and below when running in Elements—to rotate your image in 90-degree increments (**Figure 4.17**).

Figure 4.17 *Camera Raw's Rotate buttons let you rotate your image in 90-degree increments.*

Cropping

With Camera Raw 3.1 in Photoshop CS2, Adobe added a Crop tool to the Camera Raw interface. Just like the Crop tool in Photoshop, Camera Raw's Crop tool lets you crop your image simply by dragging out a rectangle to select the area you want to keep (**Figure 4.18**).

Figure 4.18 *To crop in Camera Raw, select the Crop tool and then drag out an area around the part of the image that you want to keep.*

It's often a good idea to crop before you start your exposure and tonal corrections, so that your histogram won't be affected by pixels that you're planning to discard. This is especially true if the areas you're planning to crop contain clipped highlights or shadows. If you crop these areas before you start your correction, your histogram will provide a more accurate display when you're editing.

The Crop tool also provides a drop-down menu that lets you constrain the crop to particular aspect ratios, making it easy to crop for paper with particular dimensions. The Crop menu also lets you clear your current crop setting (**Figure 4.19**).

Straightening

Camera Raw's Straighten tool provides a facility that even Photoshop itself doesn't have. Camera Raw's Straighten feature provides a two-click solution that straightens and crops.

To use the Straighten tool, select it from the tool palette at the top of the Camera Raw window or press the letter A. (Elements users don't have access to the Straighten tool.)

The Straighten tool works just like a straight-line tool in a drawing program. Click it at one end of a line in your image that should be straight; then click at the other end (**Figure 4.20**). Camera Raw automatically rotates your image so that the indicated line is now horizontal. What's more, Camera Raw automatically calculates a crop that selects the largest usable area of the now-rotated image.

Figure 4.19 *If you click and hold the Crop tool, Camera Raw opens a menu that allows you to constrain your crop to a particular aspect ratio or to clear your current crop setting.*

TIP

Because Camera Raw has only one level of undo, you won't be able to undo your cropping or straightening once you've made any additional edits to your document. However, you can clear the crop by selecting the Crop tool and right-clicking (Windows) or Control-clicking (Mac) the preview image and then selecting Clear Crop from the pop-up menu. Or you can click and hold the Crop tool to drop down the Crop menu and then select Clear Crop from there.

Figure 4.20 *Camera Raw's Straighten tool not only straightens images with just two clicks, but it also automatically crops the resulting image, saving you the trouble of a separate cropping step.*

Because straightening results in a little bit of cropping, it's a good idea to perform this step before making your tonal corrections, for the reason described in the "Cropping" section.

Workflow options

It really doesn't matter if you choose to set image size and resolution in Camera Raw or wait until you're back in Photoshop. These settings are simply provided to ease the batch processing of multiple images.

However, it *is* worth considering bit depth and color space before you start editing. As discussed earlier, most digital cameras capture 12 bits of color information per pixel. If you're shooting in JPEG mode, then your camera converts these images to 8 bits per pixel before saving. This results in a significant loss of color information. If you plan to edit and print your images, then it's worth letting Camera Raw convert your image to a 16-bit file. This will afford you much more latitude when editing. Simply select 16-bit from the Depth pop-up menu. Note that this will result in larger files, and you'll have to convert to 8-bit later if you want to save in JEPG mode. (In Photoshop, you can convert to 8-bit by choosing Image > Mode > 8-bit.)

In Chapter 3, you learned about color spaces. Although your camera likely lets you choose between sRGB and Adobe RGB color spaces, these may not be big enough to represent the full range of colors that your camera can capture. You can select from other spaces using the Space pop-up menu. You'll learn more about color space choice later. In general, Adobe RGB is a very good default color space to choose.

Using the Adjust tab

With your image straightened, rotated, and cropped (if it needed any of those operations), you're ready to start to work on tonal and exposure adjustments. Using the histogram as a reference, your goal here is to perform all of the adjustments to your image's raw data that your camera would normally perform on its own. However, because of the sophistication of Camera Raw's routines, the granularity of its controls, and the fact that your eye is possibly more refined than a factory-set algorithm, you'll likely get better results than what your camera would produce if you were shooting JPEG.

You'll perform the bulk of your work using the Temperature, Tint, Exposure, Shadows, Brightness, and Contrast sliders, possibly in that order.

NOTE

Elements users will find this same set of sliders in the Camera Raw dialog box rather than on a separate Adjust tab.

A QUICK WORD ABOUT CAMERA RAW'S AUTO BUTTONS

Camera Raw 3 introduced new Auto check boxes for the Exposure, Shadows, Brightness, and Contrast sliders. These buttons simply tell Camera Raw to take a guess at what it thinks are the best settings for each parameter. Camera Raw frequently does a very good job with its auto settings, but in most cases you'll want to fiddle with the sliders anyway, just to see what other possibilities are there in your image. For the sake of our discussion here, it's best to turn off the Auto boxes completely, so that you can see what your default image data looks like. You may find that you ultimately prefer working this way.

You can uncheck the Auto boxes by hand, but a better option is to open the Camera Raw pop-up menu and uncheck Use Auto Adjustments (**Figure 4.21**).

Figure 4.21 *You can easily activate or deactivate all of Camera Raw's Auto Adjustment settings by toggling Use Auto Adjustments in the Camera Raw pop-up menu.*

Adjusting white balance

As discussed in Chapter 2, white balancing is the process of calibrating your camera so that it renders colors correctly for the type of light in which you are shooting. If you're using an auto white balance mechanism, then your camera takes a guess as to what the correct white balance setting should be; if you're using a preset or manual white balance, then you have effectively told the camera the color temperature. No matter what white balance setting you're using, the camera stores this information with the raw file.

When your camera processes a file, it uses this white balance setting to adjust the color information in your image to compensate for the type of light in your scene. These days, most cameras do a very good job of white

balancing, so unless you inadvertently chose an incorrect manual white balance, your image will probably look pretty good. However, if it has an incorrect white balance, Camera Raw will let you correct it with ease.

When you first open a raw file, Camera Raw attempts to read the white balance tag that your camera embedded in the file, and then it sets the white balance slider accordingly. If your white balance was set incorrectly, or if the camera's auto white balance mechanism is particularly lousy, you may see an image that looks really terrible (for instance, like Figure 2.5 in Chapter 2).

Camera Raw's White Balance pop-up menu defaults to As Shot, meaning that the white balance is set to whatever value the camera was set for at the time of shooting. You can see what value this is by looking at the Temperature slider directly below the White Balance pop-up menu (**Figure 4.22**).

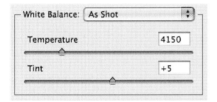

Figure 4.22 *Camera Raw provides three options for changing the white balance of your raw image. The pop-up menu contains predefined white balance settings, and the Temperature and Tint sliders give you true manual white balance control.*

The White Balance pop-up menu offers a list of standard white balance options: Auto, Daylight, Cloudy, Shade, Tungsten, Fluorescent, and Flash (**Figure 4.23**). If the color in your image looks wrong, try picking the white balance option that matches the type of light you were shooting in.

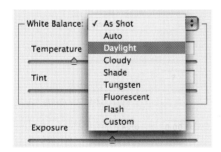

Figure 4.23 *You can use Camera Raw's White Balance menu to select a standard white balance setting for your image.*

If you were shooting in a mixed-lighting situation and your color is off, then the preset white balance options may not help you. For these instances, you'll need to take manual control and adjust the Temperature slider to correct the white balance.

You can try simply moving the slider by hand until you get color you like, and this is often the best way to proceed with correcting a bad white balance. But both the Elements and CS2 versions of Camera Raw provide an additional excellent white balance correction tool: the White Balance Eyedropper (**Figure 4.24**).

Figure 4.24 *The White Balance Eyedropper lets you set the white balance for your image by clicking an area of your image that should be a neutral tone.*

To use the eyedropper, select it and then click a part of your image that should be neutral—not white, and not colored, but a medium-tone gray. Sometimes it can be difficult to tell what, in your scene, was originally gray, but if you know for sure, then you can use the White Balance Eyedropper to perform a very accurate white balance correction with a single click (**Figure 4.25**).

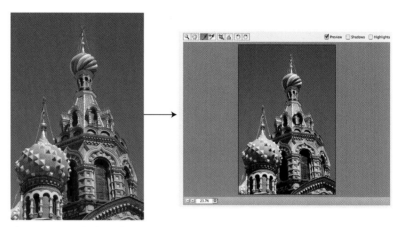

Figure 4.25 *Just before taking this picture, I had been indoors shooting with my camera set to Tungsten white balance. Unfortunately, I didn't think to switch it back to Daylight when I stepped outside. Consequently, the white balance in the left image is dead wrong. Clicking the White Balance Eyedropper on an area in the image that is supposed to be a neutral gray restored the image to more accurate color.*

If you're not sure what might be gray in your image, try clicking tones that look close to gray or that are likely to be neutral; then choose the one that looks best. If you still can't find a tone that yields a good result, then click something white. This will get you pretty close to correct white balance,

though your image may still look a little strange. You can then fine-tune the white balance using the Temperature and Tint sliders (we'll discuss Tint in the next section).

If you've ever tried to correct a white balance problem using Photoshop's normal color correction tools, then you already know that it can be *extremely* difficult to restore correct color to an image that has bad white balance. The color shifts that occur with improper white balance extend all the way from the shadows to the highlights, making it impossible to find a single operation that can restore the entire scene. What's more, by the time you've performed this correction, you will have pushed your image data so far that you'll have very little latitude left for additional edits.

The Levels control that we explored in Chapter 3 makes changes to your image by redistributing the pixel values that comprise your picture. As you saw, this redistribution results in potentially image-degrading data loss. Changing white balance in Camera Raw has no such consequences. It's a completely "free" edit in terms of preserving your image data. When you adjust the white balance of a raw file, you're not redistributing pixel values. Instead, you're making changes to the colorimetric definitions that your raw converter uses to interpret the colors in your original raw file. Rather than moving pixels, you're simply redefining the program's understanding of what each color is supposed to be. Thus, adjusting white balance in a raw file allows you to perform color corrections that would be impossible with any other color editing tool.

Adjusting tint

Just below the White Balance slider is the Tint slider. The White Balance and Tint sliders work in concert to produce an accurate white balance. When you select a white balance preset from the White Balance pop-up menu or click your image with the White Balance Eyedropper, Camera Raw automatically adjusts both sliders.

In the simplest terms, the two sliders represent two different axes of color. The White Balance slider shifts from blue on the left to yellow on the right, while the Tint slider lets you move from green to magenta.

When you move the White Balance slider manually, you may find that, though your color improves, it also picks up a green or magenta cast. You can correct this cast using the Tint slider (**Figure 4.26**).

Figure 4.26 *I corrected the white balance for this slightly complex mixed lighting situation—heavy daylight through the windows combined with shady light and a tiny bit of tungsten in the building—by first moving the White Balance slider. However, the image picked up a green cast. A small positive movement of the Tint slider shifted the image a little more toward magenta, eliminating the green.*

It's not essential to set your white balance *before* performing other adjustments, but if the white balance in your image is blatantly wrong (as in Figure 4.26), then you'll have an easier time understanding what tonal corrections to make if you correct white balance first. If you make a very large adjustment with the Exposure slider, you may need to go back and tweak your white balance.

WHY IS LIGHT MEASURED IN DEGREES?

Though the concept that a red color is "warmer" than a blue color may make some kind of intuitive sense, there's a basic scientific reason that we measure the color of a light using a temperature scale.

If you heat a black object, it will first glow red, then orange, then yellow, then white, and then blue-white. The color of the light radiating off the object is determined by the temperature to which the object has been heated. This is called *black-body radiation,* and it's usually measured in degrees Kelvin.

Creating a pure black-body generator is difficult because of impurities in the materials we have available. When light strays from being a pure black-body generator, it shifts to either green or magenta—the two colors that you can move between using the Tint slider.

So when you adjust white balance in Camera Raw, you first use the Temperature slider to specify the temperature of the black-body radiation of the light under which you're shooting, and then you use the Tint slider to correct for the inherent impurities in that light's black-body radiation.

One last point: Describing a red color as "warmer" than a blue color in fact disagrees with the Kelvin scale. In terms of black-body radiation, higher temperatures produce what we tend to describe as "cooler" colors.

Adjusting exposure

In the simplest terms, the Exposure slider brightens your image. Just as you can adjust the brightness of a scene when shooting by selecting a different exposure, you can brighten your raw file by selecting a positive exposure adjustment using the Exposure slider. Intuitively enough, you can darken your scene by selecting a negative adjustment.

The Exposure slider works very much like the Levels white point control that you learned about in Chapter 3. With that control, you can define how bright the brightest pixels in your image should be. Recall that with Levels, you can move the white point slider to a darker point on the histogram, and that point will become white. Your image will be brightened, with the pixels being redistributed in a way that maintains the shape of their overall distribution. Anything to the right of the new white point gets clipped— changed to pure white. When you look at your histogram after a white point adjustment, you will see your new tonal information spread all the way from black to white, probably with some gaps in it (**Figure 4.27**).

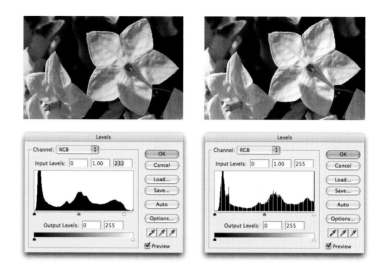

Figure 4.27 *With the Levels control, you move the white point to indicate which point on the histogram should be white.*

The Camera Raw Exposure slider works the same way—it also serves as a highlight clipping tool that allows you to redefine the white point in your image. The interface differs, though, in that the histogram updates on the fly while you move the Exposure slider. So unlike Levels, where you move the white point to a different spot on your image's existing histogram, the Camera Raw Exposure slider actually reshapes the histogram while you adjust. This allows you to immediately see what your final histogram will look like (**Figure 4.28**).

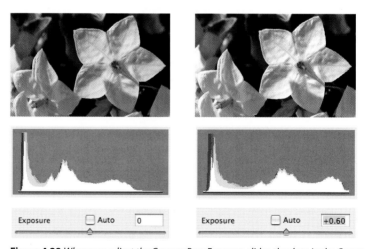

Figure 4.28 *When you adjust the Camera Raw Exposure slider, the data in the Camera Raw histogram updates in real time to show you the effect of your exposure adjustment.*

As with the Levels control, you need to be very careful when adjusting the white point with the Exposure slider. If you clip too much highlight information, you'll lose details in the highlights of your image.

However, the Exposure slider also presents some other concerns. Though it doesn't change the black point in your image, the Exposure slider does brighten the shadow areas. Shadow areas often contain noise, so as you brighten your image, you run the risk of making any shadow noise more visible (**Figure 4.29**).

Figure 4.29 *Be careful of using the Exposure slider to brighten an image. As shadows brighten, they may reveal noise.*

Exposure is the most critical adjustment you'll make when processing your raw image, and you'll learn much more about it in Chapter 6. For now, use exposure control just as you would use the white point adjustment in the Levels control. Try to pick an exposure setting that doesn't clip your

highlights—or doesn't clip them so much that loss of detail is noticeable. In general, it's best to adjust the Exposure slider so that the rightmost end of your histogram's data—the part representing the brightest pixels—just touches the edge of the histogram itself, without clipping any highlights (**Figure 4.30**).

Figure 4.30 *On a well-exposed daylight image, you'll want to adjust the Exposure and Brightness settings so that your image data approaches the right edge of the histogram, but doesn't clip.*

Adjusting shadows

The Shadows slider lets you adjust the black point in your image in much the same way that the Levels black point slider does. As with the Exposure slider, you'll see your histogram update in real time when you use the Shadows slider. Just as the Exposure slider resets the white point in your image and clips everything above it, the Shadows slider resets the black point in your image and clips everything below it to solid black. Obviously, this can lead to a loss of detail, though clipped shadows are often less noticeable than clipped highlights.

The Shadow slider is a little more sensitive than the Levels black point slider. Very small moves can have a very big effect, so you'll want to handle the Shadows control very carefully.

USING CLIPPING DISPLAYS

Both the Exposure and Shadows sliders provide a clipping display, just like the one you'll find in the Levels dialog box. Hold down the Alt (Windows) or Option (Mac) key when you move the Exposure or Shadows slider, and Camera Raw will show you where there are clipped tones in your image (**Figure 4.31**).

Figure 4.31 *If you hold down the Alt (Windows) or Option (Mac) key while moving the Exposure or Shadows slider, Camera Raw will show any highlight or shadow areas that are being clipped.*

The clipping displays can be indispensable for quickly identifying whether you've pushed an Exposure or Shadows adjustment too far. They can also be essential for working with images that have lots of bright highlights—sunlight on rippling water, for example. It's often difficult to identify a blown highlight in an image full of bright spots.

The downside to these clipping displays is that you can't see your image while you're using them. Sometimes it's worth suffering a little clipping to improve your image. Since you can't see your image while the clipping displays are active, there's no way to judge this balance.

CS2 and Elements both provide check boxes that enable a different type of clipping display. If you check the Highlights check box (located above the preview window in CS2 and below it in Elements 3), you'll still see your adjusted image, but any blown highlights will appear as bright red pixels. Similarly, if you check the Shadows check box, any clipped shadows will appear as bright blue pixels (**Figure 4.32**).

These clipping displays don't indicate clipping that's occurring in individual channels (the Alt and Option clipping displays show individual channel clipping). In Chapter 6, you'll learn more about why this might matter.

Figure 4.32 *The Shadows and Highlights check boxes provide clipping displays that are superimposed on your existing image.*

Adjusting brightness

The Brightness slider lets you brighten or darken the midtones in your image, without altering the white or black point. Yes, this is exactly what the gamma slider in the Levels control does.

For almost all edits, Brightness allows you to adjust your image without fear of clipping. However, if you're making extreme adjustments, it's worth keeping an eye on Camera Raw's clipping displays, just to ensure that Brightness hasn't overdriven your highlights.

Adjusting contrast

The Contrast slider increases or decreases the contrast in your image. Positive movements create more contrast in your image (you'll see the data in your histogram expanding to cover more range), and negative values decrease contrast (causing the histogram to contract). Adjusting the contrast achieves the same effect as adjusting the white and black points at the same time; however, it doesn't actually change either point. You'll learn more about Contrast in the Chapter 6.

Adjusting saturation

The Saturation slider lets you alter the saturation of the colors in your image, either boosting the saturation to make colors richer or draining saturation to make colors appear more pastel. Using the Saturation slider is very simple: slide it to the right to increase saturation, and to the left to decrease saturation (**Figure 4.33**).

Note that the Saturation tool can cause clipping in either the highlights or shadows, so you'll need to keep a close eye on your histogram when making saturation adjustments. Unlike white balance, saturation adjustments are not something you get "for free" in terms of your image data. It *is* possible to introduce posterization and tone breaks into your image using the Saturation control. However, if you're working in 16-bit mode—one of the big advantages of raw over JPEG—you'll be able to push your saturation adjustments farther without incurring these problems.

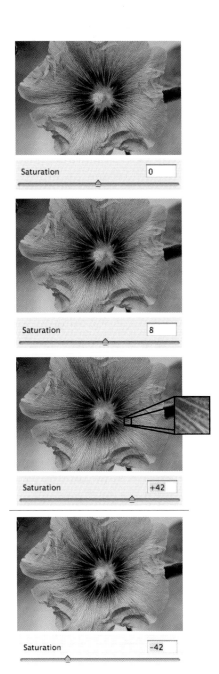

Saturation 0

Saturation 8

Saturation +42

Saturation -42

Figure 4.33 *You can increase the saturation of an image in Camera Raw by sliding the Saturation slider to the right. Don't go too far, though. Oversaturation can lead to posterizing, as you can see in the third flower. Sliding the Saturation slider to the left desaturates an image, ultimately yielding a grayscale picture.*

Adjusting white balance again

Once you've worked your way through Camera Raw's tonal correction controls, you may want to reconsider your white balance settings. Colors have tone, just as grayscale values do, and by the time you've finished with your tonal corrections, you may find that the colors in your image are slightly warmer or cooler than when you started. Consequently, you may need to make some slight adjustments to the Temperature and Tint sliders to get your color back where you want it. This doesn't mean that you've done something wrong with your other edits; it's just a simple fact of color adjustment.

KEYBOARD CONTROL IN CAMERA RAW

As you've just seen, you'll frequently move back and forth between Camera Raw's sliders, making adjustments here and there and returning to tweak properties you've already set. Camera Raw allows thorough keyboard control using nothing more than Tab and the arrow keys.

Tab and Shift-Tab will take you to the next and previous sliders, respectively. As you tab to a new slider, its numeric entry box becomes selected, allowing you to immediately enter a new value. You can also use the Up and Down arrow keys to make fine adjustments.

Finally, all of the tools on the toolbar have keyboard equivalents (**Figure 4.34**).

Z H I S C A L R

Figure 4.34 *You can use these keyboard equivalents to select any tool from Camera Raw's toolbar.*

NOTE

If you're using Elements 3, you won't have a separate tab for these controls. Instead, you'll find the Sharpness, Luminance Smoothing, and Color Noise Reduction sliders directly below the Saturation slider.

Using the Detail tab

With your image toned and corrected, you're ready to move on to the Detail tab, which will let you address any sharpness and noise troubles that your image might have.

Adjusting sharpness

Sharpening can be a touchy subject. While some people are very particular about sharpening and use special techniques to apply varying levels of sharpness to different parts of an image, other people simply want a quick sharpening process that makes their images look better. However, no matter what your particular sharpening taste, all of your raw images will need *some* sharpening.

When you shoot JPEG, your camera automatically sharpens your image before it compresses and stores it. All digital camera images need some sharpening to make up for the slight blurring that's introduced to facilitate demosaicing (see Chapter 2 for details), if for no other reason. Your camera may provide options for several levels of sharpening when you're shooting JPEG, but if you're shooting raw, then your images will come out of the camera with no sharpening applied at all.

No matter what your personal sharpening preferences, sharpening is something that should be applied at the very end of your editing workflow. If you're planning to make further adjustments to your image in Photoshop, then sharpening in Camera Raw may not be such a great idea. However, some people like to apply a little sharpening in Camera Raw and then perform more serious, localized sharpening later using Photoshop or a third-party sharpening tool.

The Camera Raw Sharpness slider lets you apply sharpening by simply sliding the control to the right. Camera Raw's Sharpness slider uses the same sharpening method as Photoshop's Unsharp Mask filter, though with fewer parameters.

Though it's generally best *not* to sharpen in Camera Raw since you'll probably make further changes later, it can still be handy to see what your image will look like sharpened while working in Camera Raw. Sharpening an image tends to increase its contrast, so being able to see a sharpened version of the image gives you a better idea of what the image's final contrast will look like—something that can be essential for proper configuration of Camera Raw's tonal controls.

Camera Raw provides a very simple solution to this dilemma. From the Camera Raw Preferences dialog box (open the Camera Raw pop-up menu or press Ctrl-K in Windows or Command-K on the Mac), choose Apply Sharpening to Preview Images Only (**Figure 4.35**). This will apply your chosen sharpening setting to the preview shown in the Camera Raw window, but will leave your final image untouched.

Figure 4.35 *Camera Raw's preferences provide an Apply Sharpening to Preview Images option that sharpens the image in Camera Raw's Preview window but leaves your final converted image unsharpened.*

If you're unfamiliar with Photoshop's Unsharp Mask filter, it's important to know that you can apply *too much* sharpening to an image. An edge in a picture is usually characterized by a sudden change in contrast, so looking for contrast change is a good way of identifying edges, and therefore a good way of identifying areas that need to be sharpened. Unsharp Mask and Camera Raw's Sharpen slider work by identifying areas of sudden contrast change in your image. Once these areas have been identified, the pixels along the light side of the edge are lightened, and the pixels along the dark side of the edge are darkened. This increases the contrast of the edge even further, making it stand out more and, therefore, appear sharper.

The risk with this sharpening technique is that if you apply too much of it, the edges in your picture will start to sport little halos of white and black. These halos can make an image appear "busy," with lots of distracting white and black textures (**Figure 4.36**).

Figure 4.36 *This image has had too much sharpening applied to it. The edges in the image are now bordered by halos of white and black pixels.*

When applying sharpening, it's best to zoom in to view your image at 100%. This will give you a better view of the details of your image, and help you keep an eye on both the level of sharpening and the white and black halos that you're adding to your image.

Using luminance smoothing

When capturing an image, your camera performs a number of electrical pro-cesses such as converting each pixel's charge to a voltage and then converting that voltage to a digital count. These activities create two types of electrical noise in your image: *luminance noise*, which appears as speckled patterns that can appear vaguely similar to film grain, and *chrominance noise*, which appears as speckled, blotchy patterns of green, yellow, or magenta.

Other factors increase the amount of noise in your image. The ambient tem-perature of your location and heat from your camera's internal electronics affect the temperature of your camera's image sensor. As the temperature of the sensor increases, so will the noise in your images. Noise also gets much worse as you increase the ISO setting of your camera. Noise levels vary from camera model to camera model, and your camera may not yield images that need much noise correction.

The Luminance Smoothing slider lets you reduce the amount of luminance noise in your image. You won't find a lot of luminance noise when shooting at low ISO settings. If there's any to be found, it will be in the shadow areas of your image; midtone and highlight areas will probably be noise free. At higher ISO settings, the odds are good that you'll see noise throughout your entire image (**Figure 4.37**).

Figure 4.37 *Low-light photographs are extremely susceptible to luminance noise, the speckled patterns you see here.*

Using the Luminance Smoothing slider is very simple: just slide it to the right to reduce the amount of luminance noise in your image.

Luminance smoothing can result in a loss of sharpness and detail in your image, so you don't want to apply any more than you have to. Also, bear in mind that noise that's visible when looking at your image onscreen at 100% may not appear at all in print. This is especially true if you have a camera with a high pixel count.

If you've brightened your image by moving the Exposure slider to the right, there's a chance that you will have revealed more of the shadow noise that's in your image. Thus, any time you make a big positive Exposure adjustment, be sure to look for increased shadow noise, and then try to reduce it using luminance smoothing.

Reducing color noise

While luminance noise often provides a nice film-like texture, color noise is just downright ugly. Appearing as speckled patterns of color—usually magenta, yellow, or green—color noise can find its way into the shadows and midtones of your image. Like luminance noise, color noise becomes worse at high ISO settings, but it can also be introduced if you brighten your image with Camera Raw's Exposure control. Removing chrominance noise can be very difficult using Photoshop's normal toolset. Camera Raw's Color Noise Reduction slider does an excellent job of removing color noise.

As with luminance noise, you don't want to apply any more color noise reduction than you need to, as increasing it can affect the sharpness and detail in your image. You may find that Camera Raw's default Color Noise Reduction setting is a little aggressive, so it's worth experimenting with a lower value.

Using the Lens tab

We now head into the features that are available in Camera Raw when running under Photoshop CS and CS2. Elements users won't find these tools, and while they're not essential, everyday tools, they can be very handy. If you're currently using Elements, it's worth taking a look at this section to see if any of these features warrant an upgrade.

CHANGING DEFAULTS

If you find that Camera Raw's default settings are consistently wrong—perhaps you find yourself repeatedly lowering the Color Noise Reduction slider or always increasing the Shadows slider—then consider changing the Camera Raw defaults.

The default slider values presented by Camera Raw are not arbitrary. Rather, they're values that the Camera Raw engineers have decided are ideal for your particular model of camera. When Camera Raw opens a raw file, it looks in the metadata stored within the file to find out what kind of camera the image was shot with (most cameras store their make and model within the metadata of every image they shoot). Camera Raw then plugs in default values it thinks are appropriate for that type of camera.

After making any changes to Camera Raw's controls, you can choose Save New Camera Raw Defaults from the Camera Raw pop-up menu (**Figure 4.38**), and Camera Raw will automatically update its defaults for the camera you used to take the current image. Any additional images you open that were shot with this same type of camera will have the same defaults.

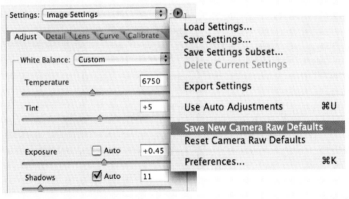

Figure 4.38 *Save New Camera Raw Defaults lets you change Camera Raw's default parameter settings for the particular camera that you used to take the current image.*

Choosing Restore Camera Raw Defaults will set the current camera defaults back to their original Adobe-specified settings.

Reducing chromatic aberration

The lens on your camera is not a single piece of glass, but a collection of lenses arranged in an array that's designed to focus light onto the image sensor inside your camera's body. Unfortunately, designing a "perfect" lens is impossible, and even an extremely good lens is very difficult to achieve, especially if it's a zoom lens. Consequently, there are a number of common problems that can afflict a lens. The most common are flares: those circles of colored light that appear on an image when you point the lens toward a bright light source.

Less common are *chromatic aberrations*: color fringes (usually red or blue) that appear along high-contrast lines in your scene. Chromatic aberrations are the result of your camera's lens' inability to precisely focus all the wavelengths of light onto the same spot on the focal plane. The fringing occurs because some wavelengths are out of registration with the others (**Figure 4.39**).

Figure 4.39 *Chromatic aberrations, the weird colored fringes shown here, can be easily removed using Camera Raw's Chromatic Aberration sliders.*

Chromatic aberrations usually occur only at very wide angles and extreme apertures, and only when shooting very contrasty situations—dark tree branches against a bright sky, for example.

Camera Raw's Chromatic Aberration sliders let you reduce—and in many cases, completely eliminate—these annoying colored fringes simply by moving two sliders. The Chromatic Aberration Fix Red/Cyan Fringe slider lets you reduce red or cyan fringes, and the Chromatic Aberration Fix Blue/Yellow Fringe slider lets you reduce blue or yellow fringes.

The Fix Red/Cyan Fringe slider works by slightly shrinking the size of the red-channel image so that it falls back into registration with the green-channel image. The Fix Blue/Yellow Fringe slider does the same thing, but reduces the size of the blue-channel image (**Figure 4.40**).

Figure 4.40 *Camera Raw's Chromatic Aberration sliders let you attack two different types of colored fringing.*

The Chromatic Aberration controls in Camera Raw are extremely effective and provide a simple solution to this sometimes vexing problem. Before you get too flipped out about chromatic aberration in your images, however, bear in mind that tiny fringes that you may be able to see when zoomed in to 100% on your computer screen may not be visible at all in print. Do some test prints at your desired print size before trying to solve a problem that isn't really a problem.

SENSOR BLOOMING: THE OTHER COLORED FRINGE

If your image has a high-contrast area that's fringed with green pixels, then the source of your problem may be something other than chromatic aberration.

When exposed to too much light, the individual photosites on your camera's sensor may become overloaded and spill electrons into neighboring sites. This spillage can, in turn, overload the receiving pixel, causing it to spill over into yet more photosites. This is called *sensor blooming*, and the practical upshot of it is green fringe. Green fringe can also be caused by poor demosaicing on the part of your raw converter software.

Camera Raw's Chromatic Aberration controls won't help with this type of color fringing. Fortunately, sensor blooming is fairly rare, especially if you're using a camera with good autoexposure, or if you've properly exposed the image yourself. When it does occur, it's usually fairly easy to paint away using Photoshop's Sponge tool. With the Sponge tool set to Desaturate, you can easily drain the color from the fringe, rendering it invisible.

Correcting vignetting

Vignetting is the darkening of corners that can happen when shooting with wide-angle lenses. Camera Raw provides a simple vignette correction that brightens the corners of your image. Move the Amount slider to control the amount of brightening to apply, and move the Midpoint slider to control the center point for the vignetting correction.

Using the Curve tab

If you've ever worked with the Curves control in Photoshop, then you'll be familiar with the interface provided on the Curve tab, which lets you perform very controlled, localized adjustments of the contrast and brightness of your image. We'll delve into the Curve tab in detail in Chapter 6.

Using the Calibrate tab

As explained in Chapter 2, to process a raw file from a particular camera, any raw converter needs a profile for that camera. Among other details, this profile contains colorimetric information about the camera's basic RGB color response. Camera Raw is no different.

Unfortunately, no matter how good a job Adobe does when building its camera profiles, they can't account for the fact that there can be variation between individual units of a particular type of camera. Thus, your particular camera may yield images that are, for example, a little more blue than images from another unit of the same make and model.

The Calibrate tab lets you fine-tune Camera Raw's built-in profile for your particular camera. Calibration is a complex process that requires you to shoot images of special color calibration targets. These targets can be pricey, and you'll want to shoot them in a controlled lighting situation. We won't be covering calibration in this book, but you can learn more about it in *Real World Camera Raw with Adobe Photoshop CS2* by Bruce Fraser, also published by Peachpit Press.

Saving your image

With all of your settings configured (in either Elements or CS2), you're ready to finish. Camera Raw provides several options at this point, each of which allows you to take a different approach to your camera raw workflow.

No matter which program you're running or what workflow you use, one of the great things about raw is that no matter what save options you choose, your original raw file will *never* be altered. Camera Raw does not save any changes back into your raw file—the file truly functions as a digital negative. You can open the same raw file several times, apply different adjustments, and save out multiple versions, but your raw file will always remain pristine.

Saving in Photoshop CS2

Camera Raw's default saving option is the Open button, which processes your raw image according to the settings you've defined and then opens the resulting image in Photoshop. Obviously, if you want to make further edits, print, or convert your image to another format, this is the way to go (**Figure 4.41**).

Figure 4.41 *When running under Photoshop CS2, Camera Raw's save buttons provide several options for handling your processed image.*

If you don't plan on making any more edits, or if you want to move on to processing other raw images before embarking on further Photoshop work, then click the Save button. This will bring up Camera Raw's Save Options dialog box, which lets you choose a file format, pick a destination, and add automatically numbered extensions to your file names (**Figure 4.42**).

Figure 4.42 *Camera Raw's Save Options dialog box lets you select a format, location, and special file naming options for your processed raw file.*

The Cancel button dismisses the Camera Raw dialog box without saving any files or opening anything in Photoshop.

The Done button neither opens the raw file nor saves a processed file. Instead, it simply saves your settings so that next time you open this raw file, it will already have the settings you've just defined. The idea is that you can work through a bunch of raw files and specify settings for each of them, but put off the *processing* of the files until later. Because processing can take a long time, this affords a simple batch processing mechanism.

All of these approaches provide several options and facilitate a few different raw processing workflows. We'll delve further into the details of saving and batch processing from Camera Raw in Chapter 5. In the meantime, it's probably best just to use the Open button and then save the resulting file from Photoshop.

Saving in Elements and Photoshop CS

If you're using Elements, your saving options are fairly simple: click OK, and Camera Raw will process your image and then open it inside Elements. Remember, at this point, that there's no actual saved file of your processed image—just the original raw file and the opened document that you now have within Elements. To create a saved document, you need to save it from within Elements, using the standard Save dialog box.

Camera Raw in Action

There's no right or wrong way to work with Camera Raw. In fact, you'll probably find that with some images, you don't need to touch certain controls. In most cases, as you work you'll find that adjustments to one control will require a readjustment of another control. The Camera Raw parameters often work in concert, so don't hesitate to move back and forth between them, tweaking and readjusting them as necessary. Following are some examples of exactly how Camera Raw was used to process some specific raw images.

Processing a well-exposed image

After reading all these pages of explanation of all of these features and parameters, you're now going to see an example that uses hardly any of them. The fact is that most cameras these days pack extremely good light meters, white balance sensors, and autoexposure capabilities. In other words, in normal lighting situations—especially daylight settings—you'll almost always get very good results right out of the camera. **Figure 4.43** shows the image as it appears when first opened in Camera Raw.

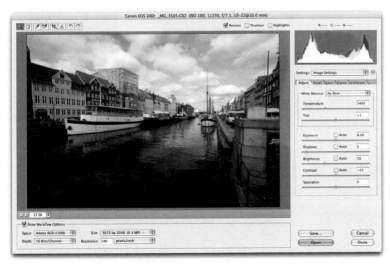

Figure 4.43 This image is very reasonably exposed, as verified by the histogram. It won't require much adjustment in Camera Raw.

First off, notice that the image came through already tagged with the Adobe RGB color space. This is because I had my camera set to shoot in Adobe RGB. I've changed the Depth pop-up menu to 16 Bits/Channel because I want my resulting image to be a 16-bit image. This will afford me a little more editing latitude when I make further edits in Photoshop to prepare the image for printing. I've left Size and Resolution at their defaults, which will give me an image with the original, full-pixel dimensions.

The default white balance is set to As Shot, and the white balance looks fine—it doesn't need any adjustment.

Overall, the image appears just a tiny bit dark. The histogram shows that the shadows are, in fact, clipping. Though the Exposure and Brightness sliders can be used to brighten an image, in this case the clipped shadows provide the best indication of how to proceed. In Camera Raw, the black point is controlled by the Shadows slider, and the defaults for my camera have Shadows set to 5. Since the shadows are clipping, I'm going to assume that this value is too high and slide the Shadows slider back down to 0 (**Figure 4.44**).

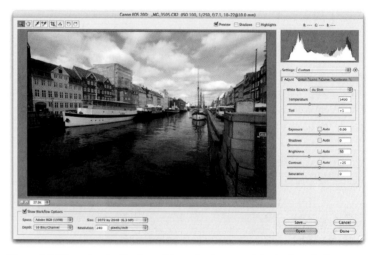

Figure 4.44 *Dropping the Shadows slider to 0 takes care of the shadow clipping problem and brightens the image a little bit.*

As you can see from the histogram, dropping the Shadows value solves the black point clipping problem. The image is still a little dark, though. Because there's no headroom above the white point, moving the Exposure slider will immediately clip the brightest part of the image: the clouds. I want to preserve as much cloud detail as possible, so I'm going to leave the Exposure slider where it is.

The Brightness slider will let me shift the midtones with minimal white point movement and so will allow me to brighten the middle tones in the foreground of the image (**Figure 4.45**).

Figure 4.45 *Sliding the Brightness slider to the right brightens the image without blowing out the highlights.*

This is better, but now the image has lost a tiny bit of contrast, so I'm going to restore the Shadows slider to a value of 2. This will result in a tiny bit of shadow clipping under the darkest parts of the boats, but there's no important detail there anyway (**Figure 4.46**). The Up and Down arrow keys are particularly handy for quickly experimenting with small adjustments to this setting.

Figure 4.46 *A final Shadows adjustment restores the tiny bit of contrast that was lost to the Brightness slider.*

The Shadows slider doesn't allow for the same level of subtlety as the Levels black point control, so I don't want to push it too far here. If the image needs further black point adjustment, I'll do that later using Levels.

This image has no noise, vignetting, or chromatic aberration troubles, and I want to perform my sharpening later in Photoshop, so I'm done. I can open the image in Photoshop and continue my edits there.

Processing a low-contrast image

Figure 4.47 shows an image that is suffering from a contrast deficiency. As you can see from the histogram, there is very little image data in the highlight areas and no information in the shadow areas, so my main goal will be to improve the contrast of the picture without blowing out the highlights.

Figure 4.47 *This image has some contrast problems. Though it lacks shadows and highlights, there's plenty of midtone data to move around and play with.*

As before, I have configured for a 16-bit Adobe RGB image at full size and 240 pixels per inch. Before I begin my tonal corrections, though, I'm going to crop the image. The focus of the picture is the reflection of the building, but there's some extra room at the top of the image that detracts from that focus and doesn't really contribute anything. Camera Raw's Crop tool lets me easily get the composition I want (**Figure 4.48**).

Figure 4.48 *I begin by cropping the image to get the composition I want. By cropping first, I don't have to worry about skewing the histogram with image data that's not going to be in the final image.*

I'm now ready to start making tonal corrections. As in the previous example, the white balance in this image looks just fine.

There are two ways that I could improve the contrast of this image: I could set the Exposure and Shadows sliders by hand, so that the data in my histogram goes all the way to the edges, or I could move the Contrast slider, which adjusts both bright areas and shadows simultaneously. I'm going to use the Contrast slider, simply because it's easy, and I'm going to keep a close eye on the highlights, since they're already very close to clipping (**Figure 4.49**).

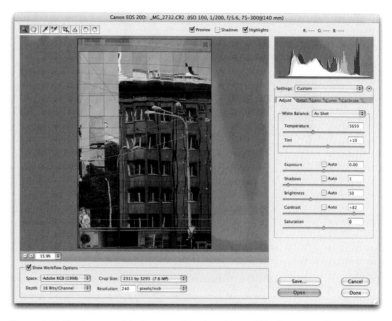

Figure 4.49 *The Contrast slider lets me adjust the white and black points with a single edit. I increased the contrast by sliding the Contrast slider to the right.*

The image already looks much better. However, as you can see from the histogram, I still have some headroom below my black point. I'm going to take advantage of this by using the Shadows slider to move the black end down a little more, to get a deeper color out of the blue sky (**Figure 4.50**).

Finally, because the reflected building is beginning to get a little overbearing, I'm going to use a slight Brightness adjustment to brighten the midtones. Like the previous image, this image doesn't need any noise or lens correction, and I will apply sharpening later (**Figure 4.51**).

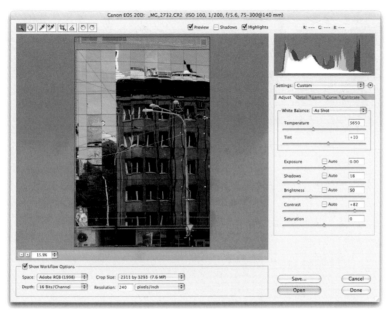

Figure 4.50 *A Shadows adjustment deepens the colors of the sky.*

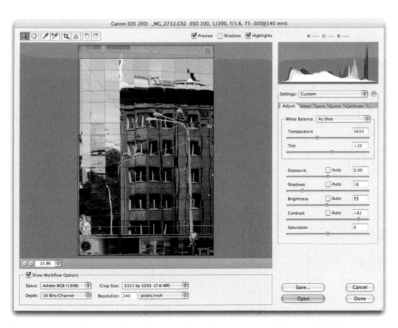

Figure 4.51 *Finally, I use the Brightness slider to bring up the midtones a little bit, to brighten the reflected building.*

Processing an underexposed image

Figure 4.52 shows an image that is plainly underexposed. This picture was shot in an extremely dark room using a Canon EOS 20D at ISO 1600. The lens was already set to its widest aperture, and because the subjects were moving, I couldn't afford a slower shutter speed.

Figure 4.52 *This image has some substantial underexposure problems.*

I knew that this picture would be dark and that my final processed image would be noisy, but there were simply no alternatives. Flash would have been intrusive, and the built-in flash on my camera would not have illuminated the entire room anyway.

The image is too dark to be able to tell anything about white balance, so I'm not going to worry about that until I make some tonal adjustments.

As before, my default Camera Raw settings have a Shadows value of 5. The histogram shows that my shadows are clipping, so my first step is to pull the Shadows value back to 0 to see if that improves anything (**Figure 4.53**).

With Shadows at 0, things are much better. It turns out that my image isn't as underexposed as I thought it was. The shadows are no longer clipping, but take a look at the left edge of the histogram. The large cyan area indicates a curious lack of red and green. It could be that the camera simply didn't capture good color in these very dark regions. Another explanation, though, is that the Adobe RGB color space (which this image was shot in)

is not capable of holding those particular dark colors that the camera was able to capture. If I switch the Space pop-up menu to ProPhoto RGB, the histogram looks a bit healthier because the image is now being mapped into a color space that's large enough to hold all of the colors that the camera actually captured (**Figure 4.54**).

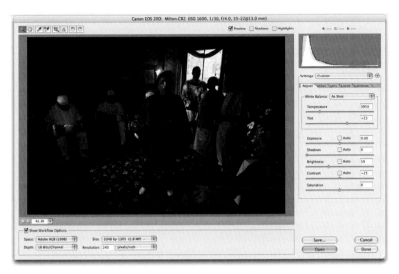

Figure 4.53 *Dialing the Shadows value down to 0 reveals that the image isn't as under-exposed as it initially seemed.*

Figure 4.54 *Switching to the ProPhoto color space places the image data into a color space that's large enough to hold all of the colors. Note how the histogram has changed.*

There's no visible change in the image when I do this, because the affected areas are too dark to see onscreen. But as a side benefit, the little bit of highlight clipping that was occurring before has been reduced, thanks to ProPhoto's larger space.

As you've seen, there's no single "correct" order in which you should use Camera Raw's controls. In this case, I needed to deal with the underexposed shadows before I could make sense of the rest of the image. With the shadows a little more under control, I can move on to trying to brighten the rest of the picture.

While adjusting the Brightness control might seem the most logical way to brighten an image, remember that Brightness is really a midtone, or gamma, control. I'm going to begin by using the Exposure slider to set the white point for the image.

The histogram shows that there's already a little bit of white clipping. However, if you look at the picture, it's pretty easy to tell that it's the bright window and the bright light behind the singer's head that are causing the clipping. These areas are already blown out to white, so there's no detail there to worry about losing. Consequently, I can push the white point farther into clipping without losing any detail that matters.

The brightest whites that contain any detail are the whites of the bata drummers that are sitting along the wall. Those are the areas that I want to be careful about as I adjust the Exposure slider. The Camera Raw clipping display (activated by pressing Alt in Windows or Option on the Mac while dragging the Exposure slider) makes it easy to see when I'm overexposing these areas (**Figure 4.55**).

For the sake of this example, Figure 4.56 shows a slightly aggressive Exposure value. You can see the whites of the hats already blowing out. For my actual Exposure setting, I'm going to back off to around +1.50.

Now it's time to tackle the midtones, which is where the bulk of this image resides. The histogram shows that the majority of my image data is still living in the deep shadows, so I'm going to move those tones up into the middle of the histogram. In theory, the Brightness control is supposed to work like the gamma control in the Levels dialog box; it should let me adjust the midtones without affecting the white point. However, it doesn't quite work like that in Camera Raw. Brightness *can* push the white point, so I'll keep a close eye on the right end of the histogram while I move the Brightness slider to the right.

The Brightness slider doesn't provide a clipping display like the Exposure slider does, but I can select the Highlights check box to get a superimposed clipping display (**Figure 4.56**).

With a Brightness value of 97, I get a lot of lightening in the midtones and not a lot of clipping in the highlights. The clipping display shows a tiny bit of clipping here and there, but nothing so bad that I'm going to worry about it.

Figure 4.55 *Using the Camera Raw clipping display, I can adjust my Exposure setting while keeping an eye on the bright highlights that I know I want to preserve.*

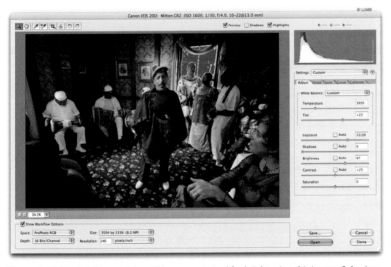

Figure 4.56 *The Brightness slider will be my main tool for brightening this image. Selecting the Highlights check box lets me ensure that I'm not clipping any highlights that matter to me.*

The image is really coming along now. As you can see in the histogram, I have a little bit of room to darken the shadows, but because images tend to go darker when printing (and I know I want to print this image), I'm going to leave this extra bit of headroom below the shadows. When I print, the relevant shadows should darken to a good black. If they don't, it's easy enough to make a further black point change later using a Levels adjustment.

Shooting in low light tends to yield images with a strong yellowish or red cast. This image suffers a bit from that, causing the picture to be overburdened by warm tones. A simple white balance shift lets me cool down the image (**Figure 4.57**).

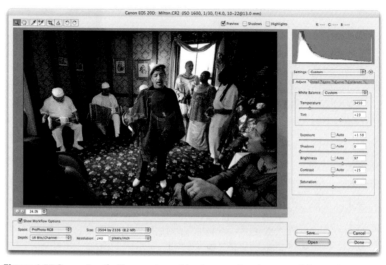

Figure 4.57 *By moving the Temperature slider, I can easily take some of the overly warm tones out of the image.*

I could achieve something similar using a slight desaturation. However, unlike a Temperature adjustment, desaturation wouldn't restore the right color to the rug. It might also result in a tiny bit of data loss. Remember: Color temperature adjustments don't degrade your image.

That's it for the tonal corrections. As mentioned earlier, this image was shot at 1600 ISO, which means it inevitably has some noise troubles. Because I was expecting this image to be noisy (and because I often like my images to have a bit of grain), I'm not too worried about the noise. However, it's still worthwhile to see what Camera Raw's noise reduction controls can do.

My default Color Noise Reduction setting is 25. If I drop it to 0, I can see that a tiny bit of color noise has been eliminated, but there isn't much color noise in this image to begin with. Because there's no reason to apply more correction than is needed, I experimented a little, but in the end found that a value of 25 is a good choice. The singer's shirt was particularly susceptible to color noise, as was the shadowy side of his face. Those are the two areas that I

Figure 4.58 *These crops show the slight improvement that's made with a Color Noise Reduction setting of 10.*

paid particular attention to while adjusting the Color Noise Reduction slider.

The bulk of this image's noise problems are luminance noise. My default Luminance Smoothing setting is 20; a little experimentation shows that this is a good setting (**Figure 4.58**).

Summary

We've covered a lot of controls and parameters in this chapter, but hopefully you've found most of the concepts similar to those we explored earlier in the book. Overall, Camera Raw's interface is very simple:

◆ The Exposure slider sets the white point of your image.

◆ The Shadows slider sets the black point of your image.

◆ The Brightness slider adjusts the midpoint without moving the white or black point (usually—it *is* possible for the Brightness slider to push the white point).

◆ The Contrast slider expands contrast by brightening the bright parts of your image while simultaneously darkening the darker parts of your image.

◆ The Temperature and Tint sliders let you adjust the white balance of your image, giving you dramatic color changes with no loss of image data.

These are the core editing controls in Camera Raw. In addition, the Luminance Smoothing and Color Noise Reduction sliders let you tackle noise, and Sharpness applies sharpening to your image. With Camera Raw's other controls, you can remove vignetting and chromatic aberration.

As you've seen, there's no set, "correct" order for using these tools. You should work with them interactively, using the histogram to guide you through your edits. You've also seen how working in 16-bit mode, with a larger color space, can afford you more editing latitude.

Bear in mind that the types of edits that you make with the Shadows, Brightness, Contrast, and Saturation sliders can also be performed in Photoshop using its normal tools. The same is true for the Exposure slider, but it has some additional functionality that we'll explore in Chapter 6.

Take some time to practice processing your own raw images. You want to not only understand Camera Raw's controls but also get a feeling for how much the images from your particular camera can be adjusted. You want to learn how far you can adjust color and contrast before you start to see posterization, and how much you can brighten an image before you overexaggerate the shadow noise. As you develop a sense of these boundaries, you will have an easier time recognizing and visualizing images when shooting.

We'll explore more editing features in Chapter 6. Before we move into advanced editing topics, though, we're going to explore the workflow and batch processing options provided by Camera Raw and Adobe's browsers.

5

Workflow

So far, we've focused on how to use Adobe's Camera Raw tools to perform the same types of edits that you would usually perform using Photoshop's normal editing controls. In the next chapter, you'll see more of Camera Raw's editing power, including a few types of edits that *can't* be performed using Photoshop's normal editing tools. But before we continue with editing, we're going to delve a little deeper into raw workflow and explore some of the features of the Adobe File Browser and Bridge.

"Workflow" may sound like something that you need to worry about only if you're a professional photographer working with a print or web designer, but even hobbyist photographers develop very refined workflows for managing images and making prints. When you shoot raw, workflow becomes especially important because of the extra processing steps required to turn a raw file into a usable image. And depending on your shooting habits, establishing a good workflow may be the only way that you ever complete any images.

We've already covered a number of concepts and techniques that will help you to produce better work. But if you really want to be a better photographer, there's one very simple thing that you can do: *take more pictures*.

Trees in Yosemite Valley.
Canon EOS 20D with
a Canon 10-22 EF-S
lens; 69 seconds at f/3.5.

When working with beginning photographers, I'm sometimes surprised to find that they believe that a *real* photographer sees a scene, figures out how it needs to be shot, takes a picture, and then goes home with a great, career-making image. Except on extremely rare occasions, this is not how it works.

Professional photographers shoot *lots* of pictures. They shoot lots of pictures because it isn't always possible to know the exact exposure, and so they must bracket. They shoot lots of pictures because sometimes—especially when photographing people or shooting under changing light conditions—identifying the perfect moment is not possible, and so they shoot huge bursts of images. They shoot lots of pictures because it's often hard to recognize the best composition while shooting—sometimes the best composition becomes obvious only later, when reviewing the images. They shoot lots of pictures because sometimes getting a good image is just a matter of luck, and the picture they take away from the scene may not be what they were originally intending. Finally, they shoot lots of pictures because, as with so many things, being a good photographer requires practice. Learning to see and visualize requires practice, and you can practice only by shooting lots of pictures (Figure 5.1).

Figure 5.1 *One of the best paths to better photos is shooting lots of pictures. For the picture of the abandoned barn, I shot many different angles and exposures until I found one I liked. Shooting drummer Jack DeJohnette involved taking many pictures to capture the combination of correct angle and compelling fleeting moment. While on a ferry, I thought I'd shoot some telephoto pictures of seagulls; through dumb luck, one burst of images yielded an interesting composition and crop.*

Obviously, if you're shooting snapshots or simply trying to document an event or location, then getting usable images is fairly straightforward, and you'll probably have a shooting ratio that's close to 1:1. That is, most of the images you shoot will be useable for your intended purpose. But if you're ultimately striving for something more akin to artistry, then the hard truth is that if you shoot 50 exposures and come away with one good image, you're doing pretty well.

If you follow this advice and shoot heavily—and especially if you follow this advice while shooting raw—you will quickly see why workflow issues are very important. Lots of shots means lots of files, which can leave you rapidly drowning in a morass of images with meaningless names like DSC004952. Image glut is difficult enough when shooting JPEG, but when shooting raw, things are more complicated because each image requires processing time. Ideally, in the interest of efficiency, you want to invest time in processing only the frames that you like.

Fortunately, as raw shooting has gained in popularity, raw processing tools have become more sophisticated. It's now much simpler to make your initial selections, and tools like Camera Raw provide batch processing options that let you quickly apply a single set of parameters to a whole folder full of images.

Even if you never end up being a high-volume shooter, understanding the raw workflow concepts presented here will make for easier editing and printing and will help you stay organized when backing up and archiving your images.

XMP: The Key to Camera Raw Editing

In addition to the fancy cameras, lenses, and lights, one of the most important tools that a professional film photographer owns is a grease pencil. When reviewing images, a photographer can easily use a grease pencil to make notations directly on proof sheets or slides. In addition to circling selections, the photographer can make notes about how to print or adjust the image. Later, the photographer—or whoever prints the picture—can refer to these notes to print the image accordingly.

In a way, Camera Raw is like an extremely sophisticated grease pencil. When you adjust the sliders in Camera Raw, as you saw in the examples provided in Chapter 4, you don't actually change any image data inside your raw file. Instead, when you move Camera Raw's sliders, you define a set of parameters that gets stored for later use. When you're finally ready to perform the conversion to create a finished image, Camera Raw reads these specifications and processes your image accordingly. (While you're editing in Camera Raw, your raw file is processed according to your settings to create the preview that you see in the main Camera Raw window.)

Recall that the Camera Raw dialog box presents four options: Save, Open, Cancel, and Done (**Figure 5.2**).

Figure 5.2 *When running Photoshop CS2, Camera Raw presents four options for handling your raw images once you're done configuring your conversion parameters.*

When you click Save, Camera Raw takes your list of parameters and uses them to process your raw file and save it in the format you specify (Photoshop, JPEG, TIFF, and so on). When you click Open, Camera Raw takes those parameters, processes the raw file, and opens the result in Photoshop. If you click Done, Camera Raw does no processing of your raw file; instead, it *stores* the parameters that you've defined, so that you can process your image later.

This ability to set parameters and perform raw processing *later* means that you can go through a batch of images and set their parameters and then tell Camera Raw to do the actual processing and saving on its own, all at once. In fact, you can even tell Camera Raw to process images in the background, while you do other things.

What's more, you can easily copy raw parameters from one image to another. This allows you to quickly apply raw settings to entire batches of similar images.

XMP: The metadata that binds

Any time you make an adjustment to an image, all of the information that you define in the Camera Raw dialog box—cropping, rotation, straightening, white balance and exposure adjustment, and everything else—gets saved. Even if you choose to open or save an image, Camera Raw saves your conversion parameters so that you can go back later and adjust them further. (At any time while you're in Camera Raw, you can hold down Alt in Windows or Option on the Mac to change the Cancel button into a Reset button, which will return all of your settings to their original defaults.)

Camera Raw never tries to write any data into your original raw file. No matter what edits you elect to make, your original data will remain completely untouched. So where does Camera Raw store all of these parameters? By default, Camera Raw running in Elements and Photoshop CS and CS2 stores all of its image parameters in an internal database. The parameters for every raw file that you edit with Camera Raw get added to this database. Camera Raw grabs these stored parameters from its database any time you open a previously edited image. Even if you move the raw file to a different location on your system, Camera Raw will still grab the right parameters.

However, because the parameters aren't stored with the raw file, they won't travel with that file as you move it around. So if you move the file to another computer and open it in Camera Raw there, you'll be back to your default parameters. If you work on only one computer and don't ever plan to send your images to someone else, then this may not be a problem. However, if you back up adjusted raw files to a CD-ROM and then later restore the image to your computer, you will have lost all of your conversion parameters. Similarly, if you delete the Camera Raw cache (perhaps in the process of upgrading your OS or your copy of Photoshop), then you'll lose your raw file parameters.

To work around this limitation, Camera Raw provides a second option when running under CS and CS2. When it's hosted by these applications, you can tell Camera Raw to store all conversion parameters in a *sidecar file*, sometimes referred to as a *sidecar XMP file*, or just an *XMP file*. A sidecar file is nothing more than a small text file that contains all of your image conversion parameters in XMP format.

Developed by Adobe, XMP is an open standard created for the express purpose of storing image metadata. As you've already seen, your camera stores certain types of metadata with your image. In addition to the date and time the image was shot, all relevant exposure data—shutter speed, aperture, ISO rating, and so on—is stored in the file. This exposure data conforms to the EXIF (Exchangeable Interchange Format) standard.

Your image editor, meanwhile, may allow you to store additional types of metadata in your image. IPTC metadata is a standard for specifying ownership, copyright information, searchable keywords, and many other important tags. The XMP standard supports and includes all of these formats and even lets you add your own data (the *X* stands for eXtensible).

All of this information is readable by Photoshop, and editable using either the CS File Browser or Adobe Bridge. When you tell Camera Raw to store parameters in a sidecar file, Camera Raw creates a separate text file in the same directory as your raw file. It's given the same name as the raw file, but appended with the .xmp extension (**Figure 5.3**). Any time you move the file to another computer, you can simply send the XMP file along with it. As long as the files are in the same directory, you need open only the raw file, and Camera Raw will automatically read the associated XMP data and set the raw file's parameters accordingly.

horse in field2.CR2 horse in field2.xmp

Figure 5.3 *If you configure Camera Raw to store its XMP metadata as sidecar files, then Camera Raw will create a separate XMP file for every raw file that you process.*

To tell Camera Raw to store data in XMP files rather than in its own internal database, you simply change a preference in Camera Raw itself. When running in Photoshop CS2, you access the Preferences dialog box from the pop-up menu next to the Settings pop-up menu in Camera Raw. In the Preferences dialog box, from the Save Image Settings In pop-up menu, choose Sidecar ".XMP" Files.

When running under Photoshop CS, you must first put Camera Raw in Advanced mode by selecting the Advanced radio button. The pop-up menu will then give you access to the Preferences dialog box. From the Save Image Settings In pop-up menu, choose Sidecar ".XMP" Files.

As you'll see, keeping a list of processing parameters separate from the image data itself (whether in the internal database or a separate file) allows a much more streamlined workflow.

File Browser and XMP

The Adobe File Browser also makes substantial use of the XMP metadata that's stored with your raw files.

When you adjust the parameters of an image in Camera Raw, the Adobe browsers read this information to construct a new thumbnail and preview reflecting your edits. Because of this, if you view your images in either browser, you will see an accurate representation of the raw conversion that you've configured using Camera Raw.

But Bridge and the File Browser also let you configure a few parameters of their own. For example, the Rotate tools provided in both browsers (**Figure 5.4**) don't actually rotate any image data. Instead, they simply store a parameter that says that, when processed, the image is to be rotated in a particular way.

Figure 5.4 *The Rotate tools in Bridge. The File Browser in Elements and Photoshop CS also provides Rotate tools.*

As with Camera Raw, if you've elected to store your image data in a sidecar XMP file, then rotating an image in either Bridge or the File Browser will create an XMP file (if one doesn't already exist).

As you'll see later in this chapter, Bridge and the File Browser also let you change and edit the IPTC metadata that is stored with your image.

So what should you choose?

Though it means having to hassle with a lot of extra little files, you should use sidecar XMP files rather than the internal cache. Though you may not ever move an image to another computer or send it to anyone else, you will want to back up and archive your images. As you'll see, in the process of moving your images through your workflow, you'll assign a lot of handy organizational and cataloging information, and as your image collection grows, this information will become even more useful. Ensuring its preservation will make any future work with your images much simpler.

Working with Individual Images

If you're working with an individual image, then your workflow is pretty simple: open the image in Camera Raw, process it, save it, and output it (this is assuming, of course, that you've already transferred the image to your computer).

There are several ways to open a raw file in Camera Raw, and any of them is a perfectly reasonable way to start editing. Since there is no stand-alone Camera Raw program, Camera Raw must be run inside a host application: either Photoshop or Bridge. The host takes care of launching Camera Raw and opening the raw image, so to open a raw file, you can use any of the techniques that you would normally use to open any type of Photoshop file.

Opening a raw file in Camera Raw in Windows

No matter what version of Photoshop you're using, you can open raw files just as you would open any other type of file that Photoshop supports. So you can select File > Open from within Photoshop (or press Ctrl-O) and then navigate to the raw file of your choice. If you have a shortcut to Photoshop on your desktop, you can drag and drop raw files directly on top of it to open them, or if Photoshop is already running, you can drag and drop files directly into the Photoshop window.

Probably the easiest way, though, is to double-click the file. Windows doesn't necessarily default to opening raw files in Photoshop, but you can tell it to by right-clicking a raw file and then choosing Open With > Choose Program. The Open With dialog box lets you select the program that you want to use to open the raw file. If you check the Always Use the Selected Program to Open This Kind of File option, then your selected program will become the default raw file reader.

Opening a raw file in Camera Raw on a Mac

Just as with any other type of supported image format, you can open a raw file in Photoshop on the Mac by choosing File > Open or by pressing Command-O. This brings up a standard Open dialog box, which you can use to navigate to the file you want to open.

You can also open a raw file by dragging it onto the Photoshop icon on the OS X dock or by dragging it onto the Photoshop application icon in your Applications > Adobe Photoshop folder.

Perhaps the easiest way to open a single raw file, though, is to configure your open preferences so that you can double-click the file to open it in Photoshop. By default, raw files probably appear on your Mac as Preview documents, so that when you double-click a raw file, your Mac automatically launches the stock Preview application. If your type of raw file is supported, then Preview will process your image using default settings and open the results in a window. You have no control over the image processing, but you can save the processed image in another format if you want to edit it.

You can change your Finder preferences so that double-clicking a raw file causes it to open in Photoshop (which will automatically open it in Camera Raw). Click a raw file and choose File > Get Info. In the Open With section of the Get Info window, open the pop-up menu and change the setting from Preview to whichever version of Photoshop you have installed. Then click the Change All button beneath the Open With menu to define this as your Mac's default behavior. Now any time you double-click a raw file, it will open in Camera Raw running under Photoshop.

Opening multiple files using Camera Raw 3

If you're using Camera Raw 3 (which runs only under Photoshop CS2), then any of the techniques that you would normally use to open, say, multiple JPEG or Photoshop files you can use to open multiple raw files. Just as with a single file, Photoshop will automatically launch Camera Raw. With multiple files, though, a scrolling thumbnails view appears down the left side of the Camera Raw window (**Figure 5.5**).

Click any one of the displayed files to edit its parameters, just as if you'd opened the file separately.

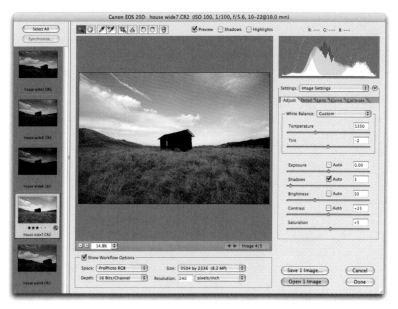

Figure 5.5 *When running Camera Raw under Photoshop CS2 or Bridge, you can open multiple raw files at once. The scrolling thumbnails view lets you switch between images with a single click.*

If you're working on a batch of images that were shot at the same time, then the odds are pretty good that the Camera Raw settings for one image will work well for the others. In the Camera Raw dialog box, click the Select All button above the thumbnails to select all of the images that you've opened; then click the Synchronize button to bring up the Synchronize dialog box. When image settings are synchronized, changing the setting for one image makes the same change in all of the others. You can choose to synchronize all of the settings, or just base settings such as Color Temperature, Tint, and Shadows. You can then quickly go through and tweak the Exposure and Brightness settings for each image by hand.

With your image parameters set, click the Open x Images button to process all of the images and open the resulting files in Photoshop, or the Save x Images button to process all of the images and save the resulting files in the format of your choice.

However, while these techniques work great for individual images and small batches, they're not much help if you've just returned from a shoot with a card full of dozens or hundreds of images. For these situations, you need a more advanced workflow.

Defining a Raw Workflow

If you're used to shooting JPEG, then your shooting workflow probably goes something like this: shoot pictures, transfer pictures to computer, drop pictures into some kind of cataloging or "light table" application, select pictures you like, make copies of those files, edit and adjust those pictures, print or turn the pictures into a web- or computer-based slideshow.

In some ways, the workflow for raw files is more akin to film workflow than to JPEG workflow because your raw file serves as the equivalent of a digital negative. Just as a film photographer must print a negative or slide to have a usable image, a raw digital photographer must process the raw data to have a usable image file. Through all of this, the original raw file remains untouched.

A typical raw workflow

When working with raw files, your basic workflow will proceed as shown in **Figure 5.6**.

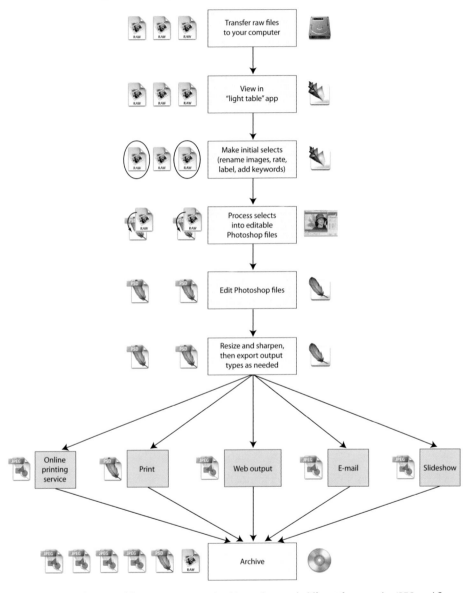

Figure 5.6 *Though raw workflow can seem complex, it's not that much different from regular JPEG workflow. These are the typical steps that you'll take when working with raw files.*

Before you can perform any editing, you must transfer your raw files from your camera to your computer, using either a cable or media card reader. Because these are raw files, you can't just look at them in a normal image viewing application—you need to use a program that knows how to read your particular raw thumbnails. A light table or image cataloger application like iView MediaPro will let you view thumbnails of your raw files. Similarly, your raw converter may provide viewing capabilities. Camera Raw lets you view thumbnails using the Adobe File Browser Organizer or Bridge, depending on which version of Photoshop you're using.

From these thumbnails, you'll choose your initial selects. Then you'll pass these selected images to your raw converter, which will process them into editable files (usually Photoshop format or TIFF files). You'll open these images and edit and correct them to taste and then output them. Outputting often results in still more files.

If you've had even a little experience with printing, then you know that the image on your screen often looks very different when printed. Thus, after making an initial print, you may need to go back and make further color adjustments to get good-looking output. It's often a good idea to make these printer-specific adjustments on a copy of your adjusted file. If you print on different types of paper, you may need to make separate adjustments for each paper type, resulting in even more copies of your files.

After printing, you may want to post a copy of the image on your web site or e-mail it to a friend. You'll need to resize your image for either of these tasks and save it as a JPEG file to facilitate faster file transfer. These will yield still more copies of your image.

Finally, with all of your output chores complete, you'll want to archive the whole set of files for safekeeping. If you keep all of the versions that you've made, then you can come back later and make additional prints or mail or post more electronic copies.

If all you want to do is take some pictures out of your camera and post them on your photoblog, then the process just described may seem like a lot of tedious hassle. Don't worry; as you'll see, Camera Raw provides some automation facilities that make speedy processing very simple.

A simplified, speedier raw workflow

If you're simply trying to cover a birthday party or other special event, then your main concern will probably be getting images distributed to other people as quickly as possible. These types of pictures are not usually ones that you meticulously edit and finesse to achieve perfect color or tone.

In these situations, shooting in raw may seem like a tremendous hassle. However, there are some things you can do to accommodate a "mass-production" workflow.

Shoot JPEG

Obviously, if raw is too much work for a particular photographic task, then you can always switch back to JPEG and return to your normal JPEG workflow. As already mentioned, when shooting most birthday parties or special events, you're just documenting. Very rarely do you end up with any "serious" shots that you want to edit and adjust. The problem is that you never know for sure when one of those serious shots may come along. While shooting that party, you may capture a particularly special moment that needs to be printed out large and glossy—but the image may have a really bad white balance because of the mixed lighting that you were shooting under. With a JPEG file, you have fewer options, but with a raw file, you can easily turn that lucky-to-have-gotten-it shot into a great image. So before you give up on raw for these types of occasions, take a look at the simplified workflow presented in the following sections.

Shoot raw and JPEG

Many cameras let you save both raw and JPEG files simultaneously. This approach gives you the simplicity of JPEG workflow, but with raw files to fall back on if you need to do any serious editing. The downside is that it uses a lot more storage space and slows down your camera's ability to shoot bursts of images at a speedy frame rate. If you have a lot of storage space and don't usually shoot bursts, then this might be the ideal way for you to shoot raw.

Shoot raw with a simpler workflow

For those times when you need to get images out of your camera and output as quickly as possible—to the web, print, e-mail, or a slideshow—then consider using the simplified raw workflow shown in **Figure 5.7**.

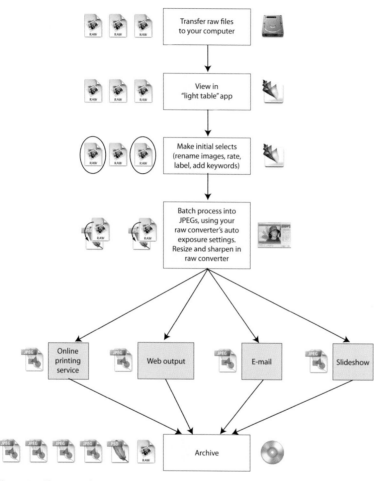

Figure 5.7 *If you simply want to quickly output a batch of raw files for the web or printing, then you can use this simplified workflow.*

For the most part, this workflow is the same as the one shown earlier. As before, you begin by transferring your images to the computer and choosing your selects. If you're gutsy, you can skip the selection stage and process every image that you shot, but you never know when you may have an embarrassing picture of people with their eyes closed, so it's better to do some paring to avoid getting yelled at later.

The main difference between the workflow shown in Figure 5.7 and the workflow presented in Figure 5.6 is that you're letting the raw converter make all of the image processing decisions for you. In addition, you're letting it handle some of the steps that you performed by hand earlier, such as resizing and sharpening. Finally, you're skipping the intermediate Photoshop file stage and going directly from raw to JPEG. This saves you some time in terms of file management, in addition to saving space and simplifying your archiving and backup tasks.

Raw Workflow with Camera Raw

With our workflow defined—transfer images to your computer, choose your selects, process selected images into finished files, edit those files in Photoshop, output, archive—we'll now take a look at how to implement it using Camera Raw and the Adobe File Browser or Bridge. Although we discussed some of these topics in Chapter 4, in this section we'll go a little deeper and explore more of the functions and capabilities of Adobe's browsers.

As before, we will be focusing on Adobe Bridge, but most of the features discussed here are also available in the Adobe File Browser provided with Photoshop Elements and with Photoshop CS.

Step 1: Transfer images

There's really no right or wrong way to transfer images to your computer. If you've been shooting JPEG files for a while, then you're probably already comfortable with image transfer.

Though the workflow that we have defined specifies archiving and backing up at the very end, it's never a bad idea to make a quick backup of your raw files immediately after transferring them. Whether you burn them to a CD or DVD or copy them to an additional hard drive, having two copies will give you a little security in the event of some terrible computer problem.

IMPORTING USING ORGANIZER

Elements 4's Organizer presents a slightly different approach to importing and organizing. When you choose to import images from any device (using File > Get Photos), Elements first asks you where you want to put the files (**Figure 5.8**). Once it has copied the files, it generates thumbnails and adds them to the main Organizer catalog. You can also get files from an existing folder full of images. Elements will leave the images where they are and add their thumbnails to the catalog.

Once images have been imported into the Organizer catalog, you no longer need to concern yourself with where they might be on your drive (though you can find out where they are by right-clicking (or, with a one-button mouse, Control-clicking) an image and selecting Show Properties). You can organize, sort, find, and open images for editing from within Organizer.

Since having to navigate and dig through your entire image collection can be a drag, Organizer lets you define collections, which are roughly the digital equivalent of a photo album. Using the Collections pane, you can create new collections and then drag and drop thumbnails onto the collection name to add images. When you add an image to a collection, you don't create another copy of the image; a collection is simply a group of references to files in your library, so you are creating only a reference.

Figure 5.8 *The Elements 4 Organizer can automatically transfer images from your camera or media card. After storing the transferred files in your chosen location, it creates thumbnails and adds them to its master catalog of images.*

DON'T WORK DIRECTLY FROM YOUR CAMERA'S MEDIA CARD

If you use a media card reader to copy images to your hard drive, there's technically no reason that you can't work directly from the card. As far as your computer is concerned, the card reader is just another drive to read. However, it's a *very* slow drive when compared to your hard drive. In addition, some types of storage media aren't designed for the kind of sustained use required by the Adobe browsers. For the sake of both speed and media integrity, it's better to copy your images to your hard drive and work with them from there.

Staying organized

When it comes to naming images, your camera is not particularly inspired. After transferring images, you'll have a bunch of image files on your computer with fairly meaningless names. The easiest way to stay organized as you amass these inscrutably named files is to be diligent about separating images into folders and giving the folders meaningful names.

Creating folder names with a meaningful title and date—Alien abduction 6-05-2005 or something similar—will help you keep track of the subject matter of a particular batch of images, even if the names of the individual files are meaningless strings of numbers.

Step 2: View images and choose selects

As you've already seen, the Adobe browsers make short work of viewing thumbnails of your raw files. When it comes to sorting images and choosing selects, the Adobe browsers also provide a lot of special tools and features that can greatly ease the examination and selection of your images.

This section covers a lot of features, and this may make the process of making selections seem very complicated. It's not. You probably won't use all of these tools all of the time, and there are some that you may never use. Nevertheless, it's good to know all of the options available.

Browser feng-shui

While Elements 3 and Photoshop CS each provide a File Browser inside Photoshop, Photoshop CS2 launches Bridge, a separate application, whenever you choose File > Browse. The browsers provide similar functionality.

As explained in Chapter 4, the Adobe browsers present several panes of information. In addition to a File Browser pane for selecting a particular folder, you will see a pane containing thumbnails of the images in the current folder, a larger preview of the currently selected image, and a list of all of the metadata for that image. As you choose your selects, there will be times when viewing thumbnails is more important than reading metadata, or when seeing a large preview is more important than anything else. To facilitate this, both Bridge and the File Browser let you resize all three panes (**Figure 5.9**).

Resizing panes allows you to retool the browser for different tasks. For example, when you need to quickly find an image, or a series of images, within a folder with hundreds of thumbnails, you can use a large thumbnail view to more easily browse the files (**Figure 5.10**).

Pane resizing controls

Figure 5.9 *You can easily resize any of the Bridge or File Browser panes by dragging the dividing lines that separate them.*

Figure 5.10 *Specifying a large Thumbnails pane makes it easier to sort through a large collection of images.*

In Bridge, you can easily resize the thumbnails themselves, by using the slider at the bottom of the Thumbnails pane. Bridge also provides several thumbnails views, which you can easily select using the buttons next to the thumbnail size slider (**Figure 5.11**).

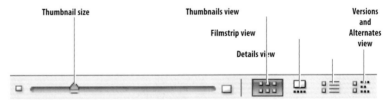

Figure 5.11 *Bridge provides simple controls for changing the size of thumbnails, as well as for changing the nature of the thumbnails view.*

Thumbnails view is the basic default view. Filmstrip view provides a scrolling display of thumbnails and a very large preview (**Figure 5.12**), while Details view provides a good-sized preview and a smattering of fundamental metadata (**Figure 5.13**).

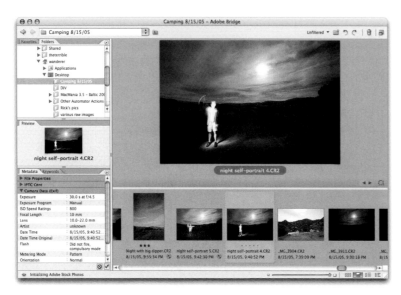

Figure 5.12 *The Filmstrip view in Bridge provides a large preview of the currently selected image, along with a scrolling list of thumbnails of the other images in the current folder.*

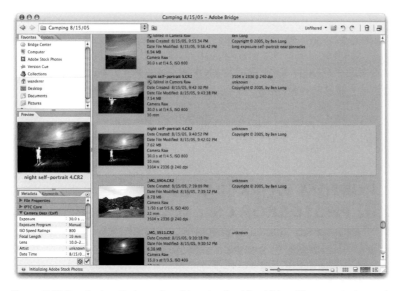

Figure 5.13 *Details view displays a list of thumbnails with additional focus on the images' metadata.*

The last option, Versions and Alternates view, is similar to Details view, but is designed to work with Adobe Version Cue, a workgroup management system that lets you track and view alternate versions of images throughout a complex print or web workflow. We won't be exploring it here.

These various views provide a speedy alternative to resizing panes when you want to see more of a particular type of information. Nevertheless, there will be times when you'll want to resize the panes. If you're using the Elements or CS File Browser, then resizing panes is your only way to see more of a particular type of information.

In Bridge, you can quickly switch between several default window arrangements by using the Window > Workspace menu (**Figure 5.14**). These predefined configurations give you window arrangements that stress thumbnails, metadata, or a large preview.

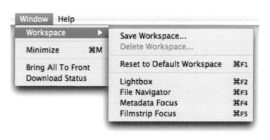

Figure 5.14 *Bridge provides several default Workspace configurations that you can easily switch between using the Workspace menu.*

TIP

Unlike the Elements 3/CS File Browser, Bridge lets you open as many browser windows as you like. This can provide a handy way to compare folders or to view different sets of images. To open a new browser, choose File > New Window or press Command-N.

In Bridge, if none of these workspace arrangements are to your taste, you can save your own custom workspaces by arranging the panes the way you want them and then choosing Window > Workspace > Save Workspace. You can create as many workspaces as you like and then switch between them by picking them from the Window > Workspace menu.

CUSTOM WORKSPACES IN PHOTOSHOP CS

Although the Photoshop CS and Elements browsers lack the predefined workspace configurations provided by Bridge, the CS File Browser does let you define your own custom workspaces. Just arrange the panes the way that you like them and then choose Window > Workspace > Save Workspace from Photoshop's main menu bar, *not* from the menu bar at the top of the File Browser window.

Renaming images

Even if you transfer your images to specific folders with meaningful names, you still may want to rename individual images with meaningful titles. Renaming images as you choose selects will simplify the process of working with the files later.

You can easily rename an individual file in either Bridge or the Elements 3 or CS File Browser by selecting the name beneath the thumbnail and entering something new. The browser will automatically rename the original file.

If you shot using particular exposure settings, you may want to include these parameters in the new name. This can be particularly handy if you want to keep track of which images in a bracketed set were over- or underexposed.

Both Bridge and the Elements 3 or CS File Browser include an excellent Batch Rename feature, which lets you automatically rename all of the currently selected images. To use it, select a range of images (pressing Ctrl-A in Windows or Command-A on the Mac will select all of the images in the current folder) and then choose Tools > Batch Rename if you're in Bridge, or Automate > Batch Rename if you're in the Elements 3 or CS browser.

The Batch Rename dialog box lets you specify a base name, and it can automatically append any number of different things to this base to create a very descriptive file name (**Figure 5.15**).

TIP

Selecting multiple images in either Bridge or the File Browser is very simple. To select a contiguous range of images, click once on the first image to select it; then hold down the Shift key and click the last image in the selection. The browser will automatically select all of the images in between. To make a noncontiguous selection, click once on the first image to be selected and then Ctrl-click (Windows) or Command-click (Mac) additional images to add them to the current selection. These two techniques can be combined to create complex contiguous/noncontiguous selections.

Add or remove file name components

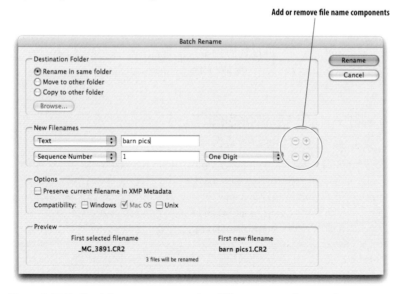

Figure 5.15 *Use Batch Rename to rename selected files, automatically appending sequential numbers, dates, and other suffixes.*

In Bridge, you can select Move to Other Folder to move the file before renaming it. This allows you to further refine the organization of your files by moving files into more specific folders. If you select Copy to Other Folder, then Bridge will copy the files to a new location before renaming them, affording you a simple way to back up your files while giving them more meaningful names.

If you want to select all of the images *except* one or two files, you can either do it the hard way, by clicking all of the images that you want to select, or you can choose Edit > Select All and then Ctrl-click (Windows) or Command-click (Mac) the images that you don't want.

To rename an image in Organizer, you must have the Properties palette open (press Alt-Enter (Windows) or Option-Enter (Mac) or choose Windows > Properties). On the Properties palette, select the General options and then edit the Name field to change the name of the file.

Deleting images

Some photographers are maniacal about saving every image they expose, and there's merit to this idea. When you first return from a shoot, it's easy to be disappointed by your images because they don't match what you thought you had taken or the fresh memory that you have of the scene. Very often, though, when you look at them again a week later, you realize that they're better pictures than you had initially thought. Consequently, if you trash an image upon your initial review, you may be throwing away perfectly good work.

Nevertheless, there will be some pictures that are, objectively, just plain lousy. Whether they're out of focus or horribly exposed or your finger's in the way, some pictures are not going to improve with age. You can easily delete these from your drive using any of the Adobe browsers by selecting the image and pressing the Delete key. The program will display a confirmation window, which you can easily disable by selecting Don't Show Again.

In Organizer, you can delete images by selecting them and then pressing the Delete key (or by choosing Edit > Delete from Catalog). The resulting dialog box asks you to confirm that you want to remove the images from the catalog, which leaves the original files on your drive. A separate check box allows you to remove images from the catalog and delete the original image files.

Rotating images

Both Bridge and the Elements 3 or CS File Browser allow you to rotate images. Many cameras include autorotation sensors that figure out when you're shooting vertically or horizontally. This information is stored in the camera's EXIF metadata, and when it is read by either browser, the thumbnail is automatically rotated.

If your camera doesn't provide this feature, or if for some reason the Adobe browsers can't read it, then you may need to rotate your image manually. Simply select a single image, or a selection of images, and click either of the Rotate tools in the browser toolbar (see Figure 5.4). You can also press Ctrl-] (Windows) or Command-] (Mac) for clockwise rotation and Ctrl-[(Windows) or Command-[(Mac) for counterclockwise rotation.

Your image data is not actually affected, of course. Instead, the browser updates your file's metadata to indicate that the image should be rotated when it's processed. If the image is a raw file, it will be rotated by Camera Raw at the time of conversion. If it's a different format, then it will be rotated by Photoshop when you open it.

It's much easier to access the browser's Rotate tools than it is to use Photoshop's Rotate Canvas command, so rotating your image during your initial selection phase can be a great time-saver.

Ranking images

As you browse through the thumbnails of your images, you'll want a way to keep track of which ones are the select files that you want to take through the rest of your workflow. You can take each select image through the entire workflow as you choose it, but choosing all of your selects first allows you to take advantage of the batch processing operations provided by the Adobe browsers.

Both Bridge and the File Browser provide mechanisms for rating your images, though Bridge provides more flexibility in this regard. Once you've rated your images, you can tell the browser to display only images that you've selected and then pass those images on to the rest of your workflow.

Figure 5.16 *In Bridge, ratings that you assign to images are displayed as a series of one to five stars displayed directly below the thumbnails.*

Figure 5.17 *Any image in Bridge can also be assigned a label, which appears as a colored fill behind the rating line.*

Figure 5.18 *Bridge's Filter menu allows you to quickly filter out any thumbnails that don't match particular rating or label criteria.*

Rating images in Bridge

Bridge allows you to rate images on a scale from 0 to 5. Each image's rating is shown as a number of stars beneath the image thumbnail (**Figure 5.16**).

To add a rating to an image, select the thumbnail. A series of dots appear. You can click any of these dots to change it to a star. You can also select a rating from the Label menu.

A much faster way of adding a rating is to use keyboard shortcuts. Select one or more images and then press Ctrl (Windows) or Command (Mac) plus 0 through 5 to rate the images. You can also increase the existing rating of a single image or a group of images by pressing Ctrl-, (Windows) or Command-, (Mac), or decrease it by pressing Ctrl-. (Windows) or Command-. (Mac).

Like rotation and Camera Raw parameters, the ratings that you apply are stored either in the internal cache or in sidecar XMP files, depending on how you've set your preferences in Camera Raw. If you're set for sidecar storage and your file doesn't yet have an XMP sidecar file associated with it, Bridge will create one when you assign a rating to the image. Bridge may issue a warning box indicating this. Your workflow will go faster if you disable this box.

In addition to rating images, you may sometimes want to give them simple labels, either to separate the images in one folder into categories or to highlight a particular image for review or analysis later. Bridge provides a simple labeling scheme that lets you assign one of five colors to any image. This color then appears behind the star display on a thumbnail (**Figure 5.17**).

As with ratings, you label an image by selecting it and then picking your desired color from the Label menu, or you can use the keyboard shortcuts listed on the menu.

Once you've rated and labeled your files, you can easily filter your thumbnails view to show only specific images. On the right side of the Bridge toolbar is a Filter pop-up menu (**Figure 5.18**). From this menu, you can select a rating or label, and your thumbnails display will be updated to show only those images that match. You can also choose to view only unlabeled and unrated images. Returning the menu selection to Unfiltered will display all of the files in the current folder.

Once rated or labeled, the ability to filter out only those images with a particular rating allows you to quickly focus on only the images that you want to process through the rest of your workflow.

Ranking images in the CS File Browser

If you're using Photoshop CS, then you'll be using that program's internal File Browser rather than Bridge. In CS, this feature is called *ranking*.

First, you need to enable the ranking display by selecting View > Show Rank from the File Browser menu bar. Rather than showing stars, the File Browser displays a Rank field beneath the thumbnail of each image.

To rank an individual image, double-click the hyphen that's displayed next to the Rank field beneath an image thumbnail. To rank groups of images, select them and then choose Edit > Rank from the File Browser menu bar.

For a ranking, you can enter any number between 1 and 9, and you can also enter letters. This affords a finer degree of ranking granularity than what you get in Bridge. Whether or not you need this many rankings is a matter of personal taste.

The CS File Browser doesn't provide any labeling function.

Rating images in Organizer

Elements 4's Organizer lets you select single or multiple images and apply ratings of one to five stars. First, select the images you want to rate. In the Tags palette, open the Favorites set and then drag your images to the tag that you want them associated with.

You can also apply ratings by right-clicking (or, on a one-button mouse, Control-clicking) any image in your selection and then selecting Attach Tag and the rating that you want. The easiest way, though, is to use the keyboard shortcuts Ctrl-1 through Ctrl-5.

Organizer displays the rating of an image by superimposing a small numbered flag over the image thumbnail.

Flagging images in the Elements 3 or CS File Browser

If all you want to do is flag the files that you want to select for the rest of your workflow, without rating or ranking them, the File Browser in both Elements and CS provides a great tool in the form of the Flag feature. Select an image or group of images that you want to flag and then click the Flag button on the File Browser's toolbar or press Ctrl-' (Windows) or Command-' (Mac). A small flag appears below the thumbnail (**Figure 5.19**).

In the upper-right corner of the thumbnail display is a pop-up menu that lets you switch from viewing all the images in the current folder (flagged and unflagged) to viewing only the flagged Files or only the unflagged Files. In this way, you can quickly filter a folder to view and work on just your selected files.

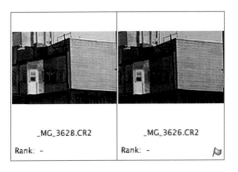

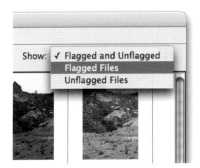

Figure 5.19 *In Elements 3 and Photoshop CS, you can mark images using the Flag command. You can then use the Show menu in the upper-right corner of the File Browser to display flagged, unflagged, or all images.*

Take the time to rate your images

No matter which Adobe browser you're using, you have simple, speedy rating tools at hand. Once you've learned the keyboard equivalents for these tools, you can quickly work through a huge folder of images and apply ratings that will make it very simple later for you to separate the good images from the bad.

Rating and labeling are important organizational tools, not just for your immediate workflow needs, but also for your long-term archiving and organization, so it's good to get in the habit of using these features.

A CLOSER LOOK AT THUMBNAILS

Bridge displays a fair amount of information with each thumbnail. By default, the thumbnail image itself is displayed, along with the file name, the rating, and the date and time the image was shot. In addition, any of three icons may appear in a thumbnail, depending on the status of the file (**Figure 5.20**)

Figure 5.20 *Bridge's thumbnails display icons to indicate when a file has had Camera Raw settings adjusted, has been cropped, or is currently open in Photoshop.*

Camera Raw settings applied
Cropped
Currently open in Photoshop

Using Bridge's Preferences dialog box, you can specify up to three lines of metadata to appear with the thumbnail (**Figure 5.21**). In addition to showing exposure and file size, as shown in Figure 5.20, you can include copyright information, a description, keywords, or any number of other metadata fields.

Figure 5.21 *Using the Bridge Preferences dialog box, you can select additional metadata items for display beneath an image's thumbnail.*

We'll explore metadata in more detail later in this chapter.

Sorting images

In addition to—or sometimes instead of—rating and labeling your files, you may want to change the order in which they're displayed in the browser window.

By default, Bridge and the File Browser let you reorganize the thumbnails into any order you want simply by dragging thumbnails from one location to another. When you next view the same directory, your images will appear in your reordered, custom configuration.

You can sort your thumbnails by any number of parameters, including the date they were shot, their labels and rankings, or their pixel dimensions. To automatically sort images in Bridge, you use the View > Sort menu (**Figure 5.22**). To automatically sort images in the Elements 3 or CS File Browser, you use the Sort menu located on the browser toolbar.

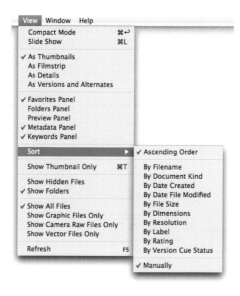

Figure 5.22 *The Bridge Sort menu lets you quickly sort the current folder by a number of different criteria.*

If you're using Elements 4's Organizer, then you must place images in a collection before you can rearrange them into a specific order. Remember that the main thumbnails view is a view of your entire image collection, and its order defaults to chronological. You need to create subsets of images using the Collections feature before you can rearrange and organize your images using other criteria.

You can sort the main thumbnails view by using the pop-up menu in the lower-left corner of the window. In addition to ascending and descending date, you can view the last batch of images that was imported.

HOW I RANK IMAGES:
ONE APPROACH TO CHOOSING SELECTS

If I've been out shooting all day, I'm usually eager to get started pro-cessing particular frames. There are almost always one or two images that I'm particularly excited to see. But because I tend to heavily bracket, I need to quickly get my images organized. In the past, I've sometimes said, "I'll get organized later, but first I want to take a quick look at this particular shot." The problem is, it's never a "quick look," because once I have the image open, I want to fiddle with it. Soon I'm making test prints and sav-ing multiple versions, and then I have an even more complex batch of images to work with. What's more, there's no guarantee that it was the best shot to work with.

Though it can be hard sometimes, I now force myself to take at least one selection pass through the day's photos before I start editing any of them.

Because I work in Bridge, I tend to review my images in Filmstrip mode, simply because it provides a large preview. If you're working with the Elements or CS File Browser, though, you can easily resize your panes to see a large preview.

Once I'm in the right mode, I simply step through the images one at a time, using the left and right Arrow keys to advance forward and backward. When I see an image that I like, I press Ctrl-3 (Windows) or Command-3 (Mac) to assign it a ranking of three stars. Since I have a hard enough time deciding which images are keepers, trying to come up with five varying degrees of appreciation is pretty much impossible. So I simply tag the images I like with three stars.

Since this is basically a binary selection process, you can achieve the same thing in the Elements or CS File browser by using the Flag feature. The reason I choose three stars is that if there ever comes a time when I do develop the ability to think in shades of rankings, I can easily increase or decrease the rankings using the Increase and Decrease commands.

I usually take two passes through the images just to be sure that I didn't select something bad or miss something good, and then I use the Filter menu to select only three-star images. Now I can focus the rest of my workflow on just the images I like.

At this point, I will sometimes change the order of the thumbnails by dragging them, but rarely do I need a particular order.

With my selects chosen, I usually use a combination of Bridge's renam-ing features to give my selected images more meaningful file names. If the whole batch of images is of a single subject, then I use the Batch Rename command on the whole set. If there are several different subjects or differ-ent groups of bracketed images, then I use the Batch Rename command on smaller groups of images. Finally, there are almost always stand-alone, individual images that need to be renamed by hand.

Finding images

If you have a large group of images, the ability to search for images can help you quickly filter out images with particular characteristics.

For example, maybe you've already renamed many of the images and now you know that you want to rank all of the files named "Bigfoot sighting." You can automatically search the current folder for any image specifically named "Bigfoot sighting" or for files with names that contain those words.

Finding images using Bridge

The Find feature lets you build complex queries that can search based on any number of criteria, including creation and modification dates, file size, label, ranking, and other forms of metadata that you'll learn about later in this chapter (**Figure 5.23**).

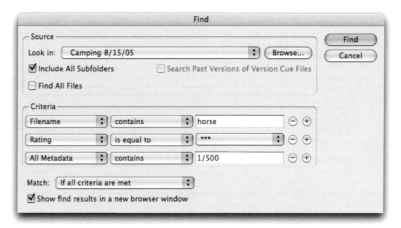

Figure 5.23 *The Bridge Find command lets you build complex search queries. Here, I'm looking for any image with "Horse" in the title and a rating of three stars. I know that some of the images I selected were a little soft because I first shot with a shutter speed that was too slow, so I'm refining my search to find only images shot at 1/500 of a second.*

When the results of a search are displayed, the browser window presents a Save as Collection button at the upper right. This allows you to save the search criteria—not the particular found set of images. The advantage to this is that if you regularly perform certain searches, you can save the criteria as a collection and then reexecute the search with a single click.

Collections are stored as simple text files in a folder on your drive. The Bridge Favorites pane provides a shortcut to the Collections folder. Click it, and you'll be presented with a window full of all of your saved collections (**Figure 5.24**). Click any of these, and the search parameters stored in

that collection will be executed. By default, the search will be executed on the same folder that you were viewing when you originally performed the search and saved the collection. Because collections are nothing more than text files, you can also drag them from the Bridge window to your desktop. You can then double-click them to execute them.

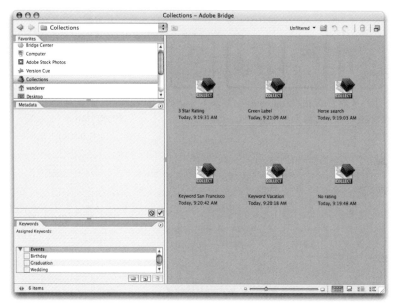

Figure 5.24 *The Collections pane lets you see all of the collections that you've created using the Find command. Collections provide you with one-button access to common searches.*

If you want to build a collection search that can be applied to any folder, you must select the Start Search from Current Folder check box when you save the collection (**Figure 5.25**). After saving, click Collections in the Favorites pane to view your saved collections. Drag the collection you just created to the Favorites pane. Now you can navigate to any folder on your system and then click the Collection entry in your Favorites pane to perform that search on your selected folder.

Figure 5.25 *If you want to search in any directory, not just the one you searched at the time you saved the collection, then you need to select the Start Search from Current Folder check box when you save the collection.*

Needless to say, this is a somewhat cumbersome search mechanism, but if you really need to perform a search, it is perfectly effective.

Finding images using the Elements 3 and CS File Browser

Like the Bridge Find command, the File Browser Search command lets you build complex searches that can find images based on multiple criteria. To access the Search command, click the binoculars icon on the File Browser's toolbar (**Figure 5.26**).

Figure 5.26 *From the Bridge and File Browser toolbars, you can click the Find icon to look for files.*

In addition to specifying where to search, you can add criteria to build a complex search function. You can search by file name or file size, date created, ranking, and more.

Unlike Bridge, the File Browser does not allow you to save search criteria. However, it does store the most recent search results, which you can access by clicking Search Results in the File Browser pane.

Finding images using Organizer

Organizer's Find menu provides a full complement of search options that allow you to search your entire image library or the currently selected collection. In addition to letting you search by file name, caption, and date ranges, Organizer provides a number of other powerful search options. For example, you can search for images that you've e-mailed to a particular person (assuming that you initiated the e-mail process from Organizer). You can also search for images printed or exported on a particular date.

If you've tagged your images with any of the tags in the Tags pane, then you only have to click the check box next to a tag in the Tags pane to filter your entire collection to just those images with that particular tag.

Perhaps one of the most interesting Find features Organizer provides is the ability to automatically identify faces in your images. You can drag and drop specific faces onto items in the Tags pane, to immediately tag those images. If you create specific tags for specific people, you can quickly create an index to particular individuals within your library.

A word about searching EXIF data

Both Bridge and the File Browser allow you to find images based on their EXIF metadata. The idea is that if you want to search a folder for all of the images that were shot at ISO 400, you can simply add a criteria that says EXIF Metadata Contains 400.

Unfortunately, while this search feature does in fact let you search the EXIF metadata, it doesn't let you specify *which part* of the EXIF information to search. So if you shot some of your images with a 200 to 400mm zoom lens, and that information is stored in your metadata, then those images will appear in your search results as well. If you find that your metadata searches yield images that you don't want, this may be why.

Organizer provides a much more sophisticated EXIF search that lets you specify particular EXIF tags to search (**Figure 5.27**).

Figure 5.27 *In Organizer, you can search for data in specific metadata fields. Here, I'm look-ing for all images shot at ISO 100 with a shutter speed greater than 1/30 of a second.*

FINDING AN ORIGINAL FILE

Being able to search within Bridge or the File Browser for images with particular characteristics can be handy, but sometimes you may also want to know where the actual file is on your hard drive.

If you're a Windows user, select a file and then choose File > Reveal in Explorer if you're using Bridge, or View > Reveal Location in Explorer if you're using the Elements or CS File Browser.

If you're a Mac user, select a file and then choose File > Reveal in Finder if you're using Bridge. If you're using the File Browser in Photoshop Elements or CS, then choose View > Reveal Location in Finder from the File Browser's toolbar.

Adding metadata

We've already discussed a few of the types of metadata that get stored with your images. In addition to the EXIF metadata that your camera writes to any type of image that it records (this is the metadata regarding exposure and other information about your shot), the Adobe browsers and Camera Raw store metadata to keep track of the types of edits that you want Camera Raw or Photoshop to make to an image.

The Metadata pane in Bridge and the File Browser is divided into sections that you can open and close to view each type of metadata (**Figure 5.28**).

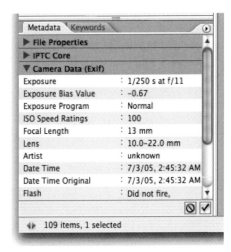

Figure 5.28 *The Metadata pane lets you view the specifics of all of the types of metadata stored in a file. Here, we've chosen to look more closely at the EXIF metadata for our image.*

While the Adobe browsers let you view all of these types of metadata, they don't let you edit EXIF or Camera Raw data, nor do they let you edit the basic file property metadata. The EXIF and file property metadata simply report that the image was shot a particular way and at a particular time and is a particular size. The Camera Raw data is simply a reflection of the edits you make in Camera Raw.

Depending on your camera's capabilities, other types of metadata may be stored here as well. For example, if your camera has a GPS system built in, then there will be GPS fields that contain the GPS coordinates where the image was shot. These fields will also be read-only.

To view metadata in Organizer, make sure the Properties palette is visible (choose Window > Properties or right-click an image and choose Show Properties). Click the Metadata button at the top of the palette and then select the Complete radio button at the bottom of the palette (**Figure 5.29**). This will provide access to all of the same metadata that is shown in Bridge's Metadata pane.

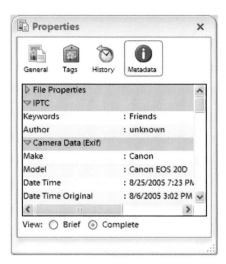

Figure 5.29 *Using Organizer's Properties palette, you can view the IPTC metadata for your image.*

There is one type of metadata that you *can* edit: the IPTC Core. Years ago, the International Press Telecommunications Council established a standard for formatting and including ownership and cataloging information in electronic images. Photoshop has supported this format for years, but before the File Browser, the only way to enter this metadata was through Photoshop's File Info command. Bridge and the File Browser make entering IPTC data much easier.

Any editable IPTC field appears in Bridge or the File Browser with a small pencil icon next to it. You can double-click the field to enter new data or click the pencil to start editing. When you're finished, press Enter or click the check box at the bottom of the Metadata pane (**Figure 5.30**).

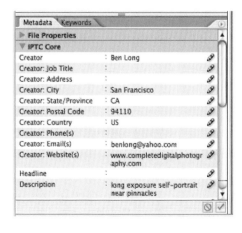

Figure 5.30 *You can edit the IPTC metadata so that it contains all of your relevant contact and copyright information, as well as descriptions and notes about your image. All of these fields and notes can be searched using Bridge or the File Browser's Search facility.*

Obviously, typing this information for every image you've shot can be tedious. Fortunately, you can bulk-edit metadata by selecting a group of images and then editing the metadata fields. Later in this chapter, you'll see another way to expedite your metadata edits.

Even if you don't want to hassle with filling in most of the fields, if you're going to post your images to a web site, it's worthwhile filling in the copyright information. Metadata tags that you insert in Bridge—even ones that you add to a raw file—will stay with any and all iterations of that file. In other words, if you create a bunch of different-sized JPEG files from your processed raw file, each one will include the copyright information that you enter now.

Adding keywords

We have not talked at all about the Keywords tab that sits alongside Metadata. Keywords are just another type of metadata, and as such, they get stored with your image and are copied to all versions of the file.

The point of keywords is to provide you with a means of sorting and searching. The Find facilities provided by all of the Adobe browsers and many third-party image catalogers let you search for specific keywords. So, for example, if you tag all of your vacation pictures with the Vacation keyword, you can easily pull those out of a larger volume of images later.

A default set of keywords are provided, and you can easily add these keywords to an image or set of images by selecting the appropriate files in the browser and then checking the box next to the keywords that you want to apply to those images (**Figure 5.31**).

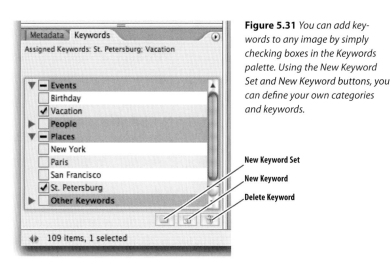

Figure 5.31 *You can add keywords to any image by simply checking boxes in the Keywords palette. Using the New Keyword Set and New Keyword buttons, you can define your own categories and keywords.*

Keywords are divided into sets in the Keywords pane, and you can create new sets and new keywords using the two buttons at the bottom of the pane.

Like flossing, practicing, and stretching, adding keywords to your images may be boring, but it can have big payoffs in the long term. By adding custom keywords, you can, over time, build a very refined search facility for cataloging and finding images. (And no, you won't find my images heavily keyworded, but I'm trying to get in the habit. You also won't find me limber or well practiced, but my teeth are clean, so I have hope for my keywording goals.)

ORGANIZER TAGS

If you're using Organizer, then you can use the Tags pane to add the equivalent of keywords to your images. Note that these tags are not initially written into the metadata information that's stored with the file. Rather, they're kept in Organizer's internal database. If you want to transfer these tags to the regular IPTC metadata fields (so that they can be read by other applications), then you need to select the images and choose File > Write Tag Info to Files.

Step 3: Process your images

After all that finding, sorting, ranking, and labeling; renaming, rotating, deleting, and flagging; and adding of keywords and metadata, you should have a collection of images that you've whittled down to the selects that you think are worth processing and outputting. Whether or not you followed all of those steps and took all of those actions or just quickly marked your select images using the flag or rating system, you're now ready to process your raw files.

In Chapter 4, you saw how Camera Raw's controls work and learned the basics of processing a raw image. It is those skills—along with additional Camera Raw tricks that you'll learn about in the next chapter—that you will employ at this stage of your workflow. Your images are selected; now you need to get them processed from raw files into regular, usable image files.

First the bad news: As you saw in Chapter 4, editing a raw file can take some time, especially if you have a tricky exposure or want to perform some very subtle manipulations and edits. If your selection stage has left you with 20 images of varying color, tone, and contrast that each need

lots of finessing in Camera Raw, then you're simply going to have to devote some time to working on each image.

The good news is that it's pretty rare that you'll end up in that situation. The fact is that under most circumstances, today's cameras do an excellent job of calculating exposure and white balance. What's more, even if you find that an image does need a boost here or a reduction in exposure there, if you shot lots of other images at the same time, you can most likely apply the same Camera Raw settings to those other images as well. This means that you may need to devote time to only a few images. You can then copy those adjustments to the rest of your selects.

With these facts in mind, here's a good way to proceed once you've finished making your selections:

1. Identify the difficult images. There probably won't be too many images that need a lot of fine attention (unless you were shooting in particularly difficult situations, such as low light). Identify those images from your group of selects and work on them first (or last, if you prefer to procrastinate on difficult tasks).

2. Group your images into similar exposures. If you shot a series of images of a single subject at one time, group these together in the browser (**Figure 5.32**). Then open the first image of the group in Camera Raw. Adjust it accordingly and then copy its settings to the other images in the group. We'll discuss how to move settings in the next section.

Figure 5.32 *Because these images were shot at the same time and are fairly similar, they probably need very similar Camera Raw settings, which means that we can get away with batch processing them, rather than tweaking each one individually.*

3. Don't open or save any of the images that you're editing. Whether it's the tough individual images or the batches of images, simply define Camera Raw's parameters and then click Done (or press Alt-Update in Windows or Option-Update on the Mac if you're using the CS File Browser). You'll let Camera Raw batch process your edits later. (More on this in the next section.)

As you work with Camera Raw and your camera, you'll get a better feel for the types of adjustments that need to be made in particular situations. This understanding, combined with Camera Raw's ability to change default settings and copy settings between files, allows you to quickly assign effective settings to entire batches of documents.

Adjusting multiple files in CS2

If you're using Camera Raw 3 in Photoshop CS2, then you have several options for processing multiple files. If you've grouped your images into batches of similar exposures, as suggested, then it's a fairly simple matter to apply the same settings to all of the images.

In Bridge, select the images that you want to edit. Next, double-click one of the selected images or choose File > Open. Either of these processes will open all of the files in Camera Raw. As you saw earlier, when you open multiple images in Camera Raw 3, the files appear in a vertical scrolling pane to the left of the Camera Raw dialog box. You can click any image in the scrolling pane and then edit its settings.

At this point, you can work through your images and adjust each by hand. However, if the images are all similarly exposed and so need similar adjustments, then a faster approach is to use the Synchronize feature.

Click the Select All button at the top of the window (or press Ctrl-A in Windows or Command-A on the Mac) to select all of the images; then click the Synchronize button. This will bring up the Synchronize dialog box, where you can select the parameters you want to synchronize (**Figure 5.33**).

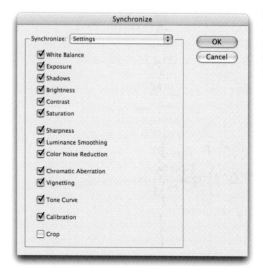

Figure 5.33 *Camera Raw's Synchronize dialog box lets you apply the same settings to all currently open images.*

If your images are very similar, then you can simply synchronize all of the settings. Any change you make to any setting of any synchronized image will automatically be transferred to all of the other synchronized images.

Even if your images don't need the exact same adjustments, Synchronize may still be of some help. For example, if the white balance of all of your images is similarly out of whack, then you can synchronize just the Color Temperature and Tint settings. Or perhaps all of the images need a similar Shadow adjustment, which you can synchronize, but separate Exposure and Brightness adjustments, which you can alter by hand.

Note that if you select a single image, thus undoing the Select All command, then your edits will affect only that one selected image. Choosing Select All again will restore you to editing the synchronized set—you won't have to resynchronize. Also note that synchronization settings are not stored in the files' metadata. As soon as you leave Camera Raw, synchronization will be lost, though the settings that you applied to the images will still be stored.

Adjusting multiple files in Elements 3, Elements 4, and Photoshop CS

Photoshop Elements and CS don't provide the same multiple file editing and synchronization that you get in CS2. However, there is a fairly simple workaround that enables you to apply the same settings to multiple images.

In the File Browser, select a group of images and then double-click one of the selected files. The first image will open in Camera Raw. Edit it as you normally would.

Hold down the Alt (Windows) or Option (Mac) key to turn the OK button into an Update button and then click the Update button. This will save your settings in the file's metadata, allowing you to process it later.

Camera Raw will immediately open the next image from the batch that you selected. From the Settings menu, select Previous Conversion (**Figure 5.34**). This will apply the same settings that you applied to the last image.

Now when you close the image, the next one will open, and you can select Previous Conversion again. In this way, you can work your way through the entire selection.

While this is a perfectly effective solution, a better solution is presented in the next section.

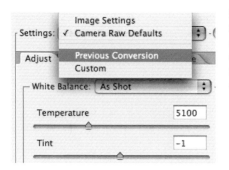

Figure 5.34 *Selecting Previous Conversion from Camera Raw's Settings menu will adjust the current image using the settings you used in your previous Camera Raw conversion.*

Copying Camera Raw settings between raw files

All versions of Camera Raw, as well as Bridge and the File Browser, allow you to copy settings from one raw file to another.

Remember: When you make adjustments to a raw file in Camera Raw, those settings are stored in the metadata for that file. Whether you choose to keep that metadata in the internal cache or in external sidecar XMP files is irrelevant.

Bridge and the File Browser provide a facility for copying settings from one raw file to another. With this functionality, you can open a single file in Camera Raw, edit it as you like, close the file, and then copy the file's Camera Raw settings to any other files that you choose. When opened, those other files will be processed in the same way. This can be a tremendous time-saver when you need to process large numbers of images.

Obviously, before you can use any of these methods of copying settings, you need some settings to copy. Open a file and adjust it appropriately; then save the settings and close the file.

Copying Camera Raw settings in Bridge

Bridge provides some very simple menu options for copying Camera Raw settings from one raw file to another. If you just finished editing the file you want to copy from, select the files that you want to apply the settings to and choose Edit > Apply Camera Raw Settings > Previous Conversion. The settings that you used in your last Camera Raw edit will be applied to the selected files.

The Apply Camera Raw Settings command has some other handy options. Copy Camera Raw Settings lets you grab the settings from the currently selected file, and Paste Camera Raw Settings lets you add those settings to

any other files. When you choose to paste settings, Bridge presents a dialog box (**Figure 5.35**) where you can select precisely which settings you want to paste. This provides an easy way to quickly apply a few settings—such as Color Temperature and Tint—to a group of files without having to open them in Camera Raw.

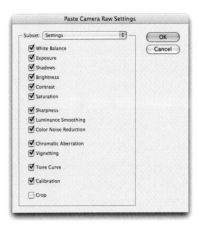

Figure 5.35 *In Bridge, when copying Camera Raw settings from one raw file to another, Paste Camera Raw Settings lets you pick precisely which Camera Raw settings to apply.*

Finally, the Clear Camera Raw Settings option returns the raw file to its original, just-out-of-the-camera state. If you've copied the wrong settings into a file, or if you've just really screwed them up with some bad edits, this option offers a simple way to return your file to its "normal" state.

Copying Camera Raw settings in Elements 3 and CS

Once you've applied settings to a raw file, you can easily move those settings to other raw files using a few simple menu commands.

First, select the files to which you want to copy settings; then choose Automate > Apply Camera Raw Settings from the Camera Raw menu bar.

In Photoshop Elements, you'll be presented with a simple dialog box that gives you several choices. First Selected Image applies the settings from the first image that you clicked in the current selection to all of the other images in the selection. Camera Default restores the image to its original just-out-of-the-camera state. Previous Conversion applies the settings from the last conversion that you made.

Photoshop CS provides the same options, but adds the ability to load settings from a file. In addition, the Advanced button gives you access to the actual Camera Raw sliders, allowing you to tweak settings before they are applied.

Batch processing your raw files

At this point, all of your selected raw files should be ready to process. Either because you edited them individually or used batch techniques for applying Camera Raw settings, or most likely some combination of both, they should now all have Camera Raw settings applied to them. This means that you're finally ready to hand them off to Camera Raw to process them into final files. Because this processing may take a while, depending on how many images you have, this is an operation that you can start and leave unattended. The procedure for triggering the batch conversion, though, differs depending on the browser you're using.

Batch processing with Bridge

One of the nice things about Bridge is that it can serve as the host for Camera Raw. This makes batch processing a little easier than it is in Elements 3 or 4 or Photoshop CS. It also means that you can let Bridge process your images while you use your computer for something else. However, if you want to keep working in Bridge, you can have Photoshop host Camera Raw, which will free up Bridge. (So far, you've most likely been using Camera Raw hosted by Photoshop for all of your edits.)

To process your images using Bridge, select the raw images that you want to process and then choose File > Open in Camera Raw. The entire batch of images will be opened in Camera Raw, though it will be hosted by Bridge. Click Select All in the Camera Raw dialog box to select all of the images; then click the Save *x* Images button. The Save dialog box opens, where you can select a file format and naming conventions (**Figure 5.36**).

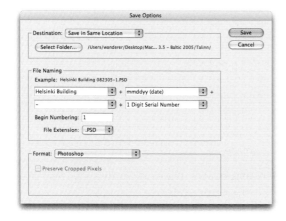

Figure 5.36 *When saving multiple images from Camera Raw, you can specify file name generation parameters as well as the destination and format.*

The Save options provided are fairly straightforward. You can select a location to save the resulting files in, or you can save the files in the same folder as the original raw files. Don't worry—your raw files will not be overwritten.

The File Naming controls let you specify a base name, which can have up to three components appended, including a sequential number or letter, the date, and a standard file extension.

Finally, you can select the file format that you want to use. In addition to regular Photoshop and JPEG file formats, you can use TIFF or Adobe's own DNG format.

Click the Save button, and Camera Raw will begin processing your images. Because Bridge is hosting Camera Raw, you won't be able to do anything with it until the conversions are done. If you'd rather not have Bridge tied up while your images are processed, you can host Camera Raw in Photoshop and perform your conversions there.

To host in Photoshop, select your images and then choose File > Open. Camera Raw will launch from within Photoshop, just as it has done in all of our previous examples, and you can follow the procedure just described. When Camera Raw is hosted in Photoshop, Bridge remains free for you to continue using.

TIP

With images selected in Bridge, you can use Ctrl-O (Windows) or Command-O (Mac) to open them in Camera Raw hosted by Photoshop, or Ctrl-R (Windows) or Command-R (Mac) to open them in Camera Raw hosted by Bridge.

If you'd rather process your images and have them open in Photoshop afterward, instead of saving, click the Open x Images button in Camera Raw, not the Save x Images button. Note, however, that if you are processing a particularly large batch of images and opening the images at full resolution (or greater), you may begin to tax the RAM of your system. Photoshop uses a very effective disk caching system for managing large amounts of data, but pushing it to the point where it must swap out lots of data to your hard drive can severely impact your computer's performance.

Batch processing with the Batch command

The Batch command provided by both Bridge and the Photoshop CS File Browser provides a way to process your images and perform a few other tasks in one fell swoop. If you're using the File Browser under Photoshop CS, this is the only option you have for batch processing your raw files. If you're using Bridge, you may want to use this technique because it will save you a few image processing steps later. (If you're using Photoshop Elements, see the next section.)

The Batch command works just like the File > Automate > Batch command in Photoshop. With it, you can process and save a batch of raw files. Although Bridge users already have a way to batch process a group of raw files, the Batch command allows automation of some additional Photoshop tasks during the conversion process.

NOTE

When you use the Batch command with Bridge, Camera Raw is hosted in Photoshop.

Before you can begin using the Batch command, you need to create an action in Photoshop that will take care of opening and saving your images. As you'll see, the Batch dialog box provides special open and save options, but these don't work properly when you're working with raw files. If you've never created an action in Photoshop, don't worry—it's not difficult.

Create a Photoshop action. In Photoshop CS or CS2, click the New Action button at the bottom of the Actions palette (**Figure 5.37**). If the Actions palette is not currently visible, select Window > Actions to activate it.

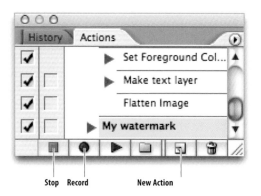

Figure 5.37 *You can use the controls at the bottom of Photoshop's Actions palette to create and record new actions.*

Give the action a name, such as Process Raw Files, and, in the resulting dialog box, make sure that Default Actions is selected in the Set pop-up menu. Then click Record. The action will appear in the Actions palette, and the Record button on the Actions palette will appear lighted, indicating that Photoshop is recording everything you do and storing those steps in the current action.

Now choose File > Open and open a raw file that you've applied settings to in Camera Raw. It's very important that you now choose Image Settings in the Camera Raw Settings pop-up menu. This will ensure that the batch processor will use the image settings stored with the raw file, instead of any default settings.

Next, configure Camera Raw's Workflow Options—color space, bit depth, size, resolution. Finally, click Open to open the image. Camera Raw will process the image and open it in Photoshop.

Photoshop is still recording your steps, so now choose Save As from the File menu. You'll be presented with the standard Save As dialog box. At this point, it doesn't matter what you enter as the name and destination. These parameters will be replaced later when the Batch command is executed. For now, just enter any name in the Name field and choose a temporary destination. I usually save to the desktop, so that I can easily find the resulting file and delete it.

Set Format to Photoshop; then click Save to save the file. Finally, close the document.

Now click the Stop button at the bottom of the Actions palette to stop recording. If you want, you can delete the file that you just saved.

You now have an action that will open a Camera Raw image, process it according to the settings saved in the metadata, and then save the resulting image as a Photoshop file. We'll use this action in conjunction with the Batch command to automatically process groups of raw images.

Run your batch process. With your action configured, you're ready to return to Bridge or the CS File Browser and select the raw files that you want to process. In Bridge, choose Tools > Photoshop > Batch to invoke the batch processing window. From the Photoshop CS File Browser, choose Automate > Batch from the File Browser menu bar.

These commands both bring up the standard Photoshop Batch window (**Figure 5.38**).

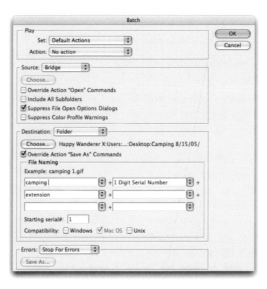

Figure 5.38 *You can trigger Photoshop's Batch command from within Bridge or the File Browser. With it, you can automatically process raw files while applying a Photoshop action.*

You must be careful to properly configure the Batch dialog box:

✦ In the Play section of the dialog box, be certain that Default Actions is selected in the Set pop-up menu. From the Actions pop-up menu, pick the action that you created earlier (in this case, Process Raw Files).

✦ If you're using Bridge, set the Source pop-up menu to Bridge; if you're using the File Browser, set it to File Browser. This will cause the Batch command to process the images that you've currently selected. Alternately, you can select Folder and then choose a specific folder full of images to process.

✦ Select Override Action "Open" Commands. This tells the batch processor to override the Open command in your action and use the next image in the selected Batch instead. If you're wondering why we bothered to create an Open command in our Photoshop action if we were just going to override it anyway, the answer is because if we let the Batch command open the files for us, it won't use the raw conversion parameters that are saved with each image.

✦ If you want the processed images to remain open in Photoshop, select None for Destination. If you want to save the converted images, select Folder. Selecting Save and Close can be dangerous because there is a chance that you'll overwrite your original raw files. It's almost always better to choose Folder, which lets you select a specific folder to save to.

✦ Select Override Action "Save As" Commands. The Batch processor won't actually *completely* override the Save As command that we recorded in our action. It will still save using the format we recorded, but it will use the name and destination information that we enter in the Batch dialog box.

✦ Use the File Naming controls to set a base name and establish any appended information that you want to use, such as a sequential number or date. Note that Photoshop will probably require you to choose at least a sequential number suffix; otherwise, all the files will have the same name.

Click OK, and Camera Raw will begin processing your selected images according to the settings that you've defined.

Though this procedure is a little more complicated than batch processing in Bridge, it's the only option you have if you're using Photoshop CS. However, whether you're using Bridge or CS, running a Photoshop action during the conversion process can be very handy.

For example, if you know that you'll want to perform some Levels or Curves adjustments after your images are processed, you could create an action that

adds a Levels or Curves adjustment layer to the current document and then trigger that action during the Batch command. Then, when your images are done processing you'll have a collection of Photoshop documents that already have Levels and Curves adjustment layers added to them.

This type of batch processing allows you to effectively build an Open command that does much more than simply process and open a raw file.

Batch processing with Photoshop Elements 3 and 4

Elements uses a scheme that's completely different from either Bridge or the Photoshop CS File Browser.

When you want to process multiple raw files in Elements 3, first select the images in the File Browser; then choose Automate > Process Multiple Files (**Figure 5.39**).

TIP

If you need to quickly process images for web delivery, use the Workflow Options settings in the Camera Raw dialog box to specify a smaller image size. You may also want to choose an sRGB color space, as this is more appropriate for web-bound images.

Figure 5.39 *In Elements 3, you can batch process images by using the Process Multiple Files dialog box.*

✦ In the Process Multiple Files dialog box, set the Process Files From pop-up menu to File Browser. This tells Elements to process the files you've selected in the File Browser. You can also set it to Folder and then pick a particular folder full of raw images.

✦ In the Destination field, either type a destination path by hand or click the Browse button to select a folder.

✦ In the File Name control, select a base file name and one type of data to append to the file. Elements will automatically append an appropriate extension to your file names.

✦ In the Image Size box, you can specify whether you want your images resized upon opening. Since Camera Raw running under Elements doesn't give you an option to set file sizes, this is a way to automatically scale your images down or up before opening. For quickly outputting images for e-mail or the web, this can be a great time-saver.

✦ From the File Type pop-up menu, select your desired output format.

The Quick Fix options let you automatically apply auto levels, contrast, or color adjustments to your image or add sharpening. You probably won't need any of these if you've done your work right in Camera Raw. The Labels feature can be handy for web postings, though. Using the Watermark feature, you can automatically superimpose a text watermark on your images.

With the dialog box configured, click OK, and Camera Raw will begin processing your images. Although you won't see the Camera Raw dialog box, you will see each image open in Elements as it's processed.

In Elements 4, choose File > Process Multiple Files. In the resulting dialog box (**Figure 5.40**), first select the source folder that contains the images you want to process. Then pick a destination folder, along with any naming or resizing options that you want performed. Finally, select a file type for the resulting images. Using the Quick Fix options, you can elect to apply some automatic image processing to your images.

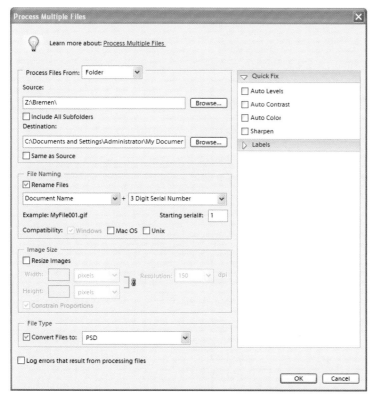

Figure 5.40 *Elements 3 and 4 offer similar dialog boxes for processing multiple images. In addition to performing scaling and file conversions, you can automatically apply basic image editing operations, such as auto levels.*

BE CAREFUL ABOUT SAVING IN JPEG FORMAT

No matter what host application or technique you're using to batch process your raw files, be careful about your format choice. If you're going to directly e-mail your resulting images or post them to the web, then JPEG is your ideal choice. But if you plan to make any additional edits using Photoshop or any other image editing tools, then JPEG is a bad choice. Remember that every time you save a file in JPEG mode, you degrade its quality. So if you're going to edit your images, it's better to save out of Camera Raw in either Photoshop or TIFF format. After editing, you can perform a final conversion to JPEG for electronic delivery.

Step 4: Edit your Photoshop files

As powerful as Camera Raw's editing tools are, there will still be some edits that are possible—or much easier—to perform only in Photoshop. Obviously, any painting, rubber stamping, or other interactive brush-oriented edits have to be performed in Photoshop.

Compositing and masking operations, custom filters, special effects, CMYK conversions—these are all operations that you may need to regularly perform. In addition, there are some tonal and color corrections that are easier to perform with Photoshop's specialized controls. In the next chapter, we'll look at some controls that particularly complement Camera Raw's tonal and color tools.

In my opinion, no matter what size your final image needs to be, it's always best to do your editing and retouching at the highest resolution your camera can manage. This will afford you more flexibility if you ever decide to repurpose your image later. Though you may think that you'll only post the image to the web, by the time you're done editing, you may decide that it would look great printed. If you scale your image down to web size *before* editing, then you won't have enough data to make a decent print.

So work at full size and save your image in a lossless format like Photoshop. You can then resize and save additional versions for your various output needs.

One of the great luxuries of working with raw is that if you somehow mess up your Photoshop file, you can simply reprocess your original raw file. Unless you change them, all of your raw settings will be the same when you return to Camera Raw. The raw file is truly like a digital negative. At any time, you can make a new, freshly processed image from your original raw data.

OPTIONAL: FLATTEN AND SAVE IN PHOTOSHOP FORMAT

If you've performed a lot of edits and adjustments using adjustment layers, or if you've created a lot of extra layers to create a composite or special effect, then you'll probably want to save a copy of your full-res, layered image in Photoshop format. Because Photoshop format preserves all layers, you'll be able to go back later and make changes to your adjustment layers or further refine your compositing and effects layers.

With your document saved in Photoshop format, you're ready to move on to the next step, which is preparing your image for final output and then saving it in the appropriate formats. Because these formats don't require layered files, you'll need to *flatten* your image. Flattening compresses the entire layer stack into a single layer. To flatten an image in any version of Photoshop, select Flatten Image from the pop-up menu at the upper-right corner of the Layers palette.

Step 5: Resize and sharpen your images

Once you've finished with your edits, you can think about what you want to do with your finished file. For instance, after completing your editing and retouching, you may need to make a version of your image for a web site. If you've been working at full size, then you'll need to resize your image and, of course, convert it to JPEG.

Or maybe you want to order prints of your completed images from an online printing service. These services almost always demand JPEG files, so though you may not need to resize, you will need to save in JPEG format.

Or maybe you're going to print your image on your own printer at a particular size, say 4 x 6 inches. If you're shooting with a high-resolution camera—5 megapixels or greater—then it's a good idea to size your image down a little before printing. You won't want to do a JPEG conversion, but you'll probably want to save a separate printing version in Photoshop or TIFF format. This will preserve your full-size edited Photoshop version and allow you to perform additional color corrections after printing a test print.

Resizing for the web or e-mail is very simple. In Photoshop CS or CS2, choose Image > Image Size. Make certain the Resample Image check box is checked; then enter your desired pixel dimensions (**Figure 5.41**). Resolution is irrelevant for web or e-mail use, so click OK to resize your image.

Figure 5.41 *To resize images for the web using Photoshop's Image Size dialog box, select the Resample Image check box and then enter your desired pixel dimensions.*

Resizing for print is a little more complicated. If you're going to send your file to an online print service, the service will probably provide image size specifications and instructions on its web site.

If you're resizing for your own printer, open Photoshop's Image Size dialog box. Make sure Resample Image is unchecked. In the Document Size fields, enter the dimensions of your target print size. As you change the dimension fields, the Resolution field will also change. If it drops below 200 for prints larger than 8 x 10 inches (or 300 for smaller prints), then it's probably a good idea to select the Resample Image button and enter 200 (or 300 for smaller prints) in the Resolution field.

Once your image is resized, you're ready to apply any sharpening that you may need. Sharpening always needs to be performed at your final output size; therefore sharpening should be your very last step before saving.

Step 6: Save your images

Now you're ready to save your image in the appropriate file format. For e-mail, web, or delivery to an online printing service, you'll want to save in JPEG format. If you're saving a separate version for your own printing, save in Photoshop or TIFF format.

If you need separate versions for web and print, then you can return to your edited Photoshop document, resize and sharpen again at the appropriate size and then save yet another version. By the time you're done preparing all of the versions for your different types of output, you may have files in several formats.

COLOR CORRECTION FOR PRINTING

If your ultimate goal is printed output of your images using your own printer, then you may have a few extra steps to perform after you've resized and sharpened your images.

As you've probably already discovered, an image on your computer monitor looks very different from the image that comes out of your printer. Though you can use special calibrating and profiling software and hardware to build a monitor and printer combination that yields greater color accuracy, an image on even the most accurate monitor is still going to look different in print. A computer monitor is a bright light-emitting device capable of displaying a fairly large gamut of colors, typically sRGB, aRGB, or others. A color print is a reflective object with a smaller gamut.

So whether your monitor and printer are very closely calibrated or not, you'll still probably need to make a few test prints and apply a few adjustments to your images to get them to print precisely the way you want them to. If you've already heavily edited your image to get it to look good on the screen, then the idea of doing *more* color correction may be frustrating. However, as you gain printing experience, you'll get a better feel for how your monitor and printer correspond and so will be able to achieve the prints that you want with fewer test prints and adjustments.

If you're frustrated by the idea of using ink and paper simply to test color, take solace in the fact that wet darkroom photographers have to do the same thing, and their printing process is more expensive and more time consuming.

Adjustment layers make it very simple to create and adjust test prints. Begin by printing your resized, sharpened, flattened document on the paper of your choice. Evaluate the image for contrast and color and then choose an appropriate type of adjustment layer to tackle your problem.

If your printed image is too dark, then you'll probably want to add a Levels adjustment layer so that you can either boost the black point or alter the gamma.

If the color in your test print is off—maybe the image has an overall green cast or is too warm—then use a Curves or Hue/Saturation adjustment layer (**Figure 5.42**).

With this first round of layers applied, make another test print. Using its results, you can then alter your existing adjustment layers or add more layers to make more corrections.

As always, when editing, keep an eye peeled for posterization and tone breaks.

When you have the image the way you want it, save a copy of this file so that you can make more prints later. I usually save separate corrected versions for each type of paper that I print on. You'll probably find that glossy paper needs a very different set of adjustment layers than matte paper does.

Finally, if you find that you're consistently having to add the same type of Levels or Curves layers to correct your prints, consider building a Photoshop action to automatically add these layers to your document.

Figure 5.42 *This image required a Levels adjustment layer to correct for an over-dark print, a Curves adjustment layer to remove a warmish cast, and a Hue/Saturation adjustment layer to tone down the yellow.*

Step 7: Archive your images

When you are finally done with all of your image editing, printing, and out-putting, you'll want to archive or back up your images. Copying to another hard drive is the fastest, easiest way to perform a simple backup. For long-term storage, burning to CD-ROM or DVD-ROM is the easiest and most cost-effective backup process.

If you set Camera Raw to save XMP data in sidecar files, be sure to archive these along with your raw files and final output files.

BACKING UP USING ORGANIZER

Organizer provides an automated backup facility that you can access by choosing File > Backup. The Backup command lets you either back up the entire catalog or simply copy or move a selection of files to a recordable CD or another hard drive. If you choose to back up the entire catalog, then Organizer will automatically keep track of what has already been archived, allowing you to perform incremental backups later (an incremental backup copies only new images that have not yet been backed up).

Just follow the simple onscreen instructions to create your backup.

That's it! You've now gone through a complete workflow from image transfer to archiving. Obviously, you may not need to perform all of these steps. You may not need to output several different versions, or your images may not require any additional Photoshop editing after your initial raw conversion.

Though this big list of steps may seem a little complex, raw workflow is actually fairly simple. To keep things easy to manage, it's worth getting in the habit of using Camera Raw's batch capabilities.

Incorporating DNG into your workflow

As discussed in Chapter 4, Adobe has developed the Digital Negative Specification, which provides an open standard for the formatting of raw camera data. Designed because there currently is no standard for the format of raw files, the Digital Negative Specification is intended to provide a safe format for raw images. Images in Adobe's DNG format will, in theory, always be readable even if Adobe or any particular camera manufacturer goes out of business.

So is there a place for DNG in your workflow? That partly depends on how paranoid you are. If you're worried that, 50 years from now, there will be no hardware or software left that knows how to read your raw files, and if you believe that there will still be a group of open-source hackers who will build a DNG reader that runs on whatever computer you might be using, then sure, why not convert your images to DNG format so future generations can pore over them?

In the short term, there is a practical advantage to using DNG files, though. The DNG format supports all of the metadata information that you've been working with in Camera Raw—not just IPTC and EXIF information, but Camera Raw settings as well. When you process a DNG file with Camera Raw, all of your conversion settings are saved in the DNG file, so you don't have to hassle with XMP sidecar files or worry about losing your settings if you copy your files to another drive. For this reason, it may be worth converting to DNG.

Whether you choose to or not, is up to you. Personally, though I laud Adobe for developing an open standard like this, I have yet to convert my images to DNG, simply because right now I have plenty of software support for my files. If the day comes when I feel that I may be losing the ability to read those files, I'll try to convert them then.

My approach may be careless, but there's no guarantee that converting to DNG for long-term image storage is the way to go, either. The fact is, we don't know much yet about the archival stability of recordable CDs and DVDs. It may turn out that archival prints are more durable than any of our electronic and optical media.

BETTER MAC WORKFLOW
THROUGH AUTOMATOR

If you're a Mac user running OS X 10.4 (Tiger), then you have an additional workflow tool that you can turn to for complex batch processing jobs. Automator, an application that's preinstalled in your Applications folder, lets you quickly and easily build stand-alone applets and Finder plug-ins that can automatically perform all sorts of complex workflow chores (**Figure 5.43**).

Figure 5.43 *Apple's Automator, a standard component of OS X 10.4 (Tiger), lets you create complex automated workflows for batch processing images. To get the most out of it, download My Free Photoshop actions for Automator.*

Automator does not ship with any Photoshop support, and Adobe has not yet provided any. However, I have written a suite of 40+ Automator actions for Photoshop that you can install in Automator. With these actions, you can use Automator to drive Photoshop and create complex batch processing operations. In addition to resizing, sharpening, performing adjustments, and executing Photoshop's own internal actions, my Photoshop Action Pack includes Automator actions that let you filter a batch of images by EXIF or IPTC information, orientation, color mode, bit depth, and more. With these filter actions, you can create complex workflows that process images in different ways depending on their characteristics. This type of logic is not possible with Photoshop's internal actions.

You can download these Photoshop Automator actions for free from www.completedigitalphotography.com.

Summary

You should now be comfortable getting raw files from your camera all the way through to finished images. You saw how Camera Raw's use of XMP metadata facilitates a highly automated workflow. You gained experience at transforming your images from raw files to adjusted Photoshop and JPEG files. You also edited a little metadata and added some keywords.

Now it's time to dig deeper into the image adjustment and editing capabilities of Camera Raw itself.

6

Advanced Editing in Camera Raw

If the last couple of chapters have made you think that shooting raw is an incredible hassle, don't worry. The fact is, most of the images that you shoot—particularly those shot in bright daylight—will probably need very little adjustment. Usually a simple Shadow and Exposure tweak and a bit of sharpening are all that you'll need. Camera Raw's automatic Shadow and Exposure tools can make short work of these adjustments, and sharpening is something that can easily be batch processed.

Where the real advantage of raw kicks in is with the images that *do* need a lot of adjustments, because they weren't properly exposed, or because you were shooting in a difficult lighting situation, or because the image that you originally envisioned has complicated exposure needs. Whether the image that you're ultimately trying to produce needs subtle adjustments or complex changes, working in raw—with its powerful tools and 16-bit capability—will afford you better control and more latitude for making your edits.

Chapter 4 worked you through the basics of how to use Camera Raw's interface and controls. Now we're going to go deeper in this chapter to give you a better understanding of how to effectively use Camera Raw.

Catherine's Palace,
St. Petersburg.
Canon EOS 20D
with Canon 24-85mm EF.
1/100 at f/4.6.

Camera Raw Interface Revisited

We took a quick run through the Camera Raw interface in Chapter 4, not stopping to discuss every single tool and option. Hopefully, you've been playing with Camera Raw on your own and so have probably discovered a few of its other tools. In this section, we'll explore some of the features that we didn't formally cover in Chapter 4.

To really get a feel for the tools, open an image in Camera Raw and follow along with the descriptions presented here.

The Zoom tools

Most of the time, when you're editing and making adjustments in Camera Raw, you'll want to work with the entire image visible in the preview window. There will be times, though, when it will be better to zoom in to examine a particular part of an image.

Camera Raw provides several zooming options. At the bottom of the Preview pane is a pop-up menu that lets you select a zoom level (**Figure 6.1**). Offering a range from 6% to 400%, this menu lets you zoom to a closer view with the Preview pane centered on the middle of the image. You can use the + and – buttons next to the pop-up menu to step through the zoom levels, and the Fit in View option to squeeze the entire image into the Preview window.

While the ability to quickly zoom to a specific percentage is handy, you will sometimes want to zoom in on a particular area of your picture, not just the center. For this, you use the Zoom tool (**Figure 6.2**).

Figure 6.1 *Camera Raw's zoom palette lets you select a specific zoom ratio for viewing your image. The zoom remains centered on the middle of your image.*

Figure 6.2 *The Zoom tool lets you zoom in and out by clicking your image. The zoom is centered on the point where you click.*

When you click with the Zoom tool, your image is magnified, centered on the point where you clicked. Alt-clicking (Windows) or Option-clicking (Mac) with the Zoom tool zooms you back out of your image by the same increments with which you zoomed in, while double-clicking the Zoom tool in the tool palette automatically sets your zoom level to 100%.

You can also drag the Zoom tool to outline the area that you want to see enlarged (**Figure 6.3**). When you release the mouse button, the area you selected will be enlarged to fill the entire Preview pane.

Figure 6.3 *If you want to magnify a particular part of your image to fill the Preview pane, drag with the Zoom tool to outline the area.*

The Hand tool

TIP

Right-clicking the Preview pane with either the Zoom or Hand tool selected brings up a pop-up menu containing the standard zoom choices. On a big monitor, this approach can save you a mouse trip to the bottom of the window.

As you may already have noticed, the Preview pane lacks any scroll bars, so if you want to pan your image, you have to use the Hand tool (**Figure 6.4**).

Figure 6.4 *The Hand tool lets you pan your image once you've zoomed in.*

Double-clicking the Hand tool in the Camera Raw toolbar restores your image to Fit in View.

ZOOMING AND PANNING WITH THE KEYBOARD

You can use Z and H to select the Zoom and Hand tools, respectively, but a better way to work is to grab the Zoom tool and then press the spacebar whenever you want to pan. The Hand tool will remain selected for as long as you hold down the spacebar. This provides a simple way to quickly switch between Zoom and Hand.

Similarly, you can temporarily switch to the Zoom In tool by holding down the Ctrl key in Windows or the Command key on a Mac. Holding the Alt or Option key temporarily gives you the Zoom Out tool.

You can also zoom in and out with any tool selected by using the keyboard shortcut Ctrl-+ (Windows) or Command-+ (Mac) to zoom in, and Ctrl-- (Windows) or Command-- (Mac) to zoom out. Any time you want to return to Fit in View, press Ctrl-0 (Windows) or Command-0 (Mac). (Incidentally, all of these keyboard shortcuts work in Photoshop as well.)

Note that pressing Z, H, or the spacebar to select a tool won't work if you are currently entering numbers in one of the Camera Raw parameter fields. You'll need to click back in the Preview pane to deactivate the parameter text entry and return your keyboard commands to normal.

Color Sampler tool

Available when running Camera Raw under Bridge, Photoshop CS, and Photoshop CS2, the Color Sampler tool (**Figure 6.5**) can monitor the color of particular areas of your image while you make adjustments with Camera Raw's parameter sliders. For example, if you want to be certain that a

particular highlight doesn't blow out to complete white, or if you want
to see how a specific color changes, you can use the Color Sampler tool to
monitor it as you edit.

Figure 6.5 *Camera Raw's Color Sampler tool lets you monitor the color
of specific pixels in your image.*

To use the Color Sampler tool, select it from the Camera Raw toolbar (or
press S) and then click the part of your image that you want to monitor. A
readout of the RGB values for that particular pixel will be displayed above
the Camera Raw Preview pane, and a numbered crosshairs icon will appear
in your image to indicate the location of the sampler (**Figure 6.6**).

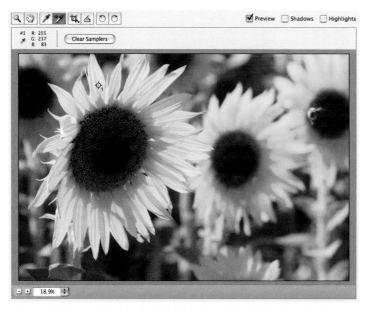

Figure 6.6 *After you click with the Color Sampler tool, an RGB readout for that
pixel's color will appear above the Preview pane.*

You can define up to nine separate color samplers, which should be more
than enough for even the trickiest image. Once you've placed a sampler,
you can move it by simply clicking it and dragging. The Clear Samplers but-
ton above the Preview pane deletes all of the samplers. You cannot delete
individual samplers.

Other keyboard controls

Except for positioning color samplers, you can actually drive Camera Raw entirely from the keyboard. Here are some other handy keyboard shortcuts:

✦ You can switch among the various parameter tabs by pressing 1 through 5 while holding down Ctrl and Alt (Windows) or Command and Option (Mac).

✦ You can rotate an image clockwise or counterclockwise by pressing R or L, respectively. Either uppercase or lowercase letters will work. You can also press Ctrl-] or Ctrl-[(Windows) or Command-] or Command-[(Mac), respectively, to achieve the same results.

✦ To temporarily activate the White Balance tool, hold down the Shift key.

✦ You can save the current image by pressing Ctrl-S (Windows) or Command-S (Mac).

✦ To activate highlight clipping, press O. To activate shadow clipping, press U. This is the same as selecting the Highlight and Shadow check boxes to turn them on and off.

✦ To toggle between viewing your original raw file and the current adjustments, press P. This is the same as selecting the Preview check box to turn it on and off.

Multiple undo levels

If you're using Camera Raw in Photoshop CS 2, then you can access multiple levels of undo using the keyboard. Ctrl-Z (Windows) or Command-Z (Mac) undoes your most recent action. If you want to step backwards through even more actions, press Ctrl-Alt-Z (Windows) or Command-Option-Z (Mac). Once you've stepped backwards a few steps, you can redo your actions by pressing Control-Shift-Z (Windows) or Command-Shift-Z (Mac). These same keyboard shortcuts work in Photoshop as well.

The histogram

You learned about histograms in general in Chapter 3, and the Camera Raw histogram in Chapter 4, but there's still one characteristic of the Camera Raw histogram that we haven't yet discussed.

You've seen that Camera Raw displays a separate colored histogram for the red, green, and blue color channels. Although the histogram still indicates clipping just like a normal histogram—by showing a white spike on either the right or left side when you've clipped your highlights or shadows—it can also indicate when you've clipped only a *single channel*.

If your image is only slightly over- or underexposed, then all three channels may not be clipped. If you're shooting a bright red subject, for example, then an overexposure may clip only the red channel, leaving the green and blue channels close to the right edge of the histogram, but not clipping. Camera Raw shows a single clipped channel by displaying a colored spike rather than a white spike (**Figure 6.7**). The color of the spike indicates which channel has been clipped.

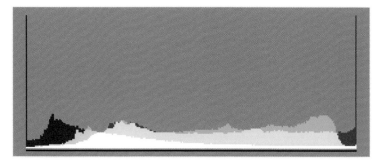

Figure 6.7 *Camera Raw's histogram display indicates a clipped channel by showing a colored spike on the edge of the histogram. This image is suffering from a clipped red channel on the highlight end and a clipped blue channel on the shadow end.*

Single-channel clipping is a very important topic in Camera Raw because of some special capabilities of the Exposure slider. We'll get to those later in this chapter.

In Chapter 4, you played with the various highlight and shadow clipping displays that Camera Raw provides. As you saw, when you hold down the Alt or Option key while dragging the Exposure slider, Camera Raw displays your image with a highlight clipping view.

You also saw that this feature doesn't work when you're using some of Camera Raw's other controls, and so Camera Raw provides special Shadows and Highlights check boxes, which also enable clipping displays.

There are differences between these two clipping displays. The Exposure slider clipping display shows clipping in different colors to indicate separate channel clipping, while the Exposure check box simply indicates *any* clipped channel or combination of channels as red (**Figure 6.8**). Most of the time, this subtle difference won't matter, and either display will serve as a valuable tool for monitoring and controlling clipping.

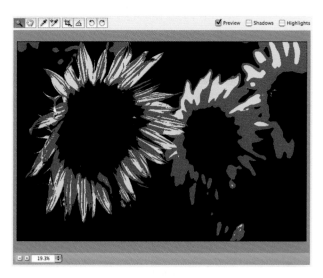

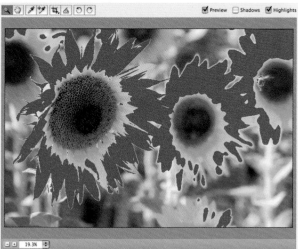

Figure 6.8 *When you hold down Alt (Windows) or Option (Mac) while moving the Exposure slider, Camera Raw provides a clipping display that highlights individual clipped channels, as well as fully clipped colors. When you select the Highlights check box, channel clipping and full clipping are indistinguishable.*

Where the Bits Are: Linear vs. Nonlinear Data

Chapter 2 touched briefly on the fact that your eye and your camera respond to light levels in very different ways. If you double the amount of light being shined at your camera, then your camera will record a 200 percent increase in illumination. Because a camera's response to light is directly proportional to the intensity of the light source, we say that it has a *linear* response to light.

Your eyes don't work this way. Your eyes are much more responsive to subtle variations in bright and dark tones than they are to changes in midtones. In other words, their response to light is not directly proportional to the intensity of the light source in question. Thus, we say that your eyes have a *nonlinear* response to light.

Like your eyes, film has a nonlinear response to light. As you saw in Chapter 2, when you shoot with your camera in JPEG mode, a *gamma correction* curve is applied to your image to make its luminance response more closely resemble the nonlinear perception of your eyes. Because JPEG's gamma correction yields a light response that is similar to the response of film, any exposure habits that you have from shooting film will most likely still apply.

When you shoot in raw mode, though, things work very differently. When you shoot in raw mode, your camera records a lot more data for brighter tones than it does for shadow tones.

Twice the data in half the stops

As you've probably already noticed, many of Camera Raw's controls seem to do the same thing. With the Exposure slider, you can brighten or darken an image, but you can also brighten an image with the Brightness control and darken it with the Shadows slider. Understanding how your digital camera captures different tones will make it easier to understand which control to use for a particular adjustment.

If your digital camera uses 12 bits of data per pixel, then it's capable of representing and processing 4,096 different levels of brightness. In a digital camera, half of those 4,096 levels go toward recording the brightest stop, half of the remaining levels go to recording the next-brightest stop, half of what's left from that go into the next-brightest stop, and so on for the remaining stops that your camera can capture. There is a straight, linear halving of data for each stop.

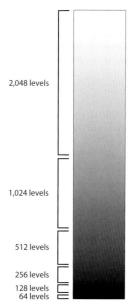

2,048 levels

1,024 levels

512 levels

256 levels

128 levels
64 levels

Figure 6.9 *Most of the data your camera captures goes to recording the brightest half of the image. Half of the remaining data then goes to recording the next stop, and so on. This means that your camera records substantially more information for the bright areas of your image than for the dark areas.*

By the time your camera gets down to the darkest stop (usually the shadow areas of an image), it may have only 64 levels left that it can use to represent your darkest shadow details (**Figure 6.9**). A less pessimistic way of looking at things is to say that if you expose for the highlights, then you ensure that your camera encodes your image with the maximum number of brightness levels. (We'll discuss how to perform this type of exposure in Chapter 7.)

As you've already seen, where there's less image data, there's a greater chance that posterization and tone breaks will occur when you make edits and adjustments. Because the camera captures so much data for the brighter stops, if you expose to capture as much information as possible from these areas, you'll have a tremendous amount of data to work with when you edit. This means that you'll be able to make large adjustments without fear of posterization.

Conversely, if you underexpose, then you'll be capturing more data in the midtones and shadow parts of the camera's range—areas that aren't represented by a large number of levels—and so you will have less editing latitude (**Figure 6.10**). When you brighten this underexposure, you'll almost certainly reveal noise that's been hiding in the shadow parts of your image.

To speak of this using terms that you learned in Chapter 3: You've seen that when you make a Levels or Curves adjustment or use the exposure sliders in Camera Raw, you are compressing or expanding different parts of the data in your image. Since your camera captures so little data in the shadow areas, expanding the shadows is a *very* bad idea, as it will almost always lead to posterization (since there's not much data there in the first place). Expanding the data-rich highlights into the shadow areas poses far less posterization risk, and because there's so little shadow data there to begin with, there's very little risk that you'll be compressing data that's already there.

You don't necessarily have to *over*expose your images to perform this kind of capture. If your camera has a good light meter, you'll be shooting with exposures that yield very good data. However, your camera's metering system is probably optimized to yield exposures that are best for gamma-corrected JPEG images. Thus, many meters often err on the side of slight underexposure. While your meter will often be right, it's important to keep an eye on what it's doing. We'll discuss this subject more in Chapter 7.

If you're coming from a film background, where you're used to under-exposing to protect your shadow detail, you'll have to retrain yourself. Underexposing when shooting raw is a *bad* idea. With digital raw photography, you want to expose to capture as much highlight detail as you can. You'll correct for your shadows later.

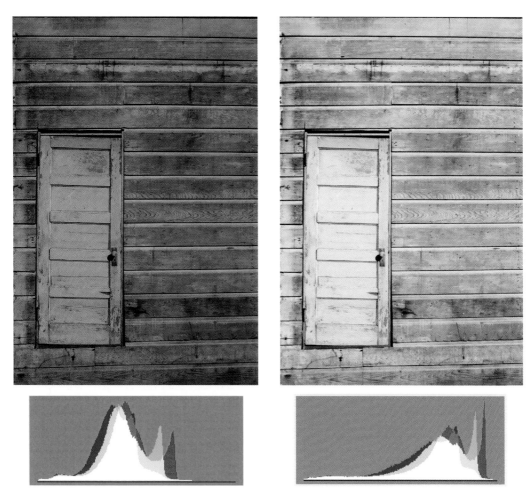

Figure 6.10 *The image on the left was slightly underexposed. Though the shadows aren't clipping and it has an acceptable range of contrast, it has very little data in the highlight areas, the areas where your camera captures the largest number of tones. The image on the right has a lot of highlight information, meaning that it's a data-rich image that can withstand a lot of editing and adjustment.*

MEASURING IN STOPS

If you have even cursory photographic experience, you've probably heard the term *f-stop*. There are two mechanical mechanisms inside your camera—the shutter and the aperture—that control the amount of light that strikes the image sensor. When you change the shutter speed from 1/125 of a second to 1/60 of a second, you double the amount of light that strikes the focal plane, because the shutter is kept open for twice as long. Similarly, when you change the aperture from f/8 to f/4, you double the amount of light that strikes the focal plane because the size of the aperture at f/4 is twice as large as at f/8. (Obviously, moving the other direction, from 1/125 to 1/500 or from f/8 to f/16, results in a halving of the light.)

Each of these doublings (or halvings) of light is referred to as a single *stop*, and you'll often hear photographers using the word *stop* as a measure of light. A simple way to think about f-stops is to remember that a smaller aperture *stops* more light from hitting the focal plane, as does a faster shutter speed.

For example, say you're shooting in a somewhat dark situation and your camera's light meter recommends an exposure of f4 at 1/30 of a second. That shutter speed is a little slow to be shooting hand-held—there's a good chance that your image will be soft or blurry at 1/30 of a second. Let's assume that flash is inappropriate in this situation. Let's also assume that you have a piece of white cardboard with you, which you use as a reflector to bounce some light onto your subject. Now when you check your meter, your camera recommends f/4 at 1/60 of a second—that's a shutter speed that's twice as fast as what the camera was recommending before. With your reflector, you've just added an entire stop's worth of light to your scene and so now have an exposure more suited to shooting handheld.

Every doubling of light can also be referred to as one *exposure value*, or *EV*. Photographers often use EV to denote over- or underexposure without having to concern themselves with specific aperture and shutter speed values. So if two photos differ in exposure by 1 EV, then one of them was overexposed by 1 stop, through a change in either shutter speed or aperture (or possibly, by a change of half a stop in *both* parameters).

The human eye has a dynamic range of 30 f-stops of light—from fully adapted night vision under starlight to brightest daylight—about a factor of 1 billion to 1. The typical digital camera (or film, for that matter) has a range of 8 to 10 f-stops of light (or 8 to 10 EV). Some natural scenes have a range of 12 f-stops (or EV) between the brightest highlights and deepest shadows. The fact that the dynamic range of camera technologies is so much smaller than that of your eye is one of the reasons that photography can be tricky. Your camera often can't record the full dynamic range of the scene, or what your eyes can see, so you have to make choices about which 8 to 10 f-stops you want to capture.

Reading it in the histogram

From what you've already learned about reading a histogram, you know that when you darken an image, the bars in your histogram shift toward the left. This happens because, after your edit, there are fewer bright values and more midtone and dark values. Similarly, if you brighten an image, the bars in your histogram shift toward the right.

If you've exposed an image to try to capture as much data in the highlights as possible, your histogram will have a distribution that's heavy on the right, like the one shown in Figure 6.10.

Such an image may appear washed out, or too bright. However, because you have so much image data, you can easily darken some of those captured levels to produce an image that looks better. In the resulting image, the data will appear to have been pushed down into the shadows (**Figure 6.11**).

With all of this in mind, some of the seeming overlap in Camera Raw's controls should make more sense, as you'll see in the next section.

Going Further with Raw Controls

Chapter 4 introduced you to Camera Raw's white balance and exposure control tools. These seven sliders are where the bulk of your raw editing work takes place. In this section, you're going to take another look at these controls, but this time framed within your new understanding of nonlinear data.

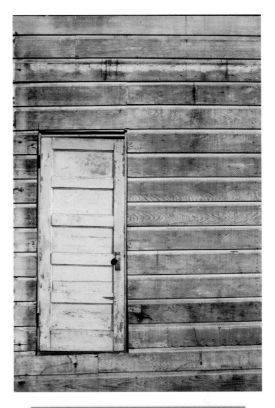

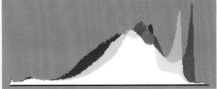

Figure 6.11 *After the right image in Figure 6.10 has been adjusted, the histogram shows tones that have shifted to the left. We've darkened some of the bright tones to place them in the middle and shadow areas.*

Adjusting white balance

You've already seen how to use the Temperature and Tint sliders and the White Point tool to adjust the white balance of your image. Although accurate white balance is great for achieving a faithful reproduction of the colors of a scene, sometimes an image will look better, or more evocative, if it has an extra bit of warmth or has been cooled down a little. Both of these effects are easy to achieve with temperature and tint adjustments.

For example, **Figure 6.12** shows three images created from the same raw file. The only thing that changed for each image was the Temperature setting in the Camera Raw dialog box. The top image uses the camera's auto white balance selection, which is fairly accurate, given that the photo was shot on a stage with very warm lighting. The middle image is much warmer, and the bottom image is very cool. Depending on the mood you are trying to evoke or the color palette of other images or graphics that you plan to use alongside your image, one white balance may be more appropriate than another.

Though you can warm up images using the Curves and Hue/Saturation tools in Photoshop, the Temperature control in Camera Raw is usually a better choice because it properly adjusts *all* of the tones in your image. Trying to warm an image with most regular editing tools means spending some time adjusting all three areas of an image: highlights, midtones, and shadows. With a white balance adjustment, you get it all at once.

Adjusting exposure

Chapter 4 introduced you to Camera Raw's Exposure tool, which is analogous to the white point tool in the Levels dialog box. With it, you define what the brightest point in an image is, and all of the other tones are remapped accordingly.

As discussed in the previous section, the brightest stops in a raw image contain the most data. If you've done your shooting job well, then most of your Exposure slider moves will be to *darken* an image, because you will have tried to capture more from the brighter stops, to collect more data. If you find that you need to use the Exposure slider to brighten an image, it's not the end of the world. Your image is not useless, and it's not ruined—there's just a better chance that your shadow detail will be posterized or noisy after your adjustments.

Figure 6.12 *You can alter the feel of an image by changing its white balance. The top image shows the camera's automatic white balance. The middle image has had a much warmer white balance applied in Camera Raw. The lowest image shows a much cooler white balance. None of these images is "right" or "wrong," but they have very different feels.*

Nevertheless, because it's your key to remapping the data-rich bright parts of your image into the midtones and shadows, the Exposure adjustment is the most critical of all of Camera Raw's controls.

Throughout this book, you've been told of the horrible consequences that result from clipping your highlights and shadows, so you may find it a little odd now to be told that if you "try to expose all your shots so that they're really bright, you'll be much happier." Shouldn't you pay attention to what your light meter says?

Absolutely. When taking this approach, you *will* run the risk of clipping your highlight values. Fortunately, Camera Raw has a fairly amazing capability that can help you with this trouble.

Using the highlight recovery function

As you saw earlier, fully clipped highlights are represented on Camera Raw's histogram by a white spike at the right edge. However, only one or two channels of a pixel may be clipped; Camera Raw displays each of these as a rightmost spike in the color of the clipped channel (Figure 6.7).

First the bad news: A completely clipped highlight is often a bad thing. It will appear in your image as complete white and will contain no detail, and there's nothing you can do about it except hope that you shot an additional, properly exposed frame.

A partially clipped highlight, though, is another story. If your highlights are only partially clipped, there's a good chance that Camera Raw can recover them.

Consider the image in **Figure 6.13**. As you can see from the histogram, the blue channel is heavily clipped, the green is barely clipped, and in a few places all three channels are clipped. (The spike on the right side is blue on top, with a tiny bit of green below and then some full white.)

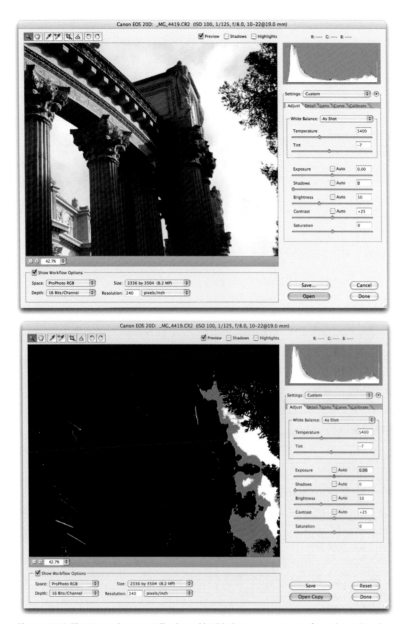

Figure 6.13 *This image has partially clipped highlights, as you can see from the right side of the histogram. In the clipping display, you can see that the clouds suffer from a lot of blue channel clipping as well as some full-blown three-channel clipping.*

By sliding the Exposure slider to the left, you can darken those clipped high-lights back into tones that can hold detail (**Figure 6.14**). In other words, areas that were previously empty white now show image detail.

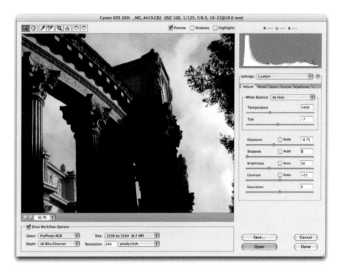

Figure 6.14 *I moved the Exposure slider to the left while keeping an eye on the histogram. When the spike completely disappeared, I let go. As you can see, the result is a –0.75-stop exposure. Though a lot of the image is darker, those areas can be brightened with the Brightness slider. The important thing to notice is how much more detail there is in the foggy areas of the sky.*

This type of highlight recovery is not possible with any of Photoshop's nor-mal tools, and it's another advantage of shooting raw. It also provides you with a little safety when exposing. The fact that Camera Raw can recover some clipped highlights gives you a little more exposure latitude.

Highlight recovery is accomplished using several techniques. Some camera manufacturers actually include a little headroom above their set white point. This means that the camera actually captures a little more data that it claims, and if this data is present, Camera Raw can simply grab it and use it to remap the clipped highlight tones.

Camera Raw can also use the data in one of the surviving channels to rebuild the missing clipped channel.

In the previous example, the histogram indicated that some tones were clipped in one channel, and others were clipped in all three. Fortunately, none of the clipping was so extreme that Camera Raw couldn't rebuild those areas. At other times, you may find that Camera Raw can pull back some of your clipped highlights, but not all, as shown in **Figure 6.15**.

Figure 6.15 *The upper image has badly clipped highlights. With the Exposure slider, we can recover a lot of detail in the clouds, but no matter how much we move the slider to the left, those completely blown sections of the sky will remain white and unrecoverable.*

When making a big Exposure slider move to recover highlights, be sure to keep an eye on the shadow end of your histogram as well. You'll need to balance the amount of highlight information that you want to recover against how dark you're willing to let the shadows in your image go.

Camera Raw's highlight recovery function is not just a handy tool for coping with highlight clipping. It's also a safety net that allows you to expose for the right end of the histogram, to try to capture as much data as possible. If you don't know how to control the exposure on your camera, don't worry—we'll cover that in detail in the next chapter.

Adjusting shadows

You previously learned that the Shadows slider works just like the Black Point slider in Levels (it defines the darkest point in the image and remaps all other tones accordingly), and your understanding of the role of the Shadows tool is hopefully a little more sophisticated now that you know more about the nonlinear nature of raw files.

Generally, since the shadow areas of an image contain so little data, it's best not to make large movements of the Shadow slider lest you risk introducing posterization and noise into the shadow parts of your picture. Obviously, if you chose an exposure that yielded very low contrast, you'll have nothing to lose by darkening the blacks in your image with a Shadows adjustment. On well-exposed images, though, you should use the Shadows slider sparingly.

Adjusting brightness

If you're following this "expose for the highlights" philosophy, then you've probably started to realize that the brightness of your images will usually not be too much of an issue. The bulk of your correction will be performed with the Exposure slider, which you'll probably use to darken the image.

However, if you've had to perform any highlight recovery, as discussed earlier, you'll probably end up with an image that's a little dark. As you saw in Chapter 4, the Brightness slider lets you adjust the midpoint of an image, just like the Gamma slider in the Levels dialog box; it brightens the midtones without moving the white point (**Figure 6.16**).

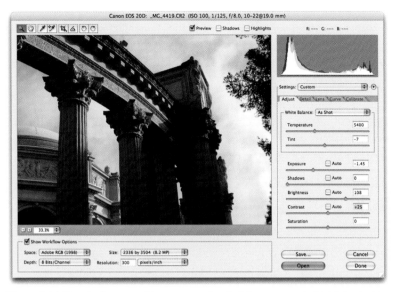

Figure 6.16 *After the Exposure slider was moved to the left to recover the highlights in this image, the picture was too dark overall. We can't brighten the image using the Exposure slider, or we'll reclip the highlights. Shifting the Brightness slider to the right restores brightness to the midtones.*

Figure 6.16 is a good example of the choices you sometimes have to make when editing. A fairly heavy Brightness adjustment is needed to restore brightness to the image. There's a good chance that this will cause some posterization in the shadows. If the negative Exposure move had been less aggressive, the image wouldn't need such a strong Brightness adjustment, but then we couldn't recover as much highlight detail in the clouds. In this case, we decided that having the well-rendered clouds is worth any damage we might be doing to the shadows in the image.

In general, highlight troubles are more noticeable than shadow troubles simply because highlight troubles are easier to see. If a shadow is dark and murky, it's not too conspicuous, but a bright area that's lacking detail and is blown out to white is easy to spot.

The trouble with this particular scene is that it has a huge dynamic range that's difficult for the camera to capture. Thus, we have little choice but to sacrifice either the shadows or the highlights.

If you simply have an image that's too dark, then you'll need to decide if you want to brighten it with the Exposure slider or the Brightness slider. When brightening an image, you should move the Exposure slider as little as possible, to keep from brightening the shadows too much. Set the Exposure slider to get your whites adjusted properly; then use the Brightness slider to brighten your shadow tones. Though you may not be able to tell a difference in the results, the Brightness slider will probably pose less of a posterization threat to the shadow areas of your image.

Adjusting contrast

The Contrast slider performs two adjustments: it brightens the tones above the midpoint, and it darkens the tones below the midpoint. (If you're used to making corrections using Photoshop's Curves control—as shown in Chapter 3—this is the same type of adjustment that you get when you apply an S-shaped curve.)

In general, the Brightness and Contrast sliders work very well together. Use the Brightness slider to add brightness to your image, and then use the Contrast slider to punch up the image with a little contrast (**Figure 6.17**).

Figure 6.17 *With a very slight Contrast move, we can punch up this image a little bit. We need only a small change since this image is already close to being too dark.*

REDUCING CONTRAST

You've read a lot in this book about how the human eye is very sensitive to contrast, and how the eye usually prefers contrast in an image, but sometimes an image can be *too* contrasty. The most obvious example is a person standing in front of a bright window: The extreme contrast difference between the darkness of the person's face and the brightness of the window can make the image difficult to read. **Figure 6.18** shows an image with harshly contrasting highlight and shadow areas.

Though you can try to lower the contrast of this image using Camera Raw's Contrast slider, this really isn't the best approach to solving the problem. First, the Contrast slider can't reduce the contrast by much, and second, it will reduce *all* of the contrast (**Figure 6.19**).

If you have Photoshop CS or CS2, a better approach is to use the Shadow/Highlight tool (Image > Adjust > Shadow/Highlight). Shadow/Highlight analyzes your image and performs an intelligent brightening of only the shadow areas. The results are sometimes incredibly effective (**Figure 6.20**).

Figure 6.19 *Camera Raw's Contrast slider lets us reduce the contrast, but it doesn't let us go very far. Also, though it lightens the shadows, it reduces the contrast in the bright areas. We need a better solution.*

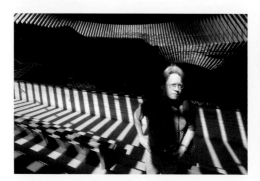

Figure 6.18 *This scene had more dynamic range than the camera could capture, resulting in an image that's too contrasty.*

Figure 6.20 *Photoshop's Shadow/Highlight tool makes short work of the contrast problem shown in Figure 6.8. The default settings bring out plenty of shadow detail without compromising the highlights.*

Contrast reduction is useful not only for correcting outright difficult situations. It can also help when an image is properly exposed, but yields just a little too much contrast, as shown in **Figure 6.21**.

Figure 6.21 *Though well-exposed, the contrast in this image makes it just a tad too harsh.*

While this image isn't bad, the shadow on the underside of the seagull is just a little too strong. In this case, lowering the contrast in Camera Raw reduces the shadow and produces an image that's a little more evenly exposed (**Figure 6.22**).

Figure 6.22 *In this instance, lowering the Contrast slider in Camera Raw reduces the intensity of the shadow on the underside of the bird, creating a gentler tonal transition.*

Adjusting saturation

While extreme adjustments to the Saturation slider can lead to posterization of bright colors, in general Saturation is a fairly harmless tool as far as your image data is concerned. Camera Raw's Saturation slider is not significantly different from the Saturation slider provided by Photoshop's Hue/Saturation control, so it doesn't really matter if you make your saturation adjustments in Camera Raw or in Photoshop.

However, if you wait to make your saturation changes using a Hue/Saturation adjustment layer in Photoshop, you'll have a little more editing flexibility. In addition to performing your saturation change in a nondestructive manner, you'll be able to use layer masks to constrain the effects of your saturation change. You'll learn more about this later in this chapter.

There are no real guidelines about saturation changes; it's purely a matter of taste. Some images are obvious candidates for saturation adjustments because they're low contrast and have weak color. Others are good saturation targets because they have strong color that can be made even stronger with a little saturation boost (**Figure 6.23**).

TIP

You can also think of Camera Raw's sliders as controlling the shape of a tone curve. The Exposure slider represents the upper-right point, Shadows the lower-left point, and Brightness the midpoint. The Contrast slider adds two more points to the curve to create a contrast-inducing S-shape.

Figure 6.23 *The only change made to the rightmost image was an increase in the Camera Raw Saturation slider.*

Some images benefit from a reduction in saturation. Whether the subject matter requires less garish color or you're trying to evoke a particular mood, reducing the saturation of an image can create a very different feel (**Figure 6.24**).

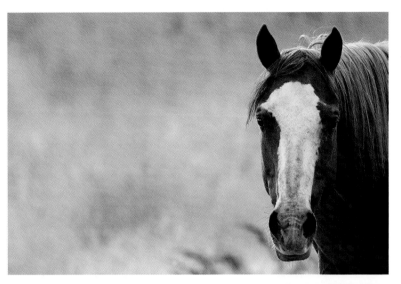

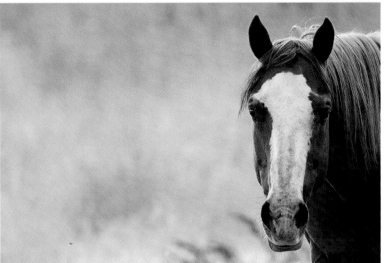

Figure 6.24 *This image takes on a different feel with less saturation. After reducing the saturation, I brightened the image a bit with the Brightness slider and then warmed it some with the Temperature slider. The bottom image shows the result.*

Curves: Another Interface to the Camera Raw Controls

In version 3.0 running under Bridge and Photoshop CS2, Camera Raw gives you an additional adjustment tool in the form of an editable curve that is very similar to Photoshop's normal Curves control. The Camera Raw Curve is a separate adjustment that is applied to your image *in addition to* the edits that you make with the Adjust sliders. The bulk—or all—of your raw work will still be done using Camera Raw's sliders. The Curve tab is simply there to provide you with some extra editing power if you want it.

Having access to curves in Camera Raw gives you an advantage over making your curve adjustments later in Photoshop. Since you can apply curve adjustments in Camera Raw, you can batch process your adjustments along with the rest of your raw editing workflow.

TIP

If you regularly use Photoshop's Curves tool to add a slight, contrast-boosting S-curve, for instance, then you can do the same thing in Camera Raw. Since Camera Raw's curve adjustment is simply a raw conversion parameter like any other, it can easily be copied to any raw image that you're processing.

Using the Curve tab

Just like the Curves tool in Photoshop, Camera Raw's Curve tab lets you add control points and move existing points to create localized changes in a particular part of the curve (**Figure 6.25**).

Figure 6.25 *Like Photoshop's Curves dialog box, the Curve tab in Camera Raw lets you make localized changes in the brightness of your image.*

For the most part, Camera Raw's curves control works just like Photoshop's. You can click the curve to set a control point and then drag that point up or down to lighten or darken the corresponding tone. The curve bends automatically to create a smooth transition to and from that point (**Figure 6.26**).

Figure 6.26 *You can add and move control points by simply clicking and dragging. Camera Raw automatically adjusts the rest of your curve to transition in and out of the new point.*

Note that the Camera Raw Curve tab displays a faint backdrop of your image's histogram behind the curve. This can help you identify which tones correspond to which points on the curve.

An easier method for identifying points is to hold down the Ctrl (Windows) or Command (Mac) key and move your mouse over your image. Camera Raw will highlight the point on the curve that corresponds to the point that you're rolling over. With the Ctrl or Command key held down, a click in your image automatically adds a control point to the relevant part of the curve.

As you learned earlier, by the time an image gets to Photoshop, it has been gamma corrected so that it has a luminance response that more closely resembles the nonlinear way that your eyes interpret light. In Camera Raw, though, you're still working with non-gamma-corrected *linear* data, which

has much more information in its highlights than in its shadows. Therefore, Camera Raw's Curve tab gives you a little more highlight control than Photoshop's does. The downside, of course, is that shadow control using Camera Raw's Curve tab is fairly weak.

You can select predefined curves from the Tone Curve menu. In addition to a straight Linear curve (which makes no change in your image), you can select a Medium or Strong Contrast curve (**Figure 6.27**).

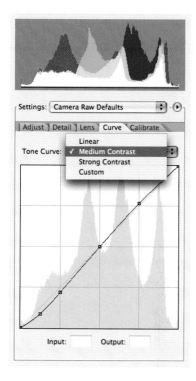

Figure 6.27 *From the Tone Curve menu, you can select preset curves.*

Finally, note that the Camera Raw Curve tab has one major interface differ-ence from the Photoshop Curves dialog box. In Photoshop's normal Curves dialog box, you see your image update in real time as you drag control points on the curve. Unfortunately, Camera Raw's Curve tab doesn't offer this feature. Adobe has wisely engineered the Curve tab control to function as you would expect it to function if you were working with gamma-corrected data. Pulling this off requires so much calculation that Camera Raw can't handle also creating a real-time preview. In Camera Raw, you won't see your image update until you release the mouse button after moving a control point.

KEYBOARD CURVES CONTROL

You can move any selected control point on the Camera Raw curve with the up, down, left, and right arrow keys. If you hold down the Shift key while using the arrow keys, then the control point will move 10 levels at a time.

You can select the next point on the curve by pressing Ctrl-Tab (Windows) or Command-Tab (Mac), and the previous point by pressing Ctrl-Shift-Tab (Windows) or Command-Shift-Tab (Mac).

Curves example

The image in **Figure 6.28** is fairly well exposed. As you can see from its histogram, the blue channel is slightly clipped, so our first step in processing this image will be to use the Exposure slider to recover a little bit of the highlight detail that's been lost in the sky.

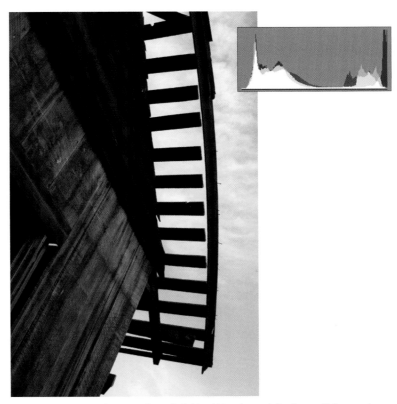

Figure 6.28 *Because this image has a little bit of blue channel clipping, we'll first use the Exposure tool to perform a little highlight recovery.*

As always, recovering highlights leaves our image a little too dark, so we'll use a Brightness move to bring the midtones back up (**Figure 6.29**).

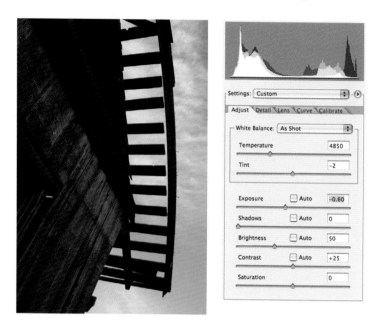

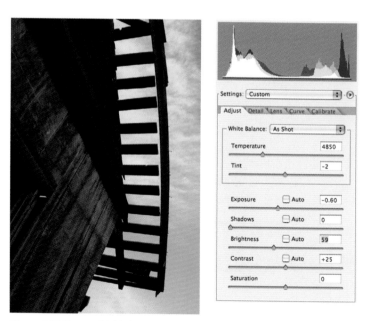

Figure 6.29 *Because highlight recovery darkens our image, we'll brighten it a bit with the Brightness slider.*

Unfortunately, we can't move the Brightness slider too much without losing the highlight detail that we regained with the negative Exposure adjustment. This means that it's not possible to get the midtones as bright as they need to be. The Contrast slider can help things a little bit, but not much because of our highlights concern. A simple adjustment with the Curves control, though, brightens the midtone sides of the barn quite nicely (**Figure 6.30**).

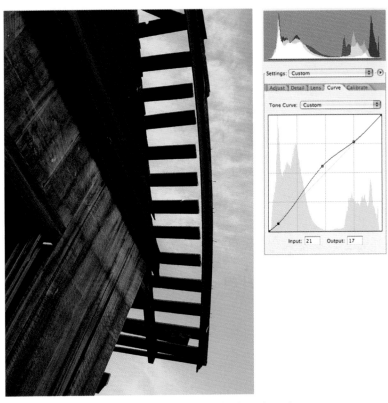

Figure 6.30 *Finally, using a curve adjustment, we'll brighten the midtones of the barn without undoing the highlight recovery in the sky.*

More Camera Raw Editing Examples

Hopefully, you now understand that your basic strategy when using Camera Raw is to use the image data that you've collected to maximum advantage. Whenever possible, this means avoiding brightening shadow details. Here are a few more editing examples.

Goal tending

The image shown in **Figure 6.31** is a fairly straightforward daylight shot. As you can see from its histogram, it's a reasonably well-exposed image. It's a little short on contrast—it would ideally be nicer to have more data across the histogram range—but there's no clipping. There's also a little too much image, so the first step will be to crop it.

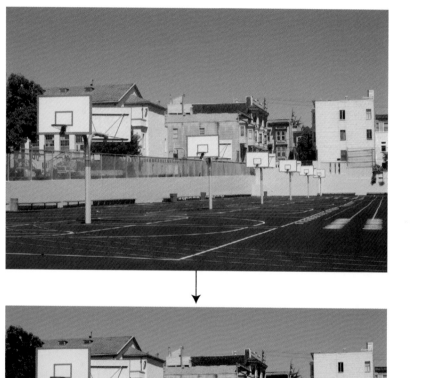

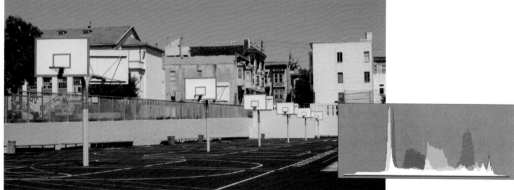

Figure 6.31 *Before any editing begins, this image needs to be cropped.*

Because this image has no blatant exposure troubles, one of the trickiest things about editing it is figuring out what, if anything, needs to be done. The white balance looks fine, so we don't need to worry about temperature or tint. We don't need to fix any highlight or clipping problems. The histogram is weighted a little to the right, which is nice; we can push data down into the shadows if we need to, but the shadow areas—the dark areas beneath the trees—are already okay. In the end, what might make this image a little more compelling is to play up the contrast between the blackness of the blacktop and the white of the basketball backboards.

We could move the Shadow slider to darken the image, but as explained before, the Shadow tool doesn't allow really fine adjustments. Instead, since we want to accentuate the difference between some strong black and white elements, we'll use a Contrast adjustment (**Figure 6.32**).

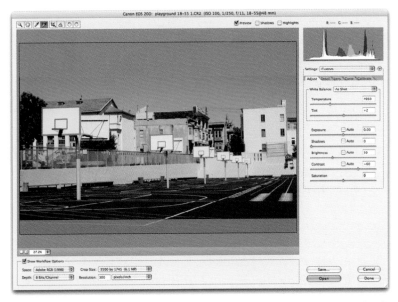

Figure 6.32 *We want to emphasize the contrast between the black of the playground and the white of the basketball goals, so we begin with a Contrast adjustment to increase the contrast in the image.*

Since we've made no other adjustments to this image, we get a very nice, even contrast change. However, as we move the slider to the right, we not only increase the contrast of the black ground and white goalposts, but we also increase *all* of the contrast in the image. Because this photo was shot in bright daylight, the contrast can easily become a little harsh, so we'll stop the Contrast adjustment at +60, which punches up the image nicely.

Nevertheless, we want the ground darker, so let's turn to the Curve tab. We hold down the Ctrl (Windows) or Command (Mac) key and click the black-top in the image to place a control point on the curve and then drag that point downward to darken the blacktop. However, because we don't want to darken any more black tones than we have to, we'll reshape the curve a little bit to try to constrain the darkening to just the blacktop's tonal range (**Figure 6.33**).

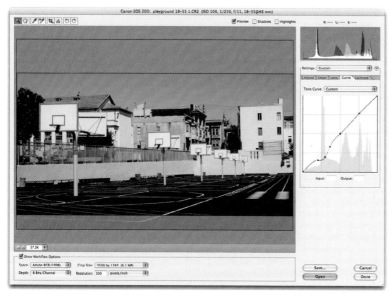

Figure 6.33 *A curve adjustment lets us darken only the blacktop tones.*

Note the histogram that's displayed behind the curve. The largest concentration of pixels is the huge tower of data that sits right behind the point where we made our curves adjustments. The blacktop is the dominant visual element in the scene—a huge collection of pixels—so it makes sense that it leaves a noticeable signature in the histogram. We could easily have chosen where to make our curves adjustments simply by following this part of the histogram.

This gets us the contrast that we want, but before leaving the Curve tab, let's try darkening the sky a little bit. A simple Ctrl-click (Windows) or Command-click (Mac) on the sky gives us a relevant control point on the curve. By moving the point downward slightly, we darken the sky and create an S-shape in the upper tones of the curve. This provides a nice extra contrast boost in the midtones and highlights of the image (**Figure 6.34**).

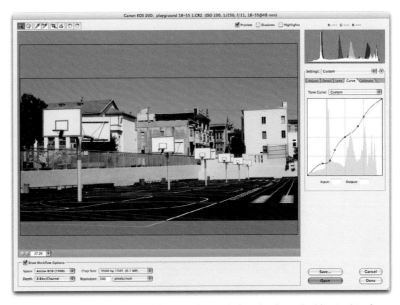

Figure 6.34 *Further refinement of the curve lets us darken the sky and add a tiny bit of contrast to the midtones of the buildings.*

Although the image looks better this way, it's still a very busy picture. It has a lot of visual elements and a lot of contrast. With a quick return to the Adjust tab, we can dial the Saturation slider down to –30. This gives the image a much calmer, almost hand-tinted look. A quick zoom in to 200% shows no noise and a tiny bit of red fringing on the extreme left side of the image. We can easily dial this out with the Fix Red/Cyan Fringe slider (on the Lens tab). Next, click Open to open the image in Photoshop; apply an Unsharp Mask filter to sharpen, and the image is complete (**Figure 6.35**).

Figure 6.35 *For the final image, a little desaturating in Camera Raw tones down the colors a bit.*

Late-night self-portrait

Figure 6.36 is a 30-second exposure shot late at night. The bright light in the sky is the nearly full moon, and the long exposure enabled the camera to capture enough light to render quite a bit of detail in the scene (in Chapter 7 you'll learn more about shooting at night, a photographic situation that is greatly aided by the raw format). Obviously, under these conditions, exposure options are a little limited, and this extremely underexposed image was the best that I could muster. Fortunately, Camera Raw makes it possible to produce a very usable image.

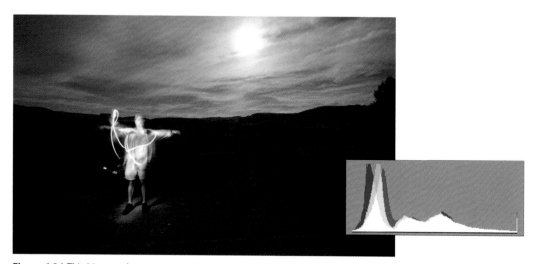

Figure 6.36 *This 30-second exposure was shot late at night under a nearly full moon. Camera Raw will let us pull detail out of the foreground.*

The histogram indicates some clipped highlights, but a quick look at the Highlight clipping display shows that the clipped areas are simply the bright disk of the overexposed moon, as well as the streaks created by the flashlight that I used to "paint" myself with light (**Figure 6.37**). There's not really any meaningful information to recover from these areas so we won't worry about trying any highlight recovery. Besides, the image is dark enough already, and lowering the Exposure slider to recover highlights will only darken things more.

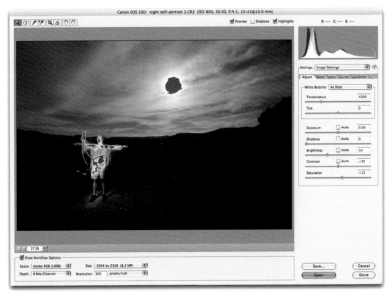

Figure 6.37 *Camera Raw's clipping display shows that the only clipped highlights are in the fully blown disk of the moon, so the image doesn't need any highlight recovery.*

However, if we make a positive adjustment to the Exposure slider, we'll clip the highlights further, which will mean losing detail in the clouds around the moon and in the glows around the flashlight. So our initial brightness adjustments will need to come from the Brightness slider (**Figure 6.38**).

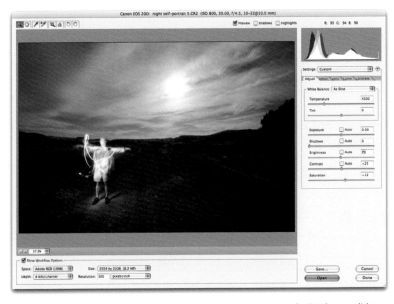

Figure 6.38 *To protect the sky, we perform initial brightening using the Brightness slider.*

Unfortunately, even the Brightness slider adds some highlight clipping, so we don't want to push it too far. Instead, we'll get the rest of our brightening by using the curves tool to apply some more refined corrections. By default, Camera Raw applies a Medium Contrast Tone curve, so this will be the starting point for our curve edits.

The area that needs the most brightening is the road and vegetation—basically, everything on the ground but me. If we hold down the Ctrl (Windows) or Command (Mac) key and roll over my image, we can see that those tones are all in the lowest quarter tones of the image—that is, they all fall within the box in the lower-left corner of the curve. Because of the default Tone curve, this area is being darkened, so we'll begin by reshaping the upper part of the lowest quarter tone to make it a little brighter.

The problem, of course, is that we're talking about the part of the image with the *least* data! Since we're dealing with the darkest tones in the image, that means that we're working with the area that has the least information in it. Consequently, we're not going to be able to brighten this part of the image very much.

Since we can't get it outright *bright*, let's try to make it more contrasty. As you've already seen, an S-curve applied to an image increases contrast, so we'll build a slight S shape into the lower quarter tone of the curve. Finally, to improve the contrast in the sky, we'll darken the midtones and brighten the highlight a tiny bit. This will cost us a tiny bit of detail around the moon, but that's okay (**Figure 6.39**).

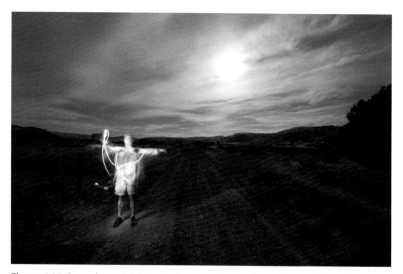

Figure 6.39 *Curves lets us brighten the foreground, as well as apply a little bit of localized contrast. This curve also improves contrast in the sky.*

Finally, let's zoom in to check for chromatic aberration and noise. There doesn't appear to be any chromatic aberration, and the noise that does exist is nothing that we wouldn't expect from a long-exposure, low-light image. Since this image is already fairly stylized, the extra texture that the noise provides is fine, and eliminating noise from this image is only going to soften details further, so we'll leave the noise alone.

Making Localized Corrections

Sometimes, you need to create edits that apply to only specific areas of your image. While Camera Raw doesn't allow you to do this (although you can perform localized brightness changes using the Curve tab), here are some quick ways to make selective edits in Photoshop and Photoshop Elements.

Adding a mask to an adjustment layer

You've already seen that you can apply Levels, Curves, and Hue/Saturation adjustments using Photoshop's adjustment layers (Elements users don't have access to Curves adjustment layers). Adjustment layers let you apply these types of edits without altering your original image data. They also allow you to go back later and tweak your adjustments.

Adjustment layers provide another advantage over the regular Levels and Curves dialog boxes. Every adjustment layer includes a built-in layer mask, which lets you control which parts of the image the adjustment affects (**Figure 6.40**).

Figure 6.40 *In Photoshop, all adjustment layers include a layer mask, which you can use to constrain the effects of the adjustment to particular parts of your image.*

Layer mask

Add an adjustment layer

Figure 6.41 shows an image that has already been processed by Camera Raw. Though the contrast is already fine, let's add some saturation to only the door, leaving the wall as it is.

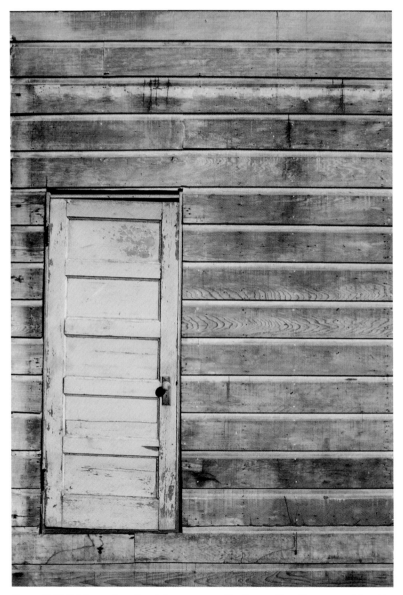

Figure 6.41 *This image has already been processed by Camera Raw. Now we want to add saturation to only the door. In Camera Raw, the Saturation slider affects the whole image.*

TIP

If you're not sure how to create an adjustment layer, see Figure 3.29 in Chapter 3.

You begin by creating a Hue/Saturation adjustment layer and configuring it to increase the saturation (**Figure 6.42**). The adjustment layer applies its saturation increase to the entire door image, boosting the saturation in the door as well as the wall.

Figure 6.42 *We begin by creating a Hue/Saturation adjustment layer and dialing in the saturation boost that we want. Right now, the entire image is being saturated.*

On the Layers palette, note the small layer mask thumbnail in the Hue/Saturation layer. It is currently completely white, indicating that the layer mask is empty. Because there's no masking information, the effect of the layer mask is applied to the entire image. Click the layer mask thumbnail to select it. Now any painting operations that you make will affect the adjustment layer's layer mask rather than the image itself.

Paint a layer mask

Select the Paint Brush tool and set the foreground color to black. Begin painting on the wall areas of the image, and you'll see the saturation effect disappear. In addition, on the Layers palette, the layer mask thumbnail will show the areas that you've painted (**Figure 6.43**).

Figure 6.43 *By painting in the adjustment layer's layer mask, we can control which parts of the image are affected by the adjustment layer. Here, you can see the incomplete mask on the Layers palette and the resulting partially saturated image.*

Layer masks work just like a stencil. Anywhere you paint with black will be protected from the effects of the associated adjustment layer. Anywhere you paint with white will allow the effects of the layer mask to fall through to your underlying layers. If you paint with shades of gray, then those parts of your layer mask will be semi-opaque, allowing varying degrees of your adjustment layer's effect to pass through. If you accidentally paint black into an area that you *don't* want to have masked, you can simply switch to white and paint areas back to normal. You can use any of Photoshop's painting tools to paint a layer mask. To fill large areas of the mask, try using Photoshop's selection tools along with the Paint Bucket tool or Fill command.

For this image, you don't need to be too concerned about having a perfect masking border around the door. If a little bit of the saturation boost spills into the wall, that's okay. Use a brush with a very soft edge, and you'll automatically get a smooth masked-to-unmasked transition around the door.

Refine the saturation settings

After painting the mask, I decided that my initial saturation boost settings weren't quite high enough, so I double-clicked the adjustment layer on the Layers palette and dialed the Saturation setting up to 50 (**Figure 6.44**).

Figure 6.44 *With the final mask, only the door receives a saturation boost.*

Adding masks to image layers

You can add a layer mask to any type of image layer and get the same type of mask painting features that you have with adjustment layers. This means that you can easily create composites of different images by stacking images and then painting a mask on the upper image so that only certain parts of it are visible.

For example, consider the picture in **Figure 6.45**. This scene had a dynamic range way beyond what my camera could capture. Trying to find an exposure that could capture both the dark shadows and the bright sky was impossible. In addition, some of the fog in the sky is clipping and has lost highlight detail.

As you saw earlier in this chapter, we can use a negative Exposure adjustment in Camera Raw to recover the lost highlights in the fog and achieve a better rendering of the sky (**Figure 6.46**).

Obviously, doing this makes the rest of the image even darker than before. In Camera Raw, we could try to use the Brightness slider to brighten the shadow details, but the negative Exposure adjustment was so extreme that there's not much we can do to brighten the rest of the image at all, let alone to brighten it without introducing noise and posterization.

Figure 6.45 *Because this scene had more dynamic range than the camera could capture, it was impossible to properly expose both the bright sky and the shadowy foreground. This problem can be fixed with a simple compositing operation.*

Figure 6.46 *We begin by processing the file in Camera Raw to recover the highlights in the fog and produce an image with a well-exposed sky.*

For **Figure 6.47**, I went back to the original raw file and processed it again, but this time I concentrated on getting a good exposure for the midtones and shadows, without worrying about the sky at all. Because I didn't need to make a negative Exposure move to save the sky, I was able to make a slight positive move to brighten a lot of the midtone and shadow areas.

Figure 6.47 *Next, we use Camera Raw on the same raw file to produce a second image with a well-exposed foreground.*

Sandwich the images

Using layer masks, it's a simple matter to composite one image on top of the other to arrive at a final image that contains the well-exposed sky from Figure 6.46 and the well-exposed shadows from Figure 6.47.

We begin by opening both images in Photoshop or Photoshop Elements. We start with the image with the properly exposed sky and choose Select > All to select the entire image and then Edit > Copy to copy the image. Next, we go to the second image and choose Edit > Paste. We now have a document with two layers, with the dark, properly exposed sky layer on top (**Figure 6.48**).

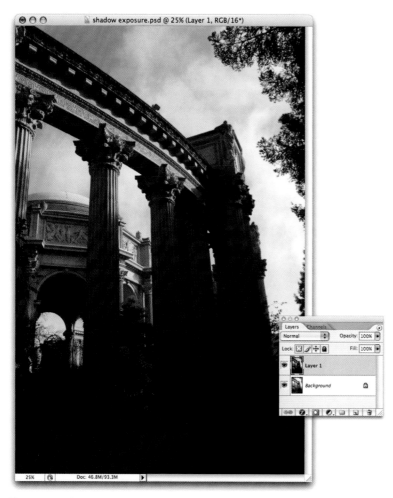

Figure 6.48 *After copying and pasting the first image into the second, we end up with two layers: one containing the well-exposed sky, and a lower layer containing the well-exposed foreground.*

Now we'll add a layer mask to the upper layer so that we can mask out parts of it to reveal the better-exposed image that lies beneath. In Photoshop, with the upper layer selected on the Layers palette, we select Layer > Layer Mask > Reveal All. This adds an empty layer mask to the upper layer—empty meaning that it is completely white, which leaves the entire upper layer visible.

We click the Layer Mask icon to select the layer mask and begin painting with black. Wherever we paint, we're indicating that those pixels of the upper layer should *not* be visible—we want them completely masked out (**Figure 6.49**).

Painting the mask goes very quickly, because we can grab a big brush and cover most of the image with a few strokes. Obviously, painting around the tree would be extremely tedious, but here, we'll make it completely silhouetted, so we don't worry about masking it at all. We can use a soft-edged brush for painting around the edges of the building that butt up against the sky. These areas don't need to be perfectly masked, because any dark areas left on the top of the building simply look like shadows. With the mask completed, we have a good composite that presents an image with a lot of dynamic range (**Figure 6.50**).

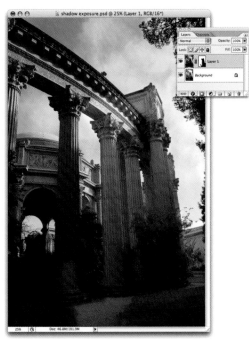

Figure 6.49 *After adding a layer mask to the upper layer, we can paint out the areas of the upper image that we don't want to see, revealing the well-exposed lower layer. Here, you can see the mask partially completed. Some of the darker columns are still visible.*

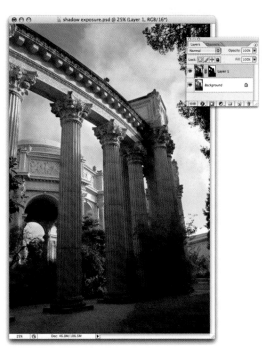

Figure 6.50 *With the mask completed, we have an image with a lot of dynamic range. Both the sky and the darker shadows are well exposed and visible. On the Layers palette, you can see the final layer mask that makes the image possible.*

Improve the mask

While this is a perfectly reasonable composite, we can make a more dramatic image by varying the layer mask to leave some areas darker than others. Painting with black or white reveals either one layer or the other. But by painting into the mask with shades of gray, we can cause a blending of the two layers. This allows us to leave some of the shadow areas a little darker, to create more contrast and contour. The final image is shown in **Figure 6.51** along with the final layer mask.

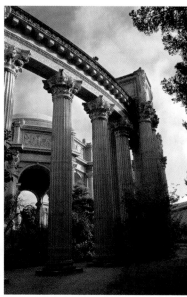

Figure 6.51 *By painting into the mask with gray, we can combine parts of the two layers, rather than replacing one with the other. This allows us to paint in shadows to give the image a little more contour. Shown here is the final layer mask, along with the final image.*

This image was fairly easy to composite because there were no tricky, fine details that had to be masked. Wisps of hair, semitransparent objects, foliage—anything with complex details—can be very difficult to mask, so using a composite for these difficult dynamic-range situations is not always possible. Fortunately, as you'll see in the next section, raw provides an alternative.

Creating High-Dynamic-Range Images

By now, you've probably been doing some raw work of your own and have experimented to see the difference between 8-bit and 16-bit images. When you tell Camera Raw to produce a 16-bit image instead of an 8-bit image, you should be able to "feel" a difference in the resulting files when you start to edit them. With 16 bits of data for each pixel, a 16-bit image can contain a much larger variety of colors than you can get in an 8-bit image.

The range from black to white may be exactly the same whether you're storing in 8 bits or 16 bits, but a 16-bit image will have a much finer gradation of tones between those two points. This finer gradation means that you can make finer edits without worrying about creating tone breaks.

NOTE

This dynamic-range limitation is not just a digital limitation. Most films have about the same range, though some black-and-white films have a slightly greater range, but still far less than your eye.

In the previous layer masking example, though, our problem was not a lack of intermediate tones. Rather, it was that the camera couldn't capture the extreme range of light to dark that was in our scene. As discussed earlier, a camera can capture only about 8 to 10 f-stops (or EV) of light, while some outdoor scenes can have a range of 12 EV. So in the previous example, the only way to capture the full range of light that was present in the scene was to shoot two exposures and composite them. Our first exposure captured the bright areas of the image, and our second captured the dark areas. By compositing them, we effectively created an image with a much wider dynamic range than a camera can capture in a single shot.

With Photoshop CS2, Adobe added support for 32-bit images. As its name suggests, a 32-bit image stores 32 bits of data per pixel. With 32 bits, you can store a mind-numbing variety of colors. However, 32-bit image mode is not intended for everyday use. Hardly any of Photoshop's regular tools or commands work in 32-bit mode, and even if they did, they would be tedious to use. A 32-bit image contains such a tremendous amount of data that even a very speedy computer would grind to a halt if you tried to perform the processor-intensive tasks that you normally execute in Photoshop.

Adobe added 32-bit support to facilitate the creation of high-dynamic-range (HDR) images. When you have 32 bits of storage space per pixel, you can represent a much larger dynamic range than when you have only 8 or 16 bits per pixel. HDR provides a way to create images that have a much higher dynamic range than what a camera can capture in a single exposure, and it allows you to do this without any compositing or masking.

HDR basics

To create an HDR image, you first need a scene with more dynamic range than your camera can handle. Creating HDR images is a bit of a chore, so HDR is not something you want to use for everyday shots. In addition to the hassle of carrying a tripod, you'll need to spend some time properly shooting your scene. You'll then spend a fair amount of time in Photoshop putting your final image together.

The most common HDR application is landscape photography, where it can be very difficult to properly expose a foreground and sky in the same shot. Interiors of buildings can also benefit from HDR when you want to capture both a well-exposed interior and the details outside a brightly lit window.

As with shooting a composite, you make an HDR image by taking a series of pictures of your scene, each with a slightly different exposure (**Figure 6.52**). We'll discuss the specifics of HDR shooting in the next chapter, but your goal is to shoot at least three images (and preferably five or six) with varying exposures.

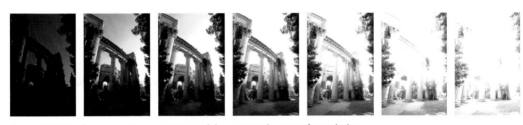

Figure 6.52 *For these seven images, I increased the exposure by 1 stop for each shot. These seven exposures will be used to create a high-dynamic-range 32-bit image.*

Your intent is to produce a series of images that fully reproduce the dynamic range of the scene—so you'll have underexposed images that properly capture the bright areas of your scene, and overexposed images that properly capture the shadow areas of your scene. This is just what we had in the previous compositing example, but with HDR, you have more source images and no masks.

Camera Raw processes your source pictures and then hands them off to Photoshop, which analyzes them. Photoshop pulls different ranges of brightness information from each of the exposures and then combines the pictures to create one 32-bit image with the full range of bright to dark that you captured.

One of the most impressive things about Photoshop's HDR capability is that it does a fairly good job of mimicking some of the things that your eye does. In the process of combining and merging your HDR source images, Photoshop compresses the overall contrast range of those images without reducing the contrast of any well-defined edges in your scene.

Creating an HDR image

Obviously, shooting your source images is the first step in creating an HDR image, and you'll learn how to do this in the next chapter. Once you have your sources, you're ready to begin merging.

Merge to HDR

You can launch the Merge to HDR feature from either Bridge or Photoshop. For this example, we'll be hosting the entire procedure in Photoshop.

In Photoshop CS2, select File > Automate > Merge to HDR. In the Merge to HDR dialog box (**Figure 6.53**), you select your raw source files. If you want, you can convert your source images yourself using Camera Raw and then open them in Photoshop. Set the Use menu to Open Files, and it will work with the currently opened images.

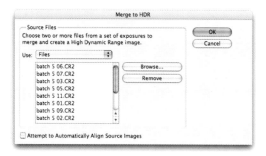

Figure 6.53 *The Merge to HDR dialog box lets you select the source images that you want to merge into a final HDR image.*

When you click the OK button in the Merge to HDR dialog box, Photoshop will spend some time opening all of your source images and then will present you with a new window containing your merged composite (**Figure 6.54**).

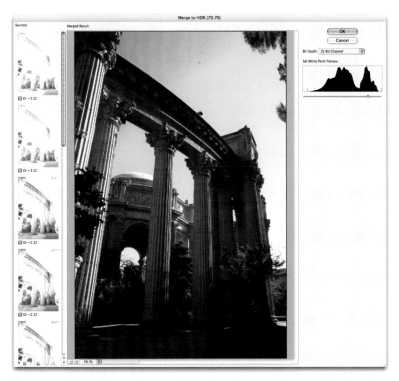

Figure 6.54 *After performing the merge, Photoshop gives you a chance to deactivate the source images and to view the entire 32-bit range of data that you have collected.*

Don't be disappointed

Here's a warning: If you thought that an HDR image would have a breath-taking sense of color and realism thanks to its much greater dynamic range—if you thought that you were going to see an image far beyond what you've ever seen before from your digital camera—then you're going to be a little disappointed.

While your 32-bit image may be overflowing with useful image data, your computer monitor is still, at best, a 10-bit display device. It simply can't come close to showing the huge range that may be present in your new 32-bit image. Sadly, a reflection print on white photo paper offers a dynamic range of only about 100:1, or 8 bits.

So what's the point of going to all of this trouble if you can't see the data on your monitor or printer anyway?

Think back to our compositing example from earlier. Our final image did not have *all* of the information that was contained in our two source images. We culled some tonal information from one image and other tonal information from the other image, and in some parts of the image, we *blended* tonal information from both sources.

HDR works kind of the same way. Though you can't see all of the tonal information that's present in your 32-bit image, the data *is* there. Where the data becomes useful is when you use some special conversion tools to turn your 32-bit image into a 16-bit image that contains tonal values culled from different parts of your entire range of source images.

Explore the data

The resulting image shown in the Merge to HDR window may look a little strange. First, notice that it has more shadow and highlight detail than any of your individual source images. However, it may appear a little washed out, and some highlights may even appear to be blown.

The left side of the window shows a scrolling thumbnail display of all of your source images, along with the exposure values that Photoshop calculated for each image. For example, in Figure 6.54, the first image has an exposure value of +3.32, indicating that it was overexposed by 3.32 EV.

The check boxes allow you to turn off each image. Deactivating an image removes its data from the merge. This can be an interesting way to see which data Photoshop is pulling from which image. Remember that the brightest image in your sequence is contributing the *darkest* information. In this case, the bright image is contributing a lot of the darker shadow tones near the base of the columns. Conversely, the darkest source images are contributing the bright areas of the sky.

Based on what you've been learning, this is good news. Since the shadows are coming from the brightest images, the ones that are overexposed, then they'll most likely be noise free.

On the right side of the window is a Set White Point Preview slider. This slider does *not* affect any of your image data. It's there only to help you explore the full range of data in your merge. By moving it, you can view brighter or darker parts of your 32-bit file.

Though the Set White Point Preview slider doesn't change any of your actual image data, its setting *is* stored with your 32-bit image and is used by Photoshop later in determining what the image should look like on the screen, so be sure to leave it on a setting that presents a pleasing image.

Create the merge

Click OK, and Photoshop will perform the final merge and deliver a 32-bit file in a normal Photoshop window (**Figure 6.55**). If you poke around in the Photoshop tool palette, you'll find that most of the tools aren't functional. However, you can use Photoshop's Rubber Stamp (Clone) tool, which is good for making minor touch-ups. You can also sharpen, blur, and apply a few other filters as well as resize and rotate the image. For the most part, though, you won't be doing any serious editing on the 32-bit file. In this case, my merge suffered from some troubles with camera sensor dust, so I removed these with the Rubber Stamp tool.

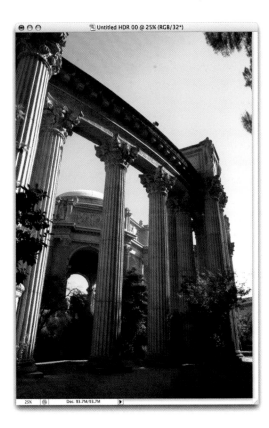

Figure 6.55 *After the merge, you'll have what looks like a normal Photoshop file. If you look in the title bar, though, you'll see that it's a 32-bit image. Because most Photoshop tools don't work on 32-bit images, there's very little you can do in the way of editing at this point.*

Save the image

Before you can start any serious editing, you need to convert your image to a 16-bit file. Just as your raw file can be processed in different ways, you can perform different 16-bit conversions of your 32-bit image, so it's a good idea to save the 32-bit file so that you can try different approaches to the conversion. Choose File > Save and save the image in Photoshop format.

Convert to 16-bit

Select Image > Mode > 16 Bits/Channel to invoke the HDR Conversion dialog box. This is where the real work of making a good-looking HDR image takes place. To perform the conversion, Photoshop has to figure out which tonal values to throw away to fit the huge mass of 32-bit data into a 16-bit data space. To allow you some control of the process, the HDR Conversion dialog box presents several conversion options, each of which provides different controls (**Figure 6.56**).

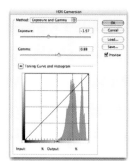

Figure 6.56 *Photoshop provides several methods for converting your 32-bit image into a more usable 16-bit image.*

The default setting is *Exposure and Gamma*, which provides two sliders. Exposure makes an overall brightness change, and Gamma shifts the brightness of the midpoint. For an image with a lot of range, this is kind of a brute-force tool that may not allow you to achieve the contrast that you want, especially in the darker parts of your image.

Highlight Compression simply compresses the brightest values in the 32-bit HDR composite, so that they fit within the range provided by a 16-bit image. While this conversion brings lots of shadow detail out of your image, it can be really brutal on highlight areas.

Equalize Histogram tries to compress both shadows and highlights to fit the whole HDR range into 16-bits. This conversion is easier on your highlights, but it may cost you a lot of shadow detail.

For images that don't possess a huge range, Highlight Compression and Equalize Histogram can work well. For most images, though, you'll want to use *Local Adaptation*. Local adaptation provides a curve interface that lets you create a tone curve that alters the brightness of specific parts of your image.

When you first select Local Adaptation, things may look pretty grim. You'll need to click the arrow to open the Toning Curve and Histogram display (**Figure 6.57**).

Figure 6.57 *Local Adaptation is your best option for making 16-bit conversions from 32-bit images. Though the image may look bad at first, the editable curve provides a tremendous amount of control.*

Just like the curve in Camera Raw or Photoshop, the Local Adaptation curve lets you roll over your image to identify where specific tones are represented on the curve. Command-clicking automatically places a control point on the appropriate spot of the curve.

Your goal is to place control points on your curve and position them to set the brightness levels of different tonal values in the image, just as you would when editing a curve in Photoshop. If you're not sure where to start, try following the histogram that's superimposed behind the curve. Where there's no data in the histogram, there's no need for a curve adjustment. Anchor the curve where the data begins and then start your adjustments by reshaping the curve into an S-shape (**Figure 6.58**).

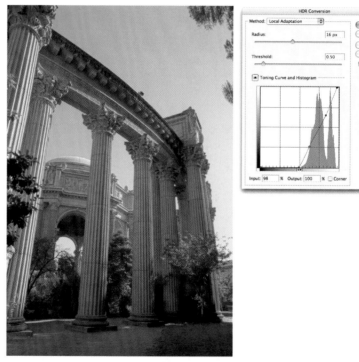

Figure 6.58 *A good place to begin your editing is to set up a simple contrast-inducing S-curve. Note that most of your curve adjustments will be extremely subtle.*

This will give you a reasonable amount of contrast and at least make the image appear a little normal. From there, you can sample points and make adjustments to bring out more or fewer shadows in some areas and to improve the contrast and brightness of the midtones and highlights in other areas (**Figure 6.59**).

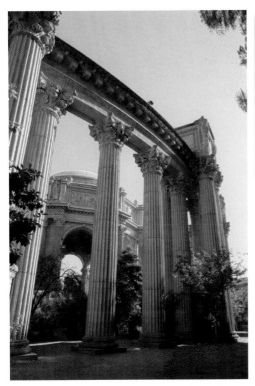

Figure 6.59 *After a few more control point additions, this curve works well for our image.*

One important difference between the Local Adaptation curve and the other curve controls you've used is that the Local Adaptation curve allows you to create corner points. Select a point on your curve and select the Corner Point check box beneath the curve display, and your point will become a corner, allowing you to isolate that point of the curve from the effects of adjacent control points.

Above the curve control are two sliders: Radius and Threshold. These control the way that the curve treats the varying brightness values of neighboring pixels. To understand how these sliders affect your image, you need to play with them. In general, the default settings are usually best.

Even slight adjustments to the curve can have a big effect on your image, and you'll have many choices about how to adjust different tones. **Figure 6.60** shows a different Local Adaptation conversion of the same image that was used to create Figure 6.59.

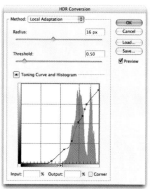

Figure 6.60 *Here's the same image data converted using a different Local Adaptation curve. Because a 32-bit image contains so much information, you can create very different interpretations of your scene simply by changing the conversion curve.*

Using the Load and Save buttons in the Local Adaptation dialog box, you can save different curves, allowing you to experiment with different conversions of your data. As you can see, by simply reshaping your curve, you can create a different interpretation of your image.

Click OK, and Photoshop will perform your specified 16-bit conversion, and you'll have a normal, editable 16-bit image. To give you an idea of how much more dynamic range you can capture with an HDR image, **Figure 6.61** shows the best single image that I was able to capture compared to my final HDR composite. The HDR image has much more detail in the shadow areas and sky, and much better tone in the midtones, offering slightly better color.

NOTE

If you want to go directly to 8-bit from your merged 32-bit image, you can simply choose Image > Mode > 8 bits/Channel. You'll be presented with the same conversion dialog box, but your resulting file will be an 8-bit image.

Figure 6.61 *Here you can see the best single exposure that I could get of this scene (left) alongside my final HDR image (right). In addition to the improved shadows and sky in the HDR image, notice the more even tone on the midtone areas of the columns.*

Refining an HDR image

Although you can do a lot of tonal correction during your conversion from 32-bit data, your image will most likely need a little editing once you've arrived at a usable 16-bit image.

Correcting motion

The trees in the upper-right corner of the final image have some annoying magenta fringe around them (**Figure 6.62**). This is not chromatic aberration, but an unfortunate result of the fact that the trees were blowing in the wind while I was shooting my separate exposures. Because they're not properly registered from shot to shot, they are slightly blurry and fringed with color in the final merge.

There's no simple way to eliminate this fringe, so rather than try to correct it, we'll simply replace the trees. We'll begin by using the Rubber Stamp tool to remove the original trees from the scene (**Figure 6.63**).

Figure 6.62 *This annoying magenta fringe is the result of the trees blowing while I was shooting my separate shots. Because the trees are not properly registered, they don't merge correctly.*

Figure 6.63 *Rather than trying to remove the magenta fringe, we're going to simply replace the tree. Using Photoshop's Rubber Stamp tool, we first erase the trees in the merged image.*

Because they're heavily backlit, the trees look fine as a silhouette. Find a source image that has a well-exposed sky and use Photoshop's Rectangular Marquee tool to select the corner of the image where the trees are. Then copy this selection and paste it into the merged document (**Figure 6.64**).

Figure 6.64 *The tree image was copied from one of the original source files and then pasted into the final merge.*

Since we picked an image with a well-exposed sky, we have a strong blue background behind the silhouetted tree. Eliminating it is very simple. With the Magic Wand tool, click the sky to make a selection and then choose Select > Similar to select all of the other sky tones in the pasted layer. Then choose Select > Feather and add a 1-pixel feather to the selection, to create a smoother edge around the selected area.

Pressing Delete deletes the selected sky, leaving the tree silhouetted against the HDR sky. Because the selection we pasted in was rectangular, it included more than just the trees in the corner. A section of the columns was also pasted, but we can remove it easily with the Eraser tool (**Figure 6.65**).

Figure 6.65 *After deleting the sky and the extra parts of the building that were pasted in, we're left with an original tree silhouetted in front of the high-dynamic-range sky.*

In general, it's best to pay attention to this sort of thing while shooting. If you're in a windy location, don't try to focus too closely on moving objects.

(While removing the trees, I also took the opportunity to remove the flood light from the top of the structure and a plastic cup that some loser had left at the bottom of one of the pillars instead of putting in a trash can.)

Correcting tone

Unfortunately, even after all that fancy high-bit work and conversion, your image may still need some tonal corrections using Photoshop's regular toning controls. To create the final image, use adjustment layers to improve the contrast of the scene and to add a little localized saturation.

Because we use layer masks for these edits, you may be thinking, "Oh great, we're back to mask painting? So what was the point of all this extra trouble?" But our masks were very simple, and also, because every part of the image has much more detail in it, we have a file that allows much more manipulation than the sandwiched composite that we looked at before. And because the shadow details were pulled from the brighter images in the sequence, we have a final image that is noise free from its brightest to darkest tones. **Figure 6.66** shows the final result.

Figure 6.66 *The final image after it's been retouched and had a slight levels and saturation adjustment applied and a little bit of sharpening.*

Too real?

One of the most curious things about high-dynamic-range images is that they don't always look "right," and one of the reasons is because they don't look like the photos we're used to seeing. We're accustomed to seeing photos with a very limited dynamic range, which often means an image with very dark shadows or very bright highlights. An HDR image, with its tremendous range, often lacks these extremes and so can look a little strange to us.

Photography is a representational medium, and normal photos are abstracted quite a way from reality. HDR, with its expanded range, creates images that are more like what your eye actually sees, but fairly far from what you're accustomed to seeing in a photo. In addition, abstracted images are often more appealing, because they force your imagination to fill in details on its own. When you provide more detail in the print, there's less for the viewer to imagine, and the viewer has less personal involvement in the viewing process.

When working with HDR images, therefore, you have to make a number of decisions about how much extra range you want to reveal. As you can see from the Highlight Compression sample in Figure 6.56, simply adjusting your image so that every tone is visible does not create a very good picture. You may even find yourself *obscuring* some shadow detail to make a more pleasantly contrasty image. What's nice about HDR is that it provides a tremendous amount of latitude for making these types of decisions.

Conclusion

If there's one simple thing to take away from this chapter it's that when working with raw files, your highlight data is your most valuable asset. The brightest tones in your image are where the bulk of your image data resides, so when making edits, you should use this data to maximum advantage.

This idea is useful only if you captured good data in the first place, so in the next chapter, you'll learn how to shoot to capture raw images that afford the greatest range of flexibility.

Shooting Raw

When we speak of image editors like Photoshop, we often say that their tools are used for performing "corrections" on an image. While this is true—a Photoshop-caliber image editor can perform amazing corrections of everything from bad exposure to lens flares—thinking of your image editor as a tool for "correction" can be a limiting mind-set when shooting.

Sure, some images need correction, but in other cases, it's simply not possible to get the image you have in mind using *only* your camera. Whether you're shooting analog or digital, the camera is very often the starting point for the image that you have in mind. For these occasions, your image editor is not used to correct the image that comes out of your camera, but to *finish* the image that comes out of your camera, so that it matches what you perceived when you saw the scene.

For example, one night while walking down the street in San Francisco, I saw the scene shown in **Figure 7.1**.

The actual scene looked slightly different from this picture. My eye could perceive a little more detail in the shadows than what you see in this image. But for the most part, this is fairly accurate. The yellow lighting of the streetlights was fairly dim, so the flower was not particularly illuminated.

What struck me about the scene though, was the fact that the flower was sticking up out of darkness into light. While my eyes saw a dimly

San Francisco Bay Bridge.
Canon EOS 20D with
Canon 10-22mm
EF-S. 6s at f/4.

lit flower sitting in a field of slightly darker, but still discernible, background, the image in my head was of a luminous white flower on a field of black. I knew that I wanted to preserve as much of the flower's detail as possible, so I chose an exposure that would properly expose the flower, and shot what you see in Figure 7.1

Though it's not particularly interesting, there's nothing wrong with this image. The shadow and highlight details are both reasonably exposed, given the available lighting; the colors are accurate, given that I was looking at a scene bathed in yellow light. This image doesn't need to be "corrected." However, it's not finished. The image in my mind of a luminous white flower in a field of black is not here. With a combination of raw processing and some additional manipulation in Photoshop, I was able to finish the image to produce the one shown in **Figure 7.2**.

Figure 7.1 *When I encountered this flower, the actual scene looked something like this.*

Figure 7.2 *With some simple adjustments, I finished the image that I began in my camera to produce a picture that matches the vision that I had when I shot the scene.*

No matter how good your camera, photography never produces a completely accurate reproduction of the reality of a scene. Just like painting or sculpture or ballet, photography is a representational process. Photographs are not three-dimensional, they don't provide the same field of view as your eye, and they are not capable of capturing the full range of light to dark that your eye can see. Because of all of these factors, you often have to decide how you want to use the capabilities of your camera to represent the scene that you're looking at. Very often, you'll need your image editor to finish this process.

Your goal when shooting, therefore, is to capture as much information as you can, and ideally to capture it in a way that will facilitate easy and effective editing later.

In this chapter, we're first going to look at how you can use your camera's exposure controls to better exploit the capabilities of raw shooting. Later, we're going to look at some of the special types of shooting that are facilitated by the raw format.

Assessing Your Camera's Capabilities for Shooting Raw

In Chapter 6, you learned a lot about how image information is stored in a raw file. To recap: In a raw file, half of the information your camera captures is used to record the highest exposure value (brightest parts) in your scene. Half of what's remaining from that is used for the next highest EV, and so on, for about 8 to 10 stops worth of light. This means that the bright areas of your image will have tremendous detail, while the shadow areas will be represented by very little information.

The practical upshot of this is that if you try to choose exposures that capture lots of bright tones, you'll have a lot of image data to work with when you edit. This will allow you to make edits with far less risk of encountering posterization or tone breaks. If you expose to capture shadow detail, the resulting image will have less data compared to one produced when you expose for the highlights, simply because of the way information is represented in digital form. If you try to brighten those shadow details, the image will become noisy and possibly posterized.

It's much more effective to darken the data-rich bright areas in a raw file than it is to brighten the low-data shadow areas.

The risk, of course, is that if you overexpose, you may clip your highlights and end up with an image with lots of useless white space in it. Fortunately, there are ways to avoid this problem.

Your camera probably provides several methods for controlling exposure, and you'll want to use all of these in conjunction with your camera's histogram display to determine a good exposure for your scene.

Before you go on, you need to determine what exposure tools your camera provides. Raw-capable cameras are usually well stocked with features, so your camera will most likely provide some variant of the capabilities discussed here.

In-camera histogram

Because a histogram provides such an easy way to judge over- or under-exposure, many cameras now provide the ability to view a histogram of any image that you've shot.

On most cameras, to see a histogram of an image, you start by using the camera's playback controls just as you normally would. If your camera has a histogram capability, you will be able to cycle through a variety of information displays, one of which will contain a histogram (**Figure 7.3**).

Figure 7.3 *When playing back images that you've shot, the Canon EOS 20D can super-impose several screens of information. In addition to basic exposure settings, the 20D can display a histogram.*

Reading an in-camera histogram is no different than reading the histograms provided by Photoshop. Like Camera Raw, some cameras provide three-channel histograms that let you view separate histograms for the red, green, and blue channels.

Many cameras that provide a histogram display also include special clipping displays. A clipping display indicates clipped highlights in the thumbnail display of your image by flashing any highlight pixels that are clipped (**Figure 7.4**).

Figure 7.4 *In this image, the camera is indicating clipped highlights by flashing clipped pixels in black.*

The image in your camera's LCD screen

While the histogram provides an easy way to spot whether you've over- or underexposed, when you shoot raw your camera's histogram is not entirely accurate. The image that's shown on your camera's LCD screen is a JPEG image generated from the raw file. Because it's a JPEG image, it has had a gamma correction curve applied. The histogram that your camera displays is a histogram of this gamma-corrected data, which means that it's not the same as the histogram that you'll see when you edit the image in Camera Raw (**Figure 7.5**).

Figure 7.5 *Unfortunately, when your camera displays a histogram of a raw file (left), it won't necessarily match the histogram you see in Camera Raw (right).*

In addition to the discrepancy caused by the gamma-corrected data that your camera is working with, the fact that Camera Raw displays single-channel information accounts for some of the other disagreement that can occur between the two displays.

In general, you'll probably find that your camera's histogram shows shadow values that are fairly accurate, but that it is very conservative about highlight values. Highlight tones that are very close to the right edge of your camera's histogram may have more headroom when viewed in Camera Raw. This is good news, actually. After all, if the histogram on your camera is going to be inaccurate, you'd rather it be overly cautious.

To be certain of how your particular camera works, do a little experimenting. Transfer some images to your computer, but leave copies of them on your camera's storage card. You can then compare the camera's histogram side by side with the Camera Raw histogram. If you find out that your camera's histogram shows highlights as being brighter than they really are, then you should be able to push your overexposures farther than what your histogram indicates.

The effect of your settings on the LCD image

Most cameras provide settings for altering contrast, saturation, sharpening, and a few other parameters. As you learned in Chapter 2, these parameters are used for processing JPEG images and are not applied to any raw files that you shoot. However, your camera *may* apply these settings to the JPEG previews of your raw files that it builds for display on the camera's LCD screen. Since your camera bases its histogram on these JPEG previews, these parameter settings can have an impact on the accuracy of your in-camera histogram (**Figure 7.6**).

Figure 7.6 *Your choice of in-camera parameter settings can affect your camera-generated histograms. Though the differences are slight, changing the camera's settings affected the histograms of these two images, shot moments apart. In addition to a slight difference in shape, the data in the right image is shifted a little to the right.*

In raw mode, shoot some test shots with different parameters and notice how both the image review and the histogram change. Most cameras provide a range of –2 to +2 for each editable parameter. However, 0 usually doesn't mean no correction; it actually means more correction than –2, but not as much as +2, so you may find that a setting of –2 yields the most accurate histogram when you're shooting raw, because it results in the least alteration of your image. However, you probably won't be able to completely eliminate the discrepancy between your camera histogram and Camera Raw's histogram, because your in-camera histogram will still be gamma corrected.

LIVE HISTOGRAM

Some cameras offer the ability to display a histogram *while* you're shooting. Live histograms are not possible on single-lens reflex cameras, but any camera in which the LCD screen can be used as a viewfinder is capable of supporting a live-histogram feature (**Figure 7.7**).

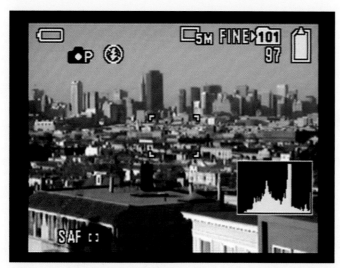

Figure 7.7 *With a live-histogram feature, you can see a histogram of the scene you're currently shooting, updated in real time as you recompose and change your exposure settings.*

A live histogram is automatically updated as you compose your scene and make any changes to your exposure settings. For tricky lighting situations, this can help you zero in on a correct exposure. However, it can be difficult to see the histogram while it's superimposed on a live scene and constantly updating. Personally, I find it much easier to use a regular playback histogram.

Shooting with a histogram

If you're simply taking snapshots or quickly documenting an event or scene, then you're probably not going to stop and take a look at the histograms for every image that you shoot. The tools and procedures we're discussing here are for composing shots that are a little more complicated—shots where you've visualized a particular image that you will shoot and then finish in your image editor.

For these types of images, your shooting workflow will usually be something like this:

✦ Shoot an initial image. In most cases, you'll simply use your camera's auto exposure setting for this shot.

✦ Review the histogram of this initial exposure and assess whether the shot needs any type of exposure adjustment.

✦ Make the adjustment and reshoot.

✦ Review the new image's histogram.

If you're shooting in a rapidly changing situation or don't have time to shoot and review and adjust, then you'll want to consider bracketing your shots, which we'll discuss shortly.

Exposure compensation

Obviously, the histogram display is essential for the workflow just described. But you'll also need controls for adjusting the exposure of your image. Your camera may provide several options.

Almost all cameras provide exposure compensation controls. Exposure compensation lets you tell your camera to over- or underexpose by a certain number of stops (or fractions of a stop). You have no control over how the camera achieves this adjustment—it may make changes to shutter speed or aperture or both. In most cases, the way the adjustment is made is irrelevant, so exposure compensation is ideal for making adjustments to your camera's default exposure.

Some cameras provide physical dials or buttons for setting exposure compensation, along with a readout that indicates the current exposure compensation setting (**Figure 7.8**).

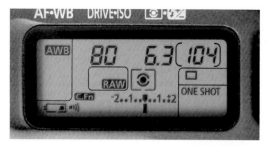

Figure 7.8 *To adjust exposure compensation on this Canon SLR camera, you simply turn a wheel on the back of the camera. The exposure compensation display on the camera's status LCD indicates the amount of compensation you've dialed in.*

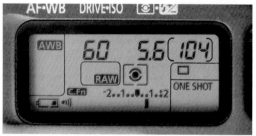

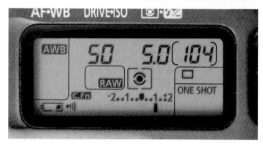

On other cameras, you access exposure compensation through the in-camera menuing system (**Figure 7.9**).

Figure 7.9 *Some cameras require you to use a menu option to change exposure compensation.*

In most cases, exposure compensation controls let you over- or underexpose by up to two stops in either one-third-stop or one-half-stop increments (many cameras let you choose the size of the exposure compensation interval).

All exposure compensation moves are based on the camera's initial metering of a scene. So, for example, your camera may meter a scene and recommend an exposure of 1/125 of a second at f/16. If you then dial in an exposure compensation setting of +1, the camera will change to an exposure that's one EV *above* that initial metering.

To determine how much exposure compensation to use, you can consult your histogram, as you'll see later in this chapter.

Shutter and aperture priority

In addition to exposure compensation, your camera may have special *priority* modes. Shutter and aperture priority also let you adjust your exposure settings, but with more control than you get with exposure compensation.

In shutter priority mode, you select the shutter speed that you want, and the camera automatically selects a corresponding aperture that yields a good exposure.

Aperture priority works the opposite way: select the aperture that you want, and the camera will automatically select an appropriate shutter speed.

To over- or underexpose in either mode, you'll still need to use your exposure compensation control. However, your camera will try to preserve your priority setting.

So, for example, if you're shooting a portrait and want to blur the background of the image, you might switch to aperture priority mode and select a wide aperture. If you then decide to over- or underexpose with exposure compensation, the camera will try to preserve your aperture setting. (You must use exposure compensation to create the overexposure, because if you open the aperture to try to overexpose, the camera will simply switch to a faster shutter speed to maintain what it thinks is the correct exposure.)

Similarly, if you're shooting a football game and want to ensure that you can freeze the motion of the players, you would choose shutter priority mode and set a fast shutter speed. If you decide that you need to overexpose your shots, you can dial in a positive exposure compensation setting, and the camera will try to achieve that new exposure without altering your chosen shutter speed setting.

Manual mode

Some cameras offer a full manual mode that gives you control of both shutter speed and aperture. Your light meter still will work as usual and will tell you what it thinks the correct exposure should be, but you're free to adjust the camera's settings any way you want.

Consequently, when you want to over- or underexpose in manual mode, you don't need to use exposure compensation (although you can). Instead, you can choose precisely how you want to achieve your exposure change. This control allows you to be absolutely certain that you preserve the shutter speed or aperture setting that you want for your intended image.

As you've already seen, your camera's exposure compensation readout indicates how much you've altered your exposure with the exposure compensation control. On most cameras, this same readout shows how much you are over- or underexposing when you make changes from the camera's initial metering using priority or manual mode.

ISO: YOUR THIRD EXPOSURE PARAMETER

One of the great advantages of digital photography is that you can change your ISO setting from shot to shot. The ability to alter the ISO setting gives you an additional exposure parameter for times when you can't quite get the shutter speed or aperture that you want.

Just as doubling the size of the aperture doubles the amount of light that strikes the focal plane, or doubling the shutter speed halves the amount of light that strikes the focal plane, doubling the ISO setting makes the camera twice as sensitive to light. This can often buy you some latitude when making exposure choices.

For example, say you're shooting a landscape and you want to use a small aperture to ensure a deep depth of field. Unfortunately, it's late in the evening and the light is dim. Your camera is set to ISO 100. With the small aperture, your camera has recommended a shutter speed of 1/15 of a second—much too slow for handheld shooting. If you increase your ISO setting to 200, then you'll gain one stop and be able to shoot at 1/30 of a second—better for handheld, but still possibly a little slow. Increase the ISO setting to 400, and you'll be able to use a shutter speed of 1/60 of a second.

Depending on the quality of your camera, the increased ISO setting may yield more noise in your final image, but a little more noise is better than a blurry picture.

Auto bracketing

Bracketing is the process of shooting multiple shots of the same image using different exposures. Bracketing is a great way to safeguard against ending up back at home with a poorly exposed photo. If you're in a tricky exposure situation, or if you're not sure what the best exposure is for shooting raw, then bracketing is a great way to ensure that you get a usable shot.

You can easily bracket using your exposure compensation control. Just shoot a shot at your regular exposure, then use exposure compensation to overexpose, shoot another shot, and then take another underexposed. Or if you know that you don't need any underexposure, shoot several shots overexposed by varying degrees.

How much of an interval to use in your bracket varies depending on the situation. Sometimes you may want to bracket by an entire stop, and other times you may merely want to bracket by a third of a stop.

If your camera has an auto bracketing feature, it can perform these exposure adjustments automatically. Most auto bracketing modes let you select the bracketing interval that you want to use. When you press the shutter, the camera will take an exposure at the default metering. When you press the shutter again, the camera will automatically shoot with your selected *under*exposure. The next shot will shoot your bracketed *over*exposure. If your camera has a drive feature, (sometimes called burst or multishot), you can activate it to shoot a burst of automatically bracketed exposures with a single shutter press (**Figure 7.10**).

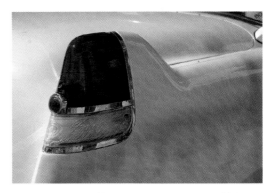

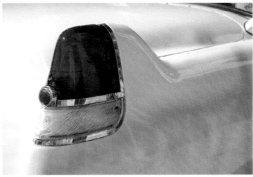

Figure 7.10 *In auto bracketing mode, my camera automatically adjusted its exposure to shoot three shots: one underexposed, one normal, and one overexposed.*

Note that auto bracketing modes work by using exposure compensation to effect different exposures. If you're very concerned about maintaining a particular shutter speed or aperture, then you'll want to use auto bracketing in conjunction with a priority mode, or perform your bracketing by hand in manual mode.

Putting it all together

When shooting raw, you want to capture as much information as you can from the bright areas of your image—without clipping your highlights— because these are the areas where your camera captures the greatest number of tones. With a histogram at your disposal, it's very easy to ensure that you've done this. If your histogram doesn't have data on the right side, then you're capturing more information from the darker areas of your scene— areas that the camera represents with very few tones.

At the same time, you want to capture an image with a good range of contrast. This means that you don't want *all* of the information pushed over to the right side of the histogram. Ideally, you want it spanning the entire range. If your scene has a lot of dark tones in it—like the playground image in Chapter 6—then your histogram will have a lot of data on its left side. This is not bad. You just want to ensure that the bright parts of your scene are being exposed more toward the right.

Figure 7.11 shows the display from a camera after shooting a flower. The +/–0 readout indicates that the camera was shooting at its recommended metering. The histogram shows an image with a good range of contrast and a lot of shadow data (which may actually be clipping), but it doesn't show a tremendous amount of data on the right side. With a little overexposure, we may be able to capture more of the bright areas of the scene, where the camera can capture a greater number of tones.

Figure 7.11 *This image has a good amount of data, but it's pretty weak on the highlights and heavily exposed in the shadows—time to try an overexposure to see if I can capture more in the highlights.*

Using the exposure compensation control, we make a +2/3 exposure adjustment and shoot again. This time, the histogram shows more information in the bright highlights (**Figure 7.12**). It also shows some highlight clipping, revealed on the histogram and by flashing black pixels on the clipped areas of the scene.

Figure 7.12 *My first over-exposure attempt does yield more highlight data—too much, according to the camera's histogram.*

Because we know that the camera's histogram will indicate highlight clipping before it actually occurs in the raw file, we decide to push our luck and do one more overexposure. We already have a couple of well-exposed images to fall back on, and as long as we don't erase them, trying this extra experiment poses no risk to getting a good final exposure.

For **Figure 7.13**, the exposure compensation was set to +1⅓. Now the histogram and clipping display indicate a heavily clipped image, but let's stick with the hunch that things probably aren't as bad as they seem.

Figure 7.13 *My camera says that my second over-exposure attempt has gone way too far in terms of highlight clipping. I'm going to trust that the camera's histogram is overcautious, and that things will be okay back in Camera Raw.*

Back in Camera Raw, the second overexposure does, in fact, have a little highlight clipping that's unrecoverable—not as much as what the camera indicated, but still enough to be annoying (**Figure 7.14**).

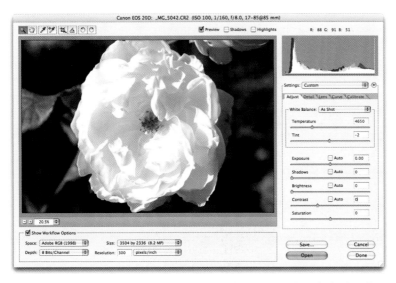

Figure 7.14 *My second overexposure was too aggressive. No matter how far back I pull the Exposure slider, there are some blown highlights that I just can't recover.*

If we go to the first overexposure, we find a little bit of single-channel highlight clipping, but nothing that can't be recovered. More important, its data is shifted a little more to the right than in the initial default exposure. This means that we've exposed for the bright parts of the image, where the camera is capable of capturing more levels (**Figure 7.15**).

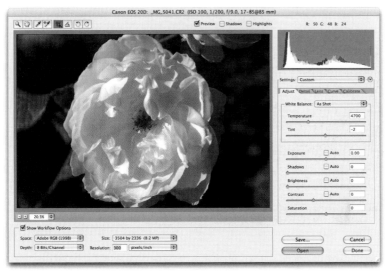

Figure 7.15 *This image has lots of useful data in the highlights and only single-channel clipping, so I can easily recover the little bits of overexposed flower.*

The rest of the edits proceed normally—first a negative exposure adjustment to recover the highlights, and then slight brightness and highlight tweaks. Finally, some cropping and then sharpening in Photoshop, and the image is complete (**Figure 7.16**).

Figure 7.16 *The final image has a lot of data to work with, so editing is quick and easy, with little concern over artifacts or tone breaks.*

Shooting HDR

At the end of Chapter 6, you were introduced to high-dynamic-range images, created using Photoshop CS2's Merge to HDR feature. Merge to HDR culls different tonal ranges from a selection of images that have all been shot with different exposures. These values are combined to create a single 32-bit image with a much wider dynamic range than you could ever shoot with a single exposure.

As you saw, when the images are combined, the resulting picture pulls the highlight, shadow, and midtone details from the appropriate exposures. Obviously, if you don't have a good selection of source images to begin with, then your merge operations won't be as successful. Good HDR work, then, begins with good shooting. HDR shooting isn't difficult, but it can take some time.

When should you shoot HDR?

Any time you encounter a scene with a tremendous range from bright to dark, you've found a good candidate for an HDR image. You want to use HDR imaging for those scenes that go beyond the dynamic range that your camera can capture. You'll usually be able to determine this simply by looking at the scene, but shooting a test shot and then reviewing it on your camera and consulting your histogram is also a good HDR test. If you can't get a shot that gives you a good shadow exposure without blowing out your highlights, or that gives you a good highlight exposure without turning your shadows to complete black, then you probably have a good candidate for HDR.

What you need to shoot HDR

Obviously, to shoot HDR you must have a camera that can shoot raw files. You're going to need to perform some precise exposure adjustments when shooting HDR. Though you can perform these adjustments with an exposure compensation control, you ideally want an aperture priority or manual mode on your camera. If you don't have these features, don't give up—it's still worth trying HDR using your camera's exposure compensation feature.

You'll need a camera that can display a histogram, and you'll need a fair amount of storage space. You'll be shooting anywhere from 3 to 10 exposures for a single HDR image, and getting it right can be complicated, so

you'll probably want to make several attempts. This means that you may be taking up to 50 raw shots to capture a single scene!

I have not found it possible to shoot usable HDR source images without a tripod. Though there are people who claim to be able to do it, I find that my images always suffer from artifacting (**Figure 7.17**). If you *are* going to try shooting HDR without a tripod, then you'll at least want to use lenses that feature some stabilization or vibration dampening. If you don't want to carry a full-size tripod, consider a small, micro-tripod. Though not as versatile as a regular tripod, they're easier to carry and provide at least some measure of stability.

Because you don't want your camera to move at all between shots, it's best to handle it as little as possible while shooting. you'll find a remote control, either wired or wireless, to be a very important HDR accessory. If you don't have one, then you can use your camera's self-timer feature. Some of your exposures may be very long, so if you're using an SLR camera, a mirror lock-up feature can be handy.

Figure 7.17 *I tried to shoot this HDR scene handheld using exposure compensation and my camera's drive mode. Even with a lot of effort to get the source frames aligned, my image is still plagued by weird artifacts brought on by misregistration of the source images. In particular, note the weirdness around the tops of the cliffs and the trees.*

Framing your shot and preparing to shoot

Frame your HDR shot just as you would any other scene. Be aware that moving subjects such as running water or blowing trees can create problems when you perform your final merge, so you may want to frame these out or minimize them as much as possible. Moving people or vehicles are pretty much impossible to shoot with HDR, so you'll also need to frame these out or wait until they've left your scene.

Your goal is to come away from your scene with a series of exposures, one stop apart, that span the darkest to lightest parts of your image. After framing your shot, your next step is to determine what that range of exposures should be.

There are many ways of changing exposure on your camera. However, you ideally want to make your exposure changes in a fairly controlled fashion. You don't want your images to be shot with varying apertures lest the resulting pictures have varying depths of field. So it's best to make your exposure changes by varying the shutter speed.

You can use exposure compensation to make these changes, but when over- or underexposing using exposure compensation, you have no control over how the camera achieves the change. For some changes, the camera may alter the aperture rather than the shutter speed.

Point-and-shoot cameras

If you're using a small point-and-shoot camera that doesn't have any other manual controls, then exposure compensation will be your only exposure option. The good news is that your small camera probably can't register a significant change in depth of field anyway. However, your exposure compensation control probably allows you only a two-stop range above and below the normal metering. This makes your shooting task fairly simple, though it doesn't afford you a lot of flexibility. If this is your situation, you can skip ahead to the next step.

Digital SLR cameras

If you're using a digital SLR camera with priority and manual modes, then you can shoot a much broader range than the four stops provided by exposure compensation. Your first goal is to determine the brightest and darkest exposures that you should shoot.

First you need to pick an aperture. If you're shooting in daylight, then stick with an aperture somewhere in the middle of your camera's aperture range, as this will afford you good depth of field and usually offer the lens' greatest sharpness. In bright daylight, f/16 is usually a good choice. If you're shooting in low light, then you may want a slightly larger aperture to shorten your shutter speed.

Switch your camera to manual mode and set your chosen aperture. On most cameras, your shutter speed will default to whatever your last manual operation was. Thus, your current shutter speed may be very wrong for your situation. When you meter your scene, your exposure compensation display should indicate whether your current settings are over- or underexposed. Change the shutter speed until the display says that you have the correct exposure for your chosen aperture.

Now you want to determine the lowest exposure that you need for your scene. Adjust your shutter speed down by three stops. Three stops may not be your final choice, but it's a good starting point for experimenting.

Shoot an image with a three-stop underexposure and then look at its histogram. Your goal is to find an exposure that underexposes the brightest elements in your scene. This way, as you work *up* the exposure scale, you will be getting good coverage of your scene's highlight areas. Usually three to four stops underexposed is all you'll need, but your histogram should give you a good indication of whether you need more or less. If the brightest areas in your scene are falling in the middle of your histogram or a little lower, then you've found a good bottom-end exposure. If they're coming in above this point, then try another test one stop lower. If the whole image is completely black, then this is more underexposure than you need, so you should dial the exposure back up and test again.

Once you've found what seems to be a good point, note the shutter speed and then go through the same test with *overexposing*. This time, you're looking for an exposure that will leave the darkest parts of your scene somewhere in the middle of your histogram. This will probably also be around three to five stops over what your meter said was a correct exposure. When you find this point, note the shutter speed (**Figure 7.18**).

Figure 7.18 *When selecting an underexposure, you're trying to ensure that you capture the very brightest parts of your scene. Similarly, your selected overexposure will serve to capture detail from the darkest parts of your scene.*

When you're finished, it's a good idea to delete the test images that you've taken, as they can confuse things when you get back home and begin sorting out which images go together.

Shooting your scene

Now that you know the brightest and darkest exposures that you need, you're ready to shoot your full range of images. Set your camera on the dark exposure that you determined in the last step.

Because you want all of your exposures to be perfectly registered, it's best to handle the camera as little as possible. If your camera has a self-timer, use it for your shots. Better yet is a remote control that lets you trip the shutter without touching the camera. As mentioned earlier, if you're using a digital SLR camera, activate its mirror lock-up feature if it has one, to reduce camera vibration.

Obviously, if you're working in rapidly changing light conditions, you need to move as quickly as possible. Wherever you're shooting, though, keep a close eye on your scene. Make sure that no birds are flying through and no people are walking by, or that any other moving elements have entered the frame. You don't want anything in one frame that won't be in all of the others.

Shoot your image and then move your shutter speed up one stop. Shoot your next image and then adjust your shutter speed again. Keep adjusting by one stop and then shooting until you've reached the upper exposure that you determined earlier.

Shooting with aperture priority

Since your goal is to preserve the same aperture through all of your shots, you can use your camera's aperture priority mode instead of manual mode. Set it on the aperture that you want and then use your exposure compensation control to over- or underexpose. However, this approach will limit you to the four stops of range provided by your camera's exposure compensation control.

Reviewing your shots

After you've worked through your entire intended exposure range, take a moment to double-check your images. Consult their histograms and see if your initial assessment of exposure range was correct. Obviously, if you've shot more than you need, that's okay, as you can simply work from the middle images.

I usually shoot two or three batches of images, just in case there was a bird flying through that I didn't notice, and to protect against any accidental movements of the camera. In addition, I usually shoot an empty shot—my hand or the lens cap—between each batch, to help me sort the separate batches later.

How many shots do you need?

Unfortunately, there's no way to tell for sure whether you have the source files you need until you get back to your computer and run the images through the Merge to HDR function. However, with a little experience, you'll get a better sense of how many shots and how much range you need to cover your scene.

If exposure compensation is your only exposure control, then you'll have a maximum of five source images (–2, –1, 0, +1, and +2). This is often plenty, and for many scenes you can even make do with just three shots. Some scenes may need more underexposure than overexposure (or vice versa), depending on their content.

Because different scenes require different amounts of source data, when you're first starting out with HDR, it's best to play it safe and overshoot. If you shoot more frames than you need, you can always deactivate them in the Merge to HDR window.

Once you're home, how do you know if you have what you need? Obviously, just trying a merge operation is the easiest way, but you can also get a good idea of how good a shooting job you've done by looking at the histogram provided in the Merge to HDR window after Photoshop performs its initial merge (**Figure 7.19**).

Obviously, the more data you have, the more latitude you'll have for editing.

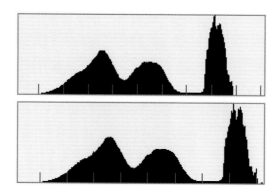

Figure 7.19 *The upper Merge to HDR histogram shows a merge that has less highlight data than the image represented by the lower histogram. Though the upper merge will still provide a lot of latitude, the situation could have been better if I'd shot a few more exposures.*

Conclusion

Shooting for raw isn't tremendously different from shooting JPEG images, and the small bit of rethinking that you have to do is worth it to get the extra editing flexibility that raw provides.

If you're an experienced film shooter, you've probably already realized that shooting raw is pretty much just the opposite of what you're used to doing when shooting film. When shooting raw, you want to protect your highlights rather than your shadows.

Obviously, when compared to shooting JPEG images, working with the raw format requires more work and a more technical understanding of certain basic technological concepts. However, as you work with raw, you'll probably find that having to consider these basic issues and concepts makes you a better photographer. Sometimes, being forced to slow down and consider your shooting parameters or to weigh different variables forces you to visualize your scene more clearly. And if you take the time to consider the issues and guidelines that you've learned in this book, then you'll capture more robust image data that will allow for more editing power and flexibility.

Now you simply need to practice. As you spend more time shooting and editing, you'll get a better feel for what is possible to achieve with raw files. Remember that even the best photographers come home with a lot of bad pictures, so don't get hung up if every shot you take isn't a keeper. Pay attention to what works and what doesn't, and your pictures will improve. In the meantime, don't get so concerned about the particulars and vagaries of raw shooting that you forget to enjoy yourself!

Index

masks
 adding to adjustment layers, 222–226
 adding to image layers, 226–231
media cards, advisory about working from, 140
MediaPro (iView), features of, 32
Merge to HDR feature
 determining amount of shots required for, 273–274
 launching, 234
metadata. *See* image metadata
 adding to images, 158–160
 displaying with File Browser and Bridge, 71
 editing, 159
 saving file settings in, 164
 storing in XMP files, 128–129
midtones
 adjusting, 49–51, 111
 adjusting in underexposed images, 118
 applying brightness to, 213
missing data, identifying, 59–60
motion, correcting in HDR images, 244–246
multisensor approach, applying to color photography, 11

N

noise, types of, 101. *See also* Luminance Smoothing slider in Camera Raw
noise reduction
 and JPEG images, 21–22
 and raw images, 29
nondestructive edits, mechanism for, 58
nonlinear response to light, significance of, 191

O

OK button, effect in Photoshop CS and Elements 3, 126
Organizer application
 backing up catalogs and files with, 178
 deleting images in, 146
 finding images with, 156
 importing images with, 139
 rating images in, 149
 renaming images in, 146
 using, 71–72
 viewing metadata in, 158–159
Organizer tags, using, 161
out-of-gamut color, overview of, 61. *See also* colors

overcorrection, recognizing, 59–61. *See also* correcting
overexposed images
 and bracketing, 262
 in manual mode, 261
 relationship to shutter and aperture priority, 260
 shooting raw, 264

P

panes
 resizing, 141
 resizing in File Browser and Adobe Bridge, 71
panning images with Hand tool, 186
parameter settings, effect on LCD images, 256–257
parameters for saving, examples of, 126
percentages, zooming at, 184
photodiodes, purpose in chips, 10
Photoshop, opening images in, 168
Photoshop actions
 building for Levels and Curves layers, 177
 creating for Batch command, 169–172
Photoshop CS
 adjusting multiple files in, 164
 Camera Raw in, 77–78
 copying Camera Raw settings in, 166
 custom workspaces in, 144
 effect of pressing OK and Cancel buttons in, 126
 saving raw images in, 108
 using XMP files with, 129
Photoshop CS2
 adjusting multiple files in, 163–164
 Merge to HDR feature in, 234
 opening Camera Raw from, 76
 saving raw images in, 107–108
 using XMP files with, 128
Photoshop Elements 3 and 4, Camera Raw in, 77
Photoshop files, editing in Camera Raw, 174
Photoshop format, flattening and saving in, 175
photosites
 exposure to excessive light, 104
 purpose in chips, 10
pictures
 determining amount for HDR, 273–274

reviewing for HDR, 273
 shooting high volume of, 124
pixel dimension versus resolution, 81
pixels
 determining colors of, 12–13
 on image sensors, 12
 indicating tonal value of, 56
point-and-shoot cameras, using HDR with, 269
points, identifying, 210
posterization
 causes of, 192
 producing from data loss, 60
 relationship to curves, 57
Preferences dialog box in Camera Raw, opening, 99
Preview pane, displaying preview images in, 73, 184–185
primary colors, examples of, 11
print, resizing for, 176
printers, resizing for, 176
printing, color correction for, 177
prints, testing with adjustment layers, 177
Process Multiple Files dialog box, displaying in Elements 4, 173
ProPhoto RGB option, using with underexposed images, 117

R

Radius slider, effect of, 242
ranking images, 147
 approach toward, 153
 in File Browser, 149
rating images
 in Bridge, 148
 in Organizer application, 149
 taking time with, 150
raw
 advantages and disadvantages of, 3
 flexibility of, 7
 process of, 3
 reasons for switching to, 4
 requirements for, 5
 shooting, 64, 263–266
raw concerns
 shooting performance, 33
 storage, 31
 workflow, 32
raw converter, explanation of, 26
raw file extensions, examples of, 69
raw file formats, examples of, 66
raw files
 batch processing, 167
 contents of, 26

raw files (continued)
 copying Camera Raw settings
 between, 165
 versus JPEG files, 136
 opening, 70
 opening in Camera Raw in
 Windows, 130–131
 opening in Camera Raw on
 Macs, 131
 opening with Camera Raw 3,
 132
 saving, 126
raw images. See also images; JPEG
 images
 and 8-bit conversion, 30
 and color adjustments, 29
 and color space, 27
 and colorimetric interpretation,
 27
 and contrast, 29
 creation of, 26
 and demosaicing, 26–27
 and file storage, 30
 and gamma, 29
 and noise reduction, 29
 processing low-contrast images,
 112–115
 saving in Elements and
 Photoshop CS, 108
 saving in Photoshop CS2,
 107–108
 and sharpening, 29
 shooting, 136
 toggling between adjustments
 to, 188
 and white balance, 28–29
raw mode
 advantages of, 30
 selecting on Canon EOS-20D, 5
 testing parameter settings in, 257
raw thumbnails. See thumbnails
raw workflow. See workflow
Rectangular Marquee tool, using,
 245
red fringes, reducing with
 Chromatic Aberration slider,
 104–105
renaming images, 145–146
Reset button, accessing in Camera
 Raw, 79
resizing
 images, 175–176
 panes, 141
resolution
 versus pixel dimension, 81
 setting in Camera Raw, 81

Rotate tools, using in Bridge, 129
rotating images, 147, 188
rotating images with Camera Raw,
 82
Rubber Stamp tool, erasing objects
 with, 244

S

sampling, process of, 10
saturation
 adding with adjustment layers,
 246
 adjusting, 207–208
saturation settings, refining for
 masks, 226
Saturation slider in Camera Raw,
 using, 96–97
saving
 HDR images, 237
 raw files, 126
saving images
 in Elements and Photoshop CS,
 108
 keyboard shortcut for, 188
 in Photoshop CS2, 107–108
S-curves
 applying to images, 54–55, 221
 using with HDR images, 240
searching, using keywords for,
 160–161. See also Find feature
 in Bridge; keywords
Select All option, using, 163–164
Select Previous Conversion option,
 using, 164–165
sensor blooming
 as colored fringe, 105
 green fringe resulting from, 104
Set White Point Preview slider, using
 with HDR images, 236
settings, effect on LCD images,
 256–257
shadows
 adjusting, 202
 considering with Exposure slider,
 93
Shadows slider in Camera Raw
 controlling black points with, 110
 versus Levels black point control,
 112
 using, 94
 using with low-contrast images,
 114, 115
 using with underexposed
 images, 116
sharpening
 images, 175–176
 and raw images, 29

relationship to JPEG images,
 21–22
Sharpness slider in Camera Raw,
 using, 98–100
shooting HDR, 267–273
shooting performance, concerns
 about, 33
shooting ratios, 1:1 ratio, 125
shooting raw, 263–266
shots. See pictures
shutter priority, availability of, 260
shutter speeds
 changing, 194
 noting for digital SLR cameras,
 271
sidecar XMP files. See XMP files
Size pop-up menu in Camera Raw,
 changing selections in, 80–81
skies
 darkening, 217–218
 protecting, 220
 vulnerability to banding, 60
sliders
 avoiding banding artifacts with,
 60
 tips for use of, 207
 using with Levels feature, 44–45
sorting
 images, 152
 using keywords for, 160–161
Space pop-up menu in Camera
 Raw. See also color space
 selecting color space from, 81
 using with underexposed
 images, 117
Sponge tool, correcting sensor
 blooming with, 105
sRGB color space, relationship to
 JPEG images, 18
stops
 measuring in, 194
 recording in digital cameras, 191
storage of raw images, concerns
 about, 31
straightening images wit Camera
 Raw, 85
Synchronize dialog box, opening,
 133, 163

T

tags, using with Organizer applica-
 tion, 161
Temperature slider
 adjusting white balance with, 91
 using with underexposed
 images, 120